D0147916

MICHAEL FREEMAN
CAPTURINGLIGHT
THE HEART OF PHOTOGRAPHY

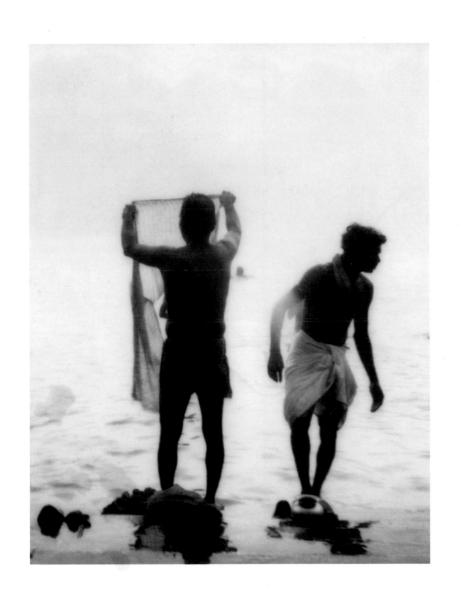

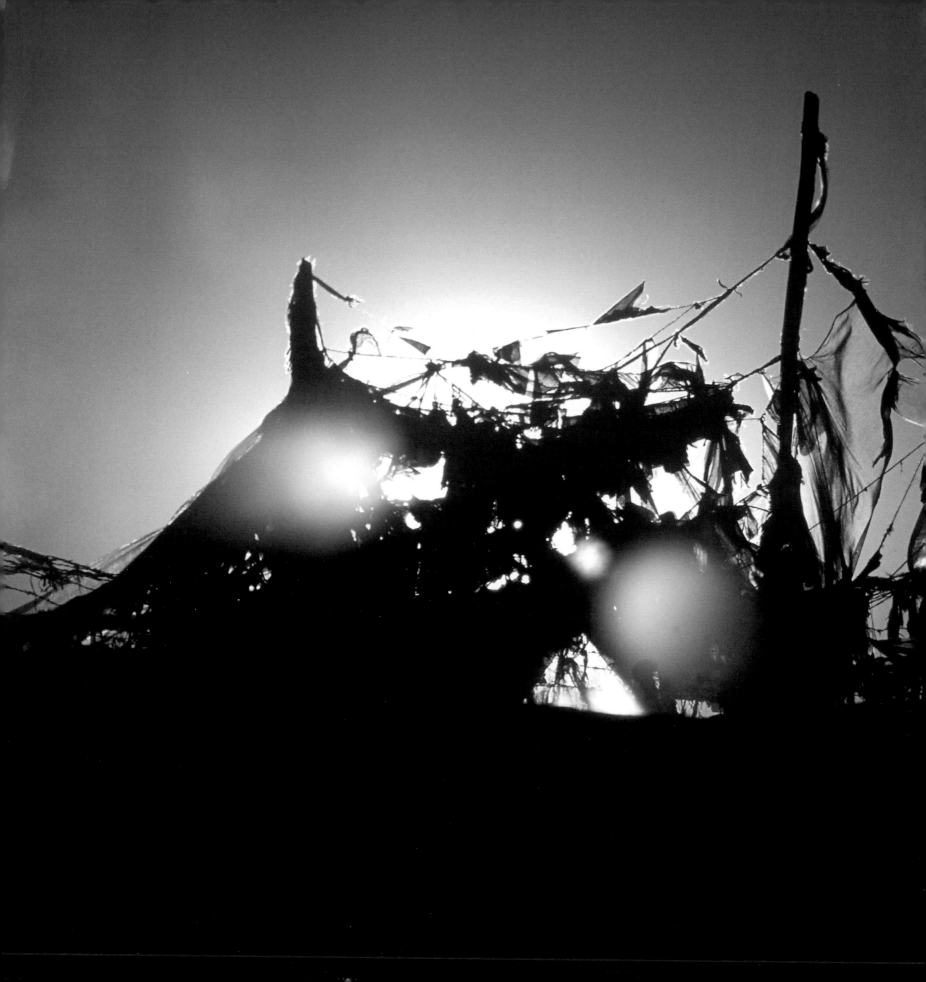

MICHAEL FREEMAN
CAPTURING LIGHT
THE HEART OF PHOTOGRAPHY

Focal Press
Taylor & Francis Group

NEW YORK AND LONDON

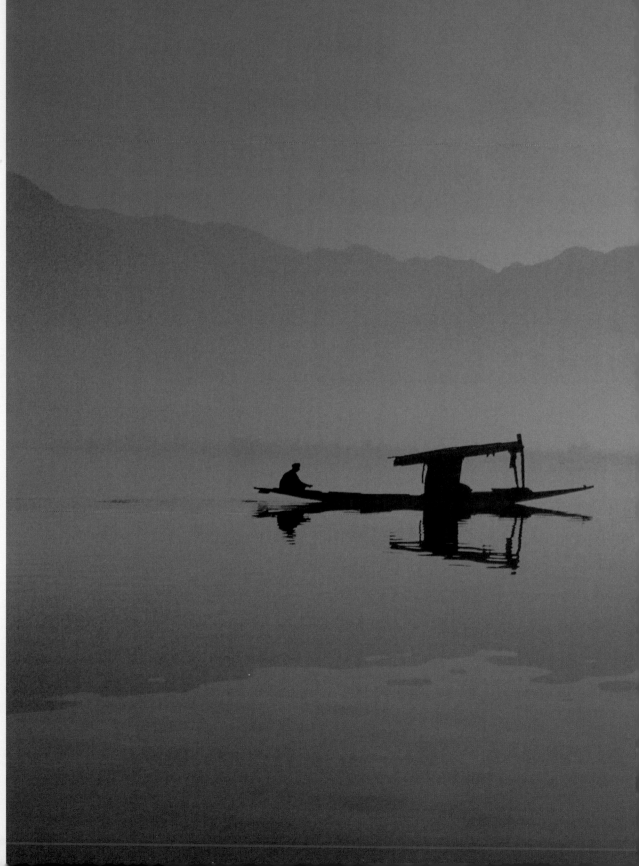

First published in the USA 2013 by Focal Press

Focal Press is an imprint of the Taylor & Francis Group,
an informa business
70 Blanchard Road, Suite 402, Burlington,
MA 01803, USA

Copyright © 2013 The Ilex Press Ltd.
All rights reserved.

This book was conceived, designed, and produced by
Ilex Press Limited, 210 High Street, Lewes, BN7 2NS, UK

PUBLISHER: Alastair Campbell
ASSOCIATE PUBLISHER: Adam Juniper
MANAGING EDITORS: Natalia Price-Cabrera & Nick Jones
SPECIALIST EDITOR: Frank Gallaugher
EDITORIAL ASSISTANT: Rachel Silverlight
CREATIVE DIRECTOR: James Hollywell
ART DIRECTOR: Julie Weir
DESIGN: Kate Haynes
COLOR ORIGINATION: Ivy Press Reprographics

No part of this book may be reprinted or reproduced
or utilized in any form or by any electronic, mechanical,
or other means, now known or hereafter invented,
including photocopying and recording, or in any
information storage or retrieval system, without
permission in writing from the publishers.

Notices:
Knowledge and best practice in this field are constantly
changing. As new research and experience broaden our
understanding, changes in research methods, professional
practices, or medical treatment may become necessary.

Practitioners and researchers must always rely on their
own experience and knowledge in evaluating and using
any information, methods, compounds, or experiments
described herein. In using such information or methods
they should be mindful of their own safety and the safety
of others, including parties for whom they have
a professional responsibility.

Product or corporate names may be trademarks or
registered trademarks, and are used only for identification
and explanation without intent to infringe.

Library of Congress Cataloging in Publication Data:

A catalog record for this book is available from the
Library of Congress.

ISBN: 978-0-415-84333-1 (pbk)
ISBN: 978-0-203-75715-4 (ebk)

Typeset in Adobe Caslon Pro

CONTENTS

INTRODUCTION

I realize that the way I've organized all these lighting situations may seem at first glance a little unexpected: waiting, chasing, then helping. Why not start, for example, with bright sunlight and then work through the times of day, then move on to different amounts of cloudiness? The reason is that while that might make complete sense to a meteorologist, it's not really the way that light works for photographers, at least in my experience. There's a huge difference in the way most photographers would think about and react to a succession of fine summer days than they would to a day of squalls passing overhead. The big difference, it seems to me, is between lighting you can reasonably plan for, and lighting that's unexpected.

All of the lighting in this book is of the kind that's handed to you by the place and the time. You could call it "found" lighting—most of it natural daylight, some of it the artificial lighting that illuminates homes, offices, and cities. As the title explains, I'm looking at how to capture lighting over which you have no real control. Constructed lighting, using flash or other lights designed for photography and filming, in studios, on interior and outdoor sets, is the subject of another book. The thought processes and working methods are completely different.

A very basic idea is the attractiveness of lighting, and why some kinds are more desirable than others to most photographers. This is a tricky subject, because it's really about aesthetics and how people's taste and judgment can differ—or coincide. Most of the time, people take it for granted that the light will look good under these conditions, but not so good under those. Think for a moment about what photographers and filmmakers call the Golden Hour. The "hour" is just approximate, but it means when the sun is low and bright, and it has its well known name because so many of us favor it and plan for it. And it features in this book, on pages 94-101. But why exactly? Why do most people find it visually attractive (and they certainly do)? Philosophically I don't think there's much value in in pursuing that question, and in the history of art and aesthetics it has never been completely answered. But what we can do very usefully is talk about being conventionally pleasing with light, and about doing the opposite, which is to buck the trend and challenging expectations.

Although I don't have any ambitions to add more jargon to photography than there already is, the lighting for any shot has a beauty coefficient, or you could call it a likeability factor. The Golden Hour, for example, would score overall about 8 out of 10 on this, and a flat grey sky would come in at around 1 or 2. I'm halfway tempted, but will resist, putting scores like this on each lighting situation in the book. We all have our prejudices and expectations about good, boring, or ugly light, so there's no need to hammer it home with a ratings system. What's useful about such a beauty coefficient, however, is that it expresses what most people like. Deep down, it's conventional, and that's why there are many occasions when you might instead want to be different.

More than that, I like personally to think that most kinds of light are good for something, if only you think and work hard enough. It's an intentionally positive, even charitable way of thinking about light, and not everyone would agree. You might think it's going too far to expect a miserable, bleak wintry day in England, for example (we're famous for weather and our complaining about it) to ignite any photographic passion.

Loi Krathong celebration, Wat Prhathat Lampang Luang, northern Thailand, 1989

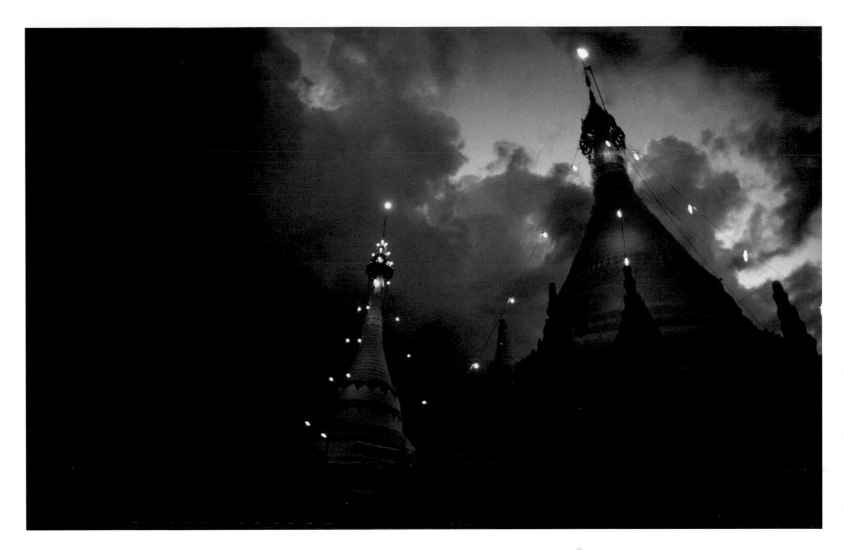

Wat Doi Kong Mu, Mae Hong Son, northern Thailand, 1982

Yet, even now I'm sometimes surprised at the results from what I thought of at the time as disappointing light—so long as I persisted in the shooting.

One book that made a great impression on me, and made me think more about the quality, mood and overall visual atmosphere of light, was *In Praise of Shadows*, a slim volume written in 1933 by a Japanese novelist, Jun'ichirō Tanizaki. I read it when I was doing several books about Japanese interiors in an effort to get my head around what may be the most distinct and introverted design culture in the world. Tanazaki helped enormously. The title is perfect. He was giving the counterview to Western Modernism, with its Bauhaus-bright emphasis on flooding life with light and whiteness, with all the associations of progress and optimism. Actually, Tanazaki railed against all of this, writing in a sympathetic but melancholy way of the beauty and even color in darkness. Specifically though, he was having a go at electricity. At one point

he maintains that "lacquerware decorated in gold was made to be seen in the dark." Interesting idea—less light, not more, and that certain experiences call for a particular light. He writes about light in temples being dilute, with a pale, white glow. "Have not you yourselves," he asks, "sensed a difference in the light that suffuses such a room, a rare tranquility not found in ordinary light?'" Close down and be somber, not unremittingly cheerful. Tanazaki made me realize how lighting contributes to mood.

Most of what follows is non-technical, but only if you define technical as strictly confined to camera and lens settings, calculations, and computer software. This ultimately comes down to exposure, and I dealt with that as exhaustively as I know how in *Perfect Exposure*. The aim here is to show how to work with natural and available light, and that starts with understanding its qualities. That in turn needs a vocabulary if we're going to work with light rather than just enjoy it as a sensory experience. Normally,

people don't have that need, and so words to describe the ways in which it falls on scenes, people, and objects are thin on the ground. Most people simply take it for granted. In this, it shares a common difficulty with other sensory experiences, like taste and smell. There is a professional vocabulary, although it is by no means as evolved as the two big sensory industries—wine and perfume. There, the size of the business and the market has forced the professionals to develop a large and precise vocabulary, on the way to becoming a common language. Here, with light, I'll be using terms like raking, sunstars, barred light, chiaroscuro, fall-off, directional, and fill. Most are self-evident, but where there's any doubt, I'll do my best to define them.

WAITING 1

Sitting around waiting doesn't sound like much of a management technique, let alone a light-management technique, but done properly it delivers the results. It depends, though, on knowing what you're waiting for, and this understanding takes things to a different level. Natural light, which is mainly what we're dealing with here, comes from a combination of climate, weather, and time of day. Climate means location, and you can plan for that by organizing a trip. Weather and time of day continue without any possibility of influence from you, and this is where intelligent waiting comes in. "Intelligent" because waiting involves planning, and it's a very deliberate approach to photography. Most of all, it's about knowing what light is possible from all the combinations, what each kind of light is good for in shooting, and how to extract the most from it in timing, framing, composition, viewpoint, and a sense of color (or black and white).

Practically, as a photographer, I divide light into the kinds I can expect, and the kinds that take me by surprise. This makes perfect sense for shooting, because they each prompt a different way of working. With the first group—the group in this first section of this book—you can anticipate and use your imagination to work out the kind of image you're about to shoot. With the second, unpredictable group, you have to react to the situation as it appears. Naturally, there are borderline cases, such as a shaft of sunlight that spotlights a small part of a scene.

If you're just passing through a new place, and the weather is uncertain, this will probably come as a surprise. But in a location you know well, and in a bout of predictable sunny weather, that spotlight will be repeated, with a slight difference, the following day.

Shooting in the kinds of lighting described here in the Waiting section depends on having reasonable expectations. It also depends on having a feeling for what the light does to landscape, people, and buildings. This includes the more technical matters of contrast: where the shadows fall and how strong they are, how well or not the light separates a subject from its background, and how clearly it explains the shape and form of things. But it also goes further, into the realm of sensation and atmosphere, which are less easy to pin down, but nevertheless powerful components of a photograph. One thing I'm going to warn about is falling into line too easily with the accepted norms of attractive light for photography. Not every scene has to be gorgeous and lyrical. Imagery means variety, and hunting for the perfect—and therefore the same—golden light across a pretty landscape actually means giving up on your imagination and following the herd. I've done it myself, and it's often hard to resist. It's especially common in contemporary published landscape photography. The problem is that taking this approach means heading in the same direction as others— a sort of photographic gold rush. Just a caution.

TIMING THE SUN

This is not a book about meteorology or trigonometry, but you'll excuse me for a moment if I trip through some basics that will help in identifying the kinds of light that bring richness to photography; they matter more for this section than the following two. Time of day meets weather to create these many lighting situations, and behind them lay location and climate. Quite a lot to keep a handle on, particularly if you travel.

It helps, I think, first to subtract the weather and just concentrate on the sun and its passage through the sky. The key end-points, as you'd expect, are sunrise and sunset, and not only do these set the timing for the day's light, but on either side of them, for about a couple of hours, the light not only changes more rapidly, but is also for various reasons especially favored for shooting. This means that most people like the light at these times of day, and even non-photographers start paying attention. Nevertheless, I learned early on that there's little point asking around for when the sun rises and sets (standard practice before GPS and smartphones could give you a running commentary on the timetables). There are, in fact, relatively few professions and trades that live by the sun; photography happens to be one of them.

It makes every sense now to rely on phones, tablets, or laptops for daylight tables, without needing to calculate anything, but the track of the sun through the sky is a slightly different matter. It changes constantly—very slowly near the equator, more definitely in higher latitudes. Personally, I use a phone app called Helios, which was designed for cinematographers, and has everything from a clinometer to a shadow-length calculator. As long as it has my location, I can work out not only where and when the sun will hit the horizon, but also where and when it will clear a skyline ridge or a high-rise block.

Factoring in the weather dramatically multiplies the possibilities, for confusion as well as shooting opportunities, so be aware that certainty is rare. Weather includes everything from atmospheric haze to clouds and storms—basically anything that prevents the sky from being crystal clear—and it's the subtleties of weather that create the many nuances of lighting that figure largely in the lives of photographers, filmmakers, and painters, but not too many others. ■

The sun's height

With Golden Hour taking up the lower 20° of the sun's path above the horizon, it's useful to be able to judge its height, particularly if you want to match this to tables. Approximately, then, if you hold your hand like this, arm out-stretched, these are the heights: 8° for the top of the palm and 15° for the tip of the thumb. Add a third again for 20°.

Key Points
Precise Timing
Elevation
Technology

HELIOS

An iPhone app designed
for cinematographers,
Helios gives many timings
and calculations, including
length of shadow as a ratio,
3D views of the sun's path,
a clinometer, and a way
of calculating when and
where the sun will clear
a hill or a building.

Archaeological dig, Kerma, Sudan, 2006

This dig in northern Sudan continued predictably. The
variable was the sunlight. I wanted the exact moment at
which the sun would clear one of the earthen walls of the
site, so that light just caught the archaeologist's hair and
the site plan on which he was writing. This is where timing
becomes important.

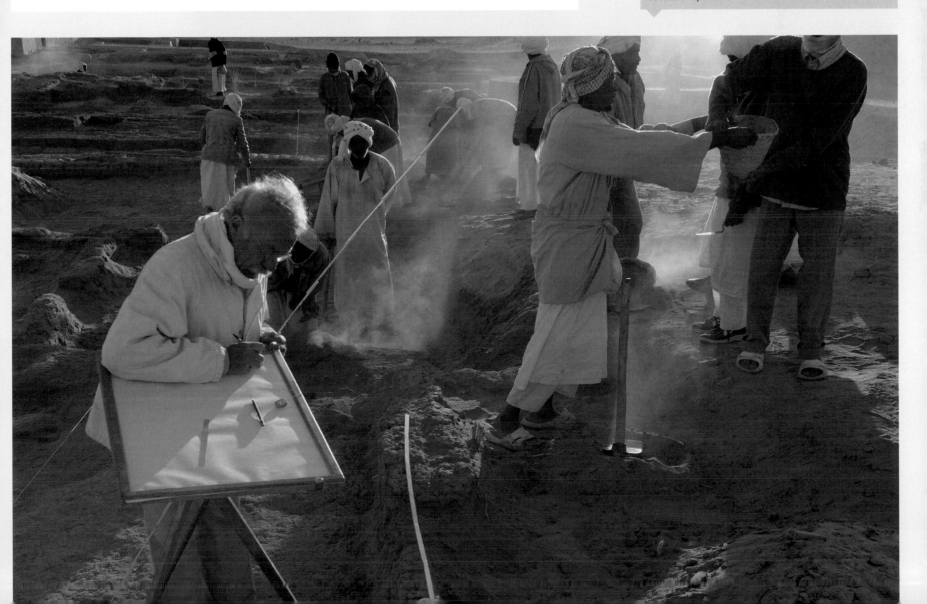

SOFT SUNLIGHT Manageable Shadows

Some light is simply more useful and less troublesome than others—not necessarily exciting, but certainly practical. Soft sunlight stands at the head of this list. This is sunlight softened by haze, to a degree that takes the edge off its clarity while still remaining what anyone would still call "sunny." It's a little like cheesecake—pleasant, but not to die for, and everyone likes it. This is universally attractive lighting that does a good job on most subjects, from people to buildings to landscapes. There's a reasonable amount of contrast that gives form and shape to things, but the gentleness in the atmosphere keeps the shadows open, their edges softened and the whole scene rounded rather than harsh.

All this makes soft sunlight particularly good for modeling things in a rounded, gentle way, perfect especially for faces. These famous towers that make up the ancient temple of Bayon at Angkor, Cambodia, also carry faces, more than 200 of them. Who they represent is disputed, possibly a Buddhist entity, possibly a king, Jayavarman VII. In any case, on this morning I thought they appeared exquisite, peaceful, and timeless. There was no one else there. I climbed onto another tower and shot.

Soft light

Softened shadows and a hint of warm color.

Bayon, Angkor, Cambodia, 1989

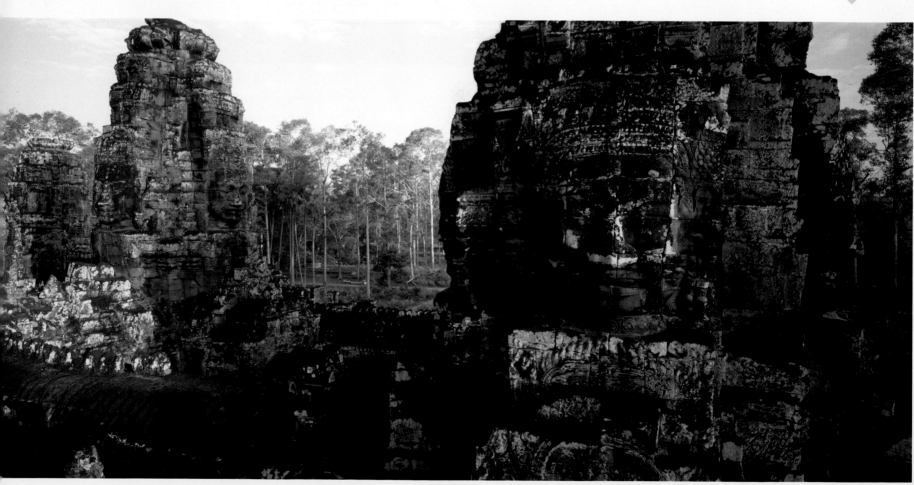

Under hard sunlight

This is how the scene would have looked under normal clear sunlight, the shadows deeper and with hard edges, and the colors more saturated.

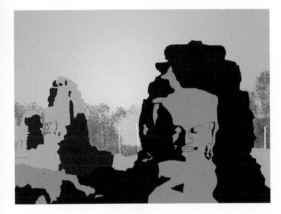

Under soft sunlight

In the scene as it was shot, the slight atmosphere—much less than misty—takes the edge off the sunlight, which becomes gentler, with less contrast because the shadows are now more open. The shadow edges are slightly softened also, the colors a little muted, and there is a more definite sense of depth to the entire scene.

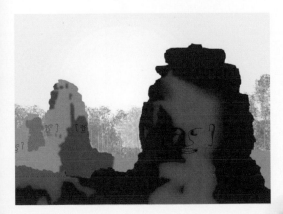

The cup of tea glowing in a similar soft sunlight, though later in the day, was taken on the terrace of a tea shop on Rong Hu Lake in Guilin. Tea in China has a much greater significance than its mere appearance suggests, and I wanted to capture the atmosphere of sitting with fresh green tea on a soft day. The shallow depth of field from a very wide aperture helps, but it's much more about the light. Stronger and more insistent sunlight would have been too sharp.

This is light that works particularly well on commercial assignments, when there's a planned subject to be photographed and a client to be satisfied, and what makes it particularly useful is its medium contrast range that fits the sensor response nicely. There's a good distance between highlight and shadow that avoids any sense of flatness, but there's still unlikely to be any need for shadow fill. It's also a condition that tends to persist, for hours at least. And because the sunlight is soft rather than intense, it stays more generally acceptable and attractive for longer, even when the sun is higher than you might like it on a really bright day. Again, this is a practical benefit that's likely to appeal more to photographers who have a specific assignment, often commercial, and who like to plan and guarantee things rather than simply go out and explore. ■

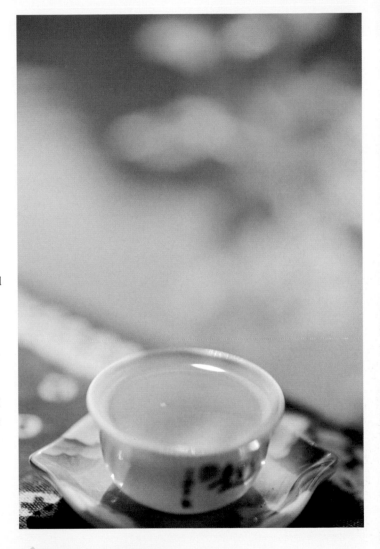

Oolong tea, Rong Hu Lake, Guilin, China, 2010

GRAY LIGHT The Beauty of Restraint

Poor gray light. Few people seem to want it. It's too ordinary, an all-too-predictable condition in mid-latitudes, often persisting day after day to the irritation of people who know that just above that low layer of shapeless cloud (low-level stratus is the culprit), a warm bright sun is shining. Not only does it give a featureless sky, but also it casts no distinct shadows that might at least give form to objects.

If there's a horizon in the view, nothing above the line of hills or row of buildings is of any interest whatsoever. This is truly the orphan of photography's lighting repertoire.

Well, hang on a minute. Is there really nothing to do with it? Are we just conditioned to find it boring? Maybe instead it's worth wondering whether we're overstimulated by impressive light. A glance at the

High Court Judge, St Paul's Cathedral, 1982

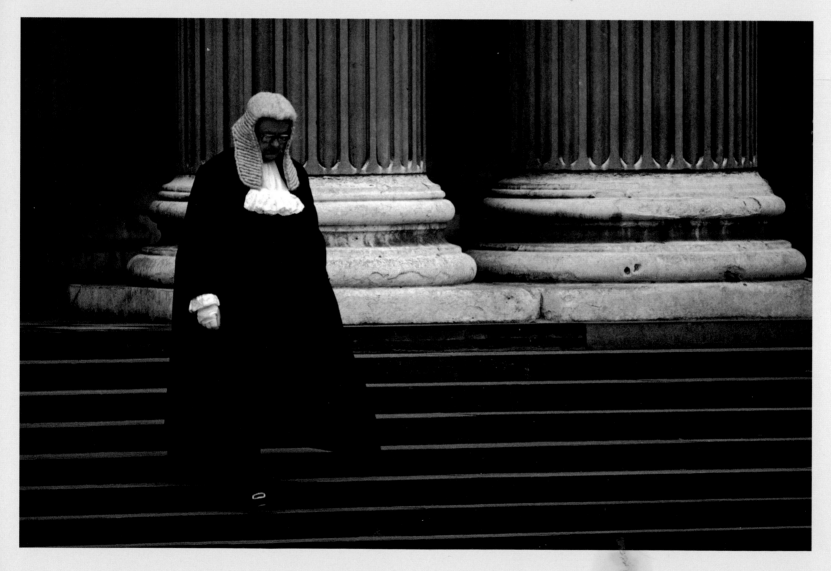

Yoga salutation, Beibei, Chongqing, China, 2012

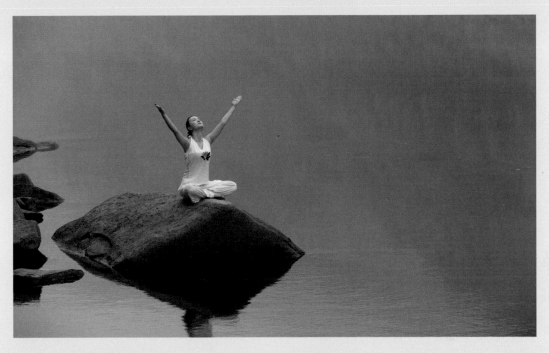

majority of competent landscape images suggests this, as photographers go to great lengths to capture the simply gorgeous—fiery sunsets, shafts of light, rich magentas, and blazing reflections. It's like the Hudson River School of painting all over again. Don't worry, we'll meet all these and more in this book, and high-octane lighting can indeed be spectacularly beautiful, and appropriate. But not all of the time. The word "mood" crops up frequently when photographers talk about light, and how it contributes. A full range of moods includes more than elation, the sublime, and surprise. There are many occasions for moods that are more reflective, quieter, even melancholy. I learned much about this in the few years I spent shooting in Japan, where restraint in many things conveys a kind of pleasure.

Above all, this is sober light that does little to interfere with the subject. It demands, perhaps, a more rigorous approach to composition, especially with placing subjects against backgrounds that contrast because of their natural tones and colors. Colors, interestingly, can benefit from gray light, as we'll see on the following pages. Both of the pictures here work beautifully in this shadowless light—to my mind, better than they would have in any kind of sunlight (a personal view, naturally). In one, a High Court judge descends the steps of St Paul's Cathedral in London; in the other, a yoga position on a rock in a still Chinese river. Contemplative light in both cases, you might say. The pair also illustrates an important choice when working with gray light: how light or dark to make the exposure. The contrast in this lighting is low, so there are no benchmarks for brightness. You can see the scene as darker gray or paler gray, and expose and process accordingly. ■

Darker gray

If you treat the overall gray theme as medium-to-dark, the shadow areas tend to come across more forcefully. This is treating gray light as darker-than-normal sunlight.

Paler gray

With the lower overall contrast under gray light there is always a choice of brightness. Overexposing lifts the sense of the image to something lighter and more open.

GRAY LIGHT In the Japanese Garden

In case you weren't convinced by the previous pages, let me take you through a shoot that might explain some more of gray light's qualities. I was making a book about Japanese gardens, contemporary gardens in fact, but many of them nevertheless followed traditional principles, or developed on them. There have been a number of styles within the long history of Japanese garden design, but most of them eschewed overt colorfulness. Occasional color certainly exists, which explains cherry-blossom and maple-leaf viewing, both valued for their short seasonality. On the whole, however, bright colors from lots of flowers are considered a bit uncouth, and what is valued is a subtle interplay of greens.

To capture these delicate differences, you have to avoid distractions, and one way of doing this is to avoid the contrast from direct sunlight. Another thing you may have noticed from these and the pictures on the previous pages is that I've been careful to frame the shots without any sky. Most skies on gray days have no features, and more than that, they are usually much brighter than the land. The result is that the sky raises the overall contrast, but to no purpose. More than this, however, is the effect of gray light on color saturation, and I learned the lesson quite quickly that Japanese gardens often look their best this way. At least, they tend to look the way that the gardener liked (and gardening in Japan is a fully formed art). The interesting thing here is that if you take a range of colors all from the same group—the same sector of the color circle— they appear at their best saturation when the lighting is even and gentle, not bright and contrasty. This seems counterintuitive, but it's because flat light does away with bright highlights and sharp, dark shadows, neither of which have much color at all. Look at the two illustrations. The hues are the same, but the lighting is different. The sunlit version catches attention because of its contrast, but the saturation in the other one is actually stronger by a quarter. ■

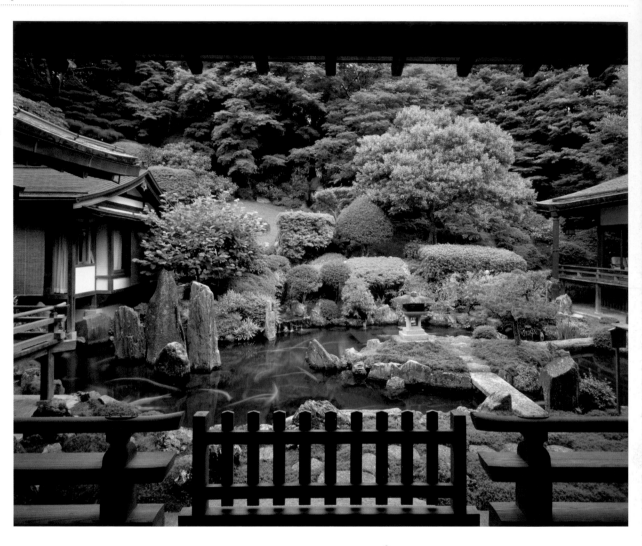

Ichijo-in temple garden, Koya-san, Japan, 1996

The illusion of richer color

In sunlight, the higher contrast gives a sense of colors being rich, but this is an illusion, albeit an effective one. In this illustration, the greens are actually 25% less saturated than those on the next illustration.

Deeper saturation in flat light

In gray light, without shadows or edges, the same colors are better saturated, by 25%.

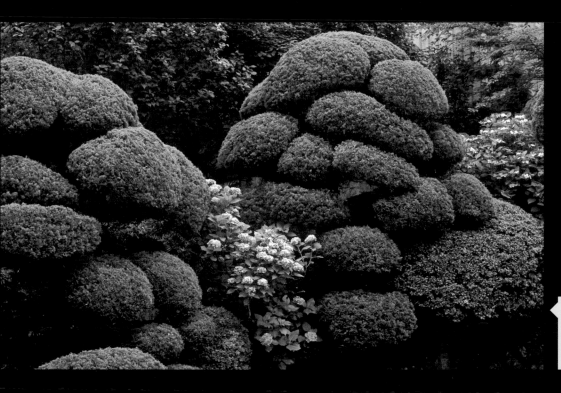

Rich greens

Pillow-like Japanese topiary, also on Koya-san, looks well modeled and rich in color under the same light.

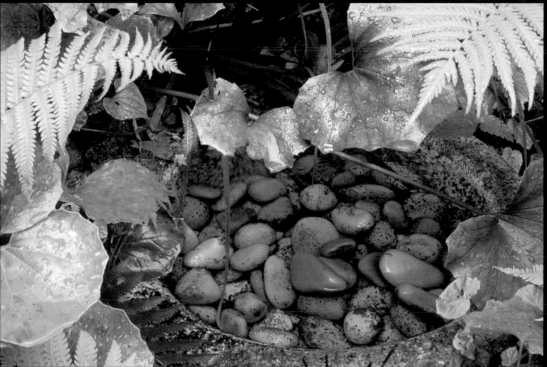

Green variety

More gray light and a detail of another Japanese garden, this time featuring a deliberate variety of green hues, which extends to the specially selected pebbles.

SOFT GRAY LIGHT On West Lake

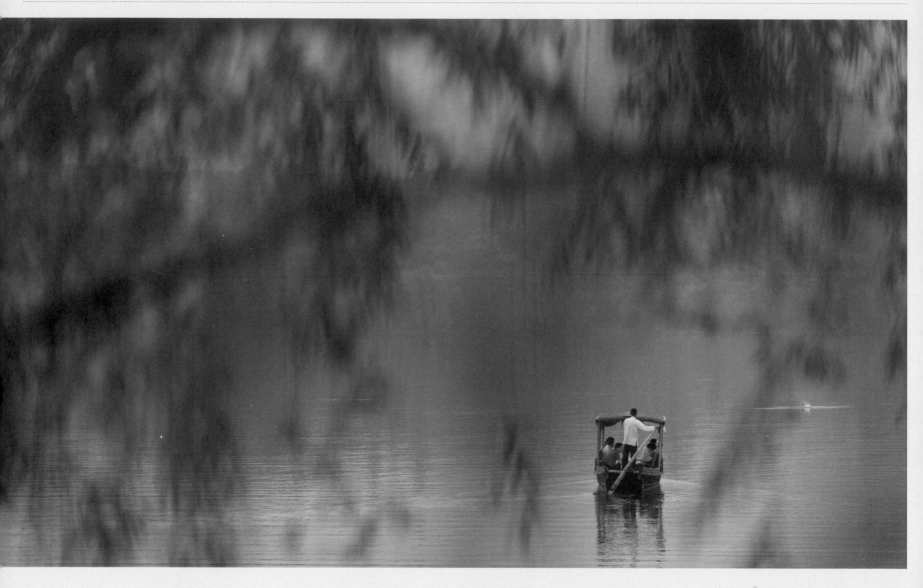

West Lake, Hangzhou, 2012

One of the secrets of photographing the gardens on the previous pages was to frame the shot so that no sky appeared. A wedge or bar of sky would take the contrast of the scene completely out of range. If you include sky, or as in this case here, its reflection in water, you have to deal with the exposure in a different way. This is West Lake in Hangzhou, China. Along with the renowned Dragon Well tea from the surrounding hills, and a history of cultured learning, this lake is what

Hangzhou is famous for, and it has served as inspiration for poets, philosophers, and artists for centuries. You walk along the lake paths, or take a small boat, or simply sit and look. With thousands of other people unfortunately, if it's a weekend (this is where photography's ability to turn off the sound is a positive advantage). I had my usual ideas about how lakes can be captured, which in the past have generally involved low sunlight from one direction or another. But on this day in May, sunlight was

unlikely, and my first reaction was some disappointment, though my friends who live here said that this is exactly what to expect—Hangzhou is also famous for rain.

So, what to do with West Lake on a gray day? The answer was to learn a little bit more about its place in Chinese culture, and what better way than the poets themselves? Here are the opening lines from a series of poems written by Ouyang Xiu in the eleventh century (there are some very different sounding English translations because the combination of characters is open to interpretation):

A light boat with short oars—West Lake is good.
A gentle curve in the green water

Deep in spring, the rain's passed—West Lake is good.
A hundred grasses vie in beauty

Who can explain why we love it—West Lake is good.
The beautiful scene is without time

I read other poems and picked out lines and phrases that evoked a similar mood:

Fine mist on distant water,
One white egret flying from the Immortal Isle

Misty mountains shrouded the rain

In the shade of the green willows

The water's surface has just smoothed,
the foot of the cloud low

The blur of color across the hills is richer still in rain

The direction was plain. Gray cloud and still water, green willows, a small boat, a bird, and above all, soft. Little pleasure boats still operate, and all that remained was to find the right, simple combination, keep bright colors out of the frame, and enjoy the gray. ■

A BIAS TO DARKER MID-TONES

Because of the lower contrast in gray light, the tones do not fill the width of histogram from black to white. As a result, you can choose where to place them, darker (as here), or brighter.

West Lake, Hangzhou, 2012
Other versions of the same scene, trying to capture the traditional appeal of West Lake.

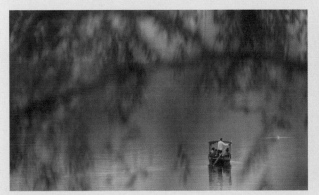
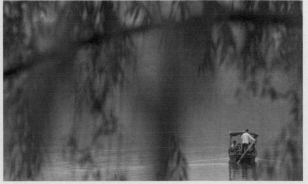

DARK GRAY LIGHT Wild Weather

Iceland is one of the truly wild and strange landscapes in the world. In fact, most of it is landscape, because with a population of just over 300,000 and a capital city that feels like a small town, the feeling of traveling around the island is distinctly primordial. Even sheep are thin on the ground. This has often attracted filmmakers, particularly when the film has a science-fiction theme, though they tend to founder on the number of bad-weather days. One film that made a virtue of this was the recent *Prometheus* by Ridley Scott, and here is the wild waterfall that opens the movie. Typically, the weather had changed totally in several

hours; the day before had been cloudless and had also been the longest day of the year, with a 24-hour midsummer sun here in the north. Now there was a looming dark sky, which suited this landscape very well, and made it look distinctly otherworldly.

It also raises an interesting question with this kind of low-contrast light. How dark is a gray sky? No, it's not a Zen koan; it does have an answer. The idea of normal brightness for any kind of scene revolves around the idea of a mid-tone—something we take for granted in photography. It's the principle behind the camera's metering system, and indeed behind all the ways of presenting images, in print and on screen.

An average mid-tone is the benchmark, and if you decide to go higher or lower, it's for a purpose, generally that of mood. Gray days are no exception, but they are easier to see and experience on a scale of brightness. Once you get used to the idea of gray light, you find that it comes in different shades. There are paler grays and heavier grays, and because the contrast is lower than in bright sunlight, there is room for interpretation. As the histograms show, you can expose higher or lower with impunity. Within a range of a couple of stops, the scene will stay within the sensor's dynamic range, but it will look and feel different—and the feeling is what it's all about.

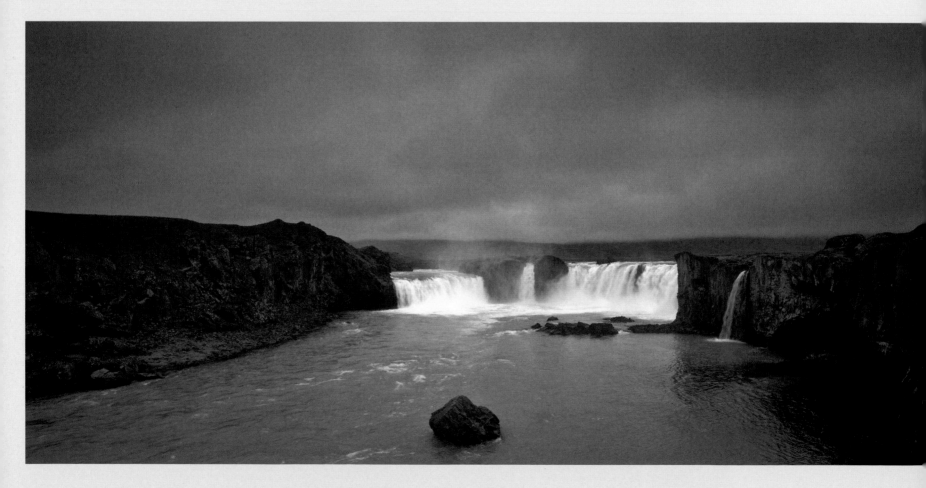

SHIFTING THE HISTOGRAM LEFT

A low-contrast subject under diffuse gray lighting always gives a processing choice, as the histogram does not fill the scale. Shifting it left until the darkest tone becomes black makes the most of dark gray light.

So who decides? Certainly not the camera. Given the flexibility you have in exposing, and later in processing, the only sensible way to judge is to rely on your impression at the time. And yes, this can be influenced by things other than just the physical light—the scene, the subject, your mood, some idea you might have. Shooting in gray light with low contrast is technically easy (it's difficult to expose out of range) and that makes it important to think about the feeling of the scene at the time of shooting, and even more, to remember it. ■

Port-Eynon Bay, 1980

Icelandic waterfall, 1987

Very dark gray

Normally our eyes simply adjust to the level of gray brightness, but with the lighting situations shown here, the sensation is distinctly darker than average.

WET GRAY LIGHT Falling Rain

Backwaters, Pattanakkad, Kerala, 1981

One of the things about flat gray days is that they often lead seamlessly to rain. And rain has a bad reputation in photography, though it's not entirely deserved. For a start, most people find it uncomfortable, and photographers instantly feel the need to protect expensive gear from it, so it's generally a much easier option to avoid it and put your feet up. Drops get on the lens and have to be wiped off constantly, the humidity causes condensation on internal glass surfaces like the eyepiece and lens filter, and the camera body itself can take only so much. And even so, the light is still gray. If you're wondering what the difference is between gray light on the previous pages and this, the answer is something like a glistening, or slicked effect. If gray light suits green plant life, vegetation positively basks in rain. The water adds a sheen to leaves that lifts the local (very local) contrast in a special way that gives a subtle sharpness. Rain also does other good things, such as adding raindrops to glass surfaces and rings to water. Generally, people don't like getting wet in rain, but they do respond to its soft melancholy, as long as they're dry while they watch it—as if it were already a photograph.

Falling rain is actually less visible in a still photograph than many people think, and certainly less than in a video. The vertical streaks have a habit of blending into what looks like a kind of mist, and to stand out, the rain needs to be heavy, or the lighting bright, enough to highlight them (see Rain Light—*Shower in a Sculpture Park* on pages 162–163). What usually helps the atmosphere is the collection of side effects, like umbrellas and drops bouncing off the ground.

I had an assignment once, early on in my career, to photograph the coastline of Kerala in southern India for the *Sunday Times Magazine*. The shoot was scheduled for late October, which should have been fine, but that year the monsoon was late, and we had unremitting rain for a week. I wanted "good" light, but had to put up with this, which I found annoying; but really, that was a rather childish reaction. Of course it wasn't comfortable—everything was sodden, including me—but that was the point, if I had only realized at the time. If you get too locked into the idea of "good" light being golden hour, you also start to associate rewarding photography with pleasant, holiday-style weather. In reality, they're not perfectly matched. I ended up with many good shots from that week, but appreciated them only later. Another lesson learned. ∎

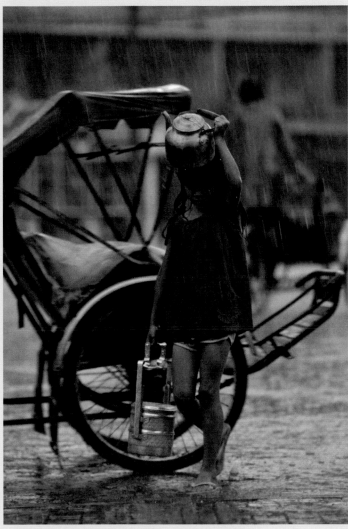

Cambodian girl in rain, Phnom Penh, 1989

Light in falling rain

For rain to be visible, it usually has to be heavy, and contrasting in some way with the background. Backlighting helps. Overall, it has an almost misty effect.

WET GRAY LIGHT Soft Drizzle

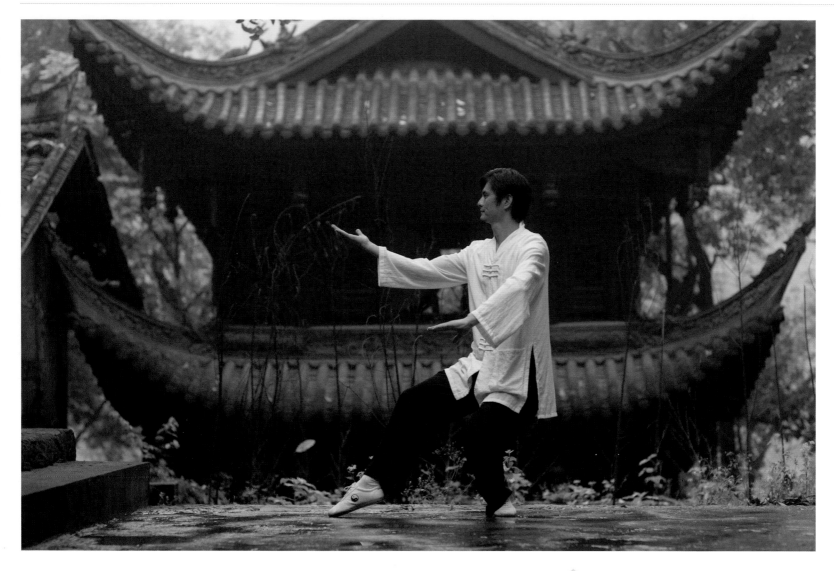

The more you look into all this wetness and grayness, the more variations you discover, and if you're prepared to enjoy the subtleties, there's a surprising amount to explore in terms of viewpoint, tone, color, depth, and more. In a valley north of Chongqing is an old Buddhist monastery on a forested slope among natural hot springs. I was working for a client who had a high-end resort property close to the monastery, and early in the morning, before breakfast, I went for a walk in very light drizzle. Just a few occasional small drops,

not enough to shelter from, but the grounds of the temple were laden with a soft, damp atmosphere that seemed to dampen sounds. I passed this old drum tower, on a lower level because of the slope, and thought how perfect it would be if someone just happened to walk by, giving a kind of purpose to the gray flaring roof and an air of abandonment. No one did, even though I waited a while. The best action that happened was a monk and some women sweeping the grounds and clearing a pond, which didn't really do it for me (opposite, top).

Tai chi, Wen Quan Buddhist Temple, Beibei, Chongqing, China, 2012

24

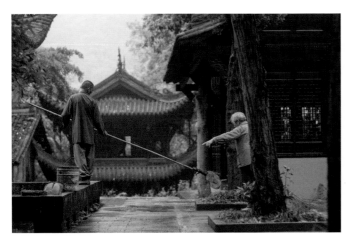

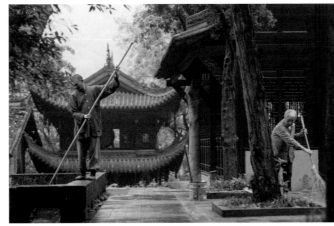

Drum tower & cleaners
After a quarter of an hour, some activity.

The temple drum tower, early morning
The scene as I came across it, with no people, an hour earlier.

But a little later, I found that I had a shot to do for my client—a tai chi demonstration by a visiting kung-fu master (opposite). Well, I had the perfect location. He would be wearing white, for which this dark and delicate background was as perfect as if it had been a stage set. I filmed the subject also, and in the video the light drizzle is just visible, adding a little bit more mood. Above all, what works in the lighting is the very slight aerial perspective as the drizzle adds a layer of substance to the air. This gently helps the man stand forward from the temple building, and the temple building from the trees behind. It also suffuses everything with a muting effect that reduces color. As with all of these gray scenes, the low contrast makes it important to decide how dark or light the gray should be. I was mainly concerned with keeping a good, but not overdone, contrast between the man and the parts of the building under the spreading eaves. Overall, I went for a slightly darker result than average. Practically, what I did was to shoot according to the meter, which was set to matrix metering, then reduced Whites and Shadows a little during processing. ∎

25

WET GRAY LIGHT Glistening Stones

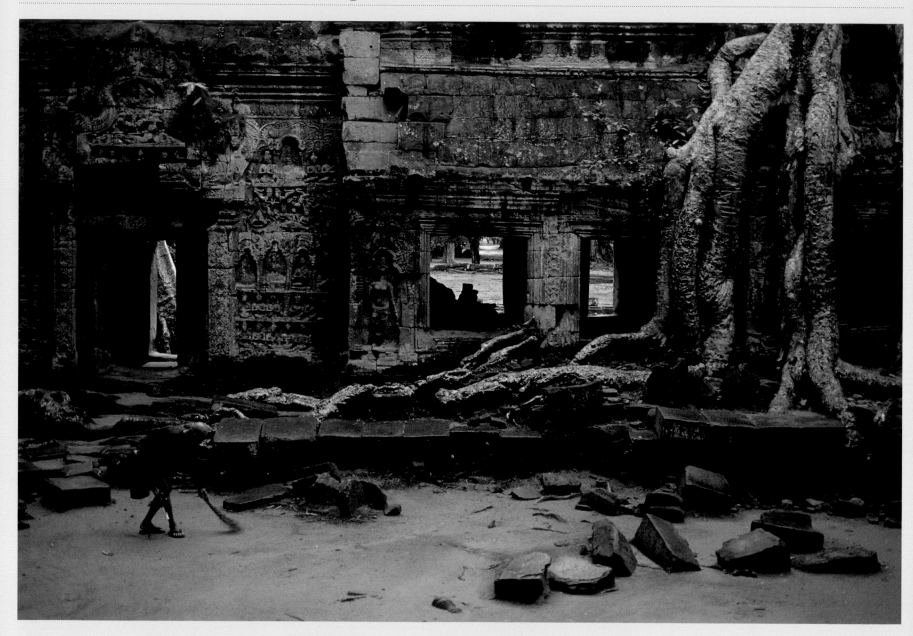

Ta Prohm, Angkor, Cambodia, 2002

When the rain stops, it leaves behind yet another slightly different variety of gray light. Often the air is clearer, and the wetness gives a fresh feeling to the scene. Unless there's more rain on the way soon, it's a situation that doesn't last as long as you might think, as evaporation starts quite quickly. In warm weather, the water will start to dry off surfaces well within the hour; and in the tropics, in the monsoon season, even faster than that. Another thing that affects shooting is that rain tends to clear other people out of the scene—very useful if you're shooting in a site populated by tourists, as with Angkor in this picture. When it stops, they slowly reappear, along with muddy footprints.

Wet gray light

Reflections in flat wet surfaces, while top surfaces reflect light from the sky, givng a glistening effect and higher local contrast.

Painters' Stone, Kyoto, 2001

It's interesting that you need only a few visual clues, like the glistening surfaces of stones in the shot of Angkor opposite, or the unbelievably costly stone in a Japanese artist's garden (right), to turn the perception of plain gray light into its wet version. Just a hint of something slicked with water, tucked away in the image, and suddenly the mood has changed. As before, wet weather is lovely to look at, all the more so when you're not standing in it.

The picture of the semi-ruined temple of Ta Prohm in Angkor was shot in the rainy season, making a refreshing change from all the other times I had been there, which had always been in the cool dry season when the sunlight is guaranteed. This monsoon shoot had a lot going for it, not least the greenery and the moss. There were also fewer people around, which suited me. My first visits to Angkor were during the civil war and there were truly no other foreigners at all, so I became a little spoiled. This, though, was exactly what I wanted: early morning after rain, no tourists, even the muddy ground freshened overnight, and the old caretaker working on a few fallen leaves.

The Japanese garden on the right belonged to a painter, and this was the view from his studio, looking out to the costliest stone I ever came across. In the Japanese tradition of paying great attention to rocks and stones, which goes back to at least the sixteenth century, this artist, Akira Kaho, had had his eye on one special stone for two decades before he could afford to buy it at a staggering twenty million yen (about $10,000). Called a sajiishi, it is unique, with a flat top eroded into a complex of deep runnels, as if some strange worms had tunneled into it. Most stones look their best when wet, and this one certainly deserved special treatment. ■

HARD LIGHT Graphic Geometry

Hard light

The intensity of this hard light creates denser shadows, which play a greater part than usual in photographs.

Normal sunlight

Standard sunlight gives reasonably strong contrast and hard edges to shadows, but not to the extent of the lighting in the Greenberg House image shown opposite.

After gray light, the most commonly rejected and unloved is the hard-edged light from a high sun. You'll find more advice published about how to avoid it than how to use it. There's little mystery about hard light, and this is one of the reasons why it often gets thought of as un-special, unkind to subjects, and even downright ugly. The "hard" refers to the shadows that it casts, because the source is a bright sun in a clear sky, with little of the filtering effect from atmosphere that characterizes soft sunlight. The result is dense shadows with hard edges, and inevitably high contrast.

Here we're back to likeability, and the attractiveness index of hard light is rated low by most photographers—hence its name, and the common refrain, "the light's too hard." The reasons given include poor modeling (true), high contrast with blocked-up shadows (yes, if you need them open), and coming from above, so that it casts shadows in strange places on people's bodies and faces (without a doubt). Technically, then, it's problematic if you're trying to make people look attractive, when you'll need a lot of help in the form of filling, shading, or diffusing (see Section 3—Helping).

However, this apart, the reputation of hard light may be overdone. When it comes to, say, the raking light of the following pages, where hard shadows and intense sunlight can pick out details and texture in a highly tactile way, it becomes desirable. And at the ends of the day, during golden hour (see below), the intensity of rich, warm sunlight set off against deep shadows gets many landscape photographers excited, particularly those shooting in stark landscapes like the Arizona desert. What hard light does have going for it is hard shadows and an intensity that, with a suitable subject, can deliver a degree of abstraction. Abstract imagery is a move away from the real, turning a scene into something else, at least until the viewer's eye has settled down to seeing what is really going on.

Geometrical abstraction is arguably what hard light does best, and it's no coincidence that my example here is a Los Angeles house by the renowned architect Ricardo Legorreta, not the first or last Mexican architect to design specifically for the cloudless skies of southern California and northern Mexico. Everything here is straight-line sculptural and hard-edged, and specifically created to be overlaid with shadows and enhanced by contrast. ■

SEPARATING COLOR CONTRAST & SHADOWS

The total deliberate effect comes from combining the rectilinear geometry of the structure (below) with strong colors (top left, one of these from the Southern Californian sky), and hard-edged shadow shapes (top right).

Greenberg House, Los Angeles, 1994

HARD LIGHT Angular Subjects

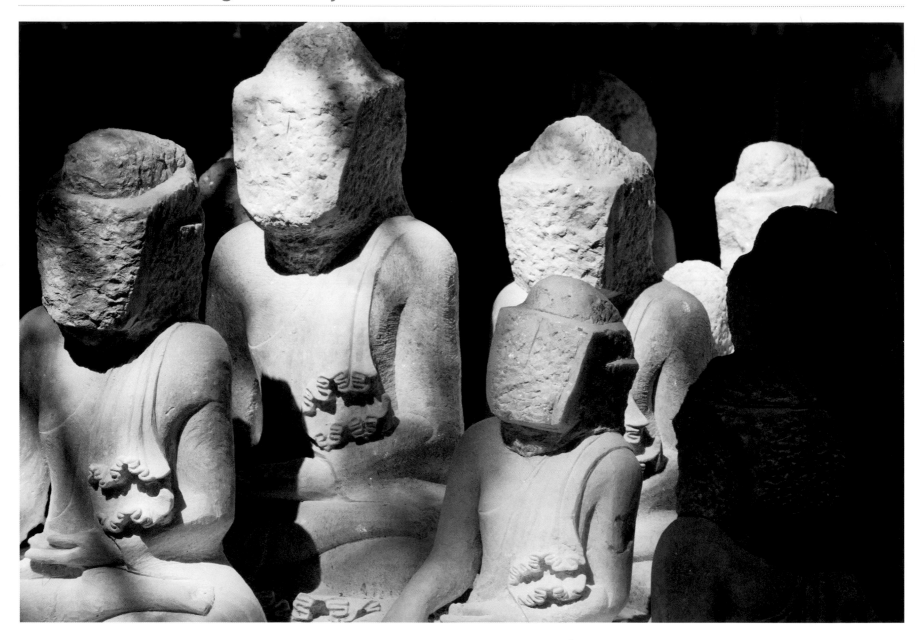

We can go further with the idea of hard light suiting hard-edged subjects. Largely because of portraiture, where the aim is usually (though thankfully not always) to make people look attractive, the idea of soft, directional light to give gentle, rounded form gets a lot of promotion. Yet angular objects tend to do better with lighting that shows off their hard edges and contrasting surfaces. Lighting angle becomes more critical when there is no diffusion, but when it's right for the subject, the effect is strong and eye-catching.

There is a street in the Burmese city of Mandalay, just one street, where the entire activity is the carving of statues of the Buddha from local white marble.

The setting

Midday in Mandalay, with a group of Buddha statues waiting for the master carver to start on their faces.

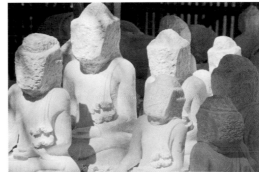

The Raw file, unprocessed

As exposed, without processing, and in color.

The demand for these across Myanmar is considerable, so it's a busy place, and the statues are in all stages of production in the small workshops lining the street. Because of the weather (hot), these are open with awnings, but stones that are waiting for attention are more usually out in the tropical sun. The combination of white marble and a high Burmese sun makes for extreme brightness, and so this is really pushing the limits of contrast. Again, a choice: return for a lower sun, or do something with these midday extremes? If the latter, why not take the extreme and push it further? We're back to graphic imagery, for which hard light can definitely do favors. Besides, there were these blocky, faceless statues waiting for the sculptor (labor is divided here, with the top craftsmen concentrating on the more demanding face of the Buddha).

At this time of day, the sun is pounding down across vertical surfaces—raking light, as we'll see shortly—and that was putting a lot of attention onto the yet-to-be-carved face blocks. One option was

to shoot for black and white, which for the reasons explained on the following pages, makes it easier to process for extreme contrast. The fairly simple division between just dark and light, with very little intermediate shading, thanks to the hard light, made it possible to take the contrast in the final image very high. The shadows could go to perfect black, and the white marble simply had to remain a couple of levels below knock-out white. ∎

Processed for maximum visibility

The Raw file opened up to the full—more information, much less impact.

Processed for maximum contrast

Going even further than the main picture with the high-contrast processing, emphasizing the cast shadows.

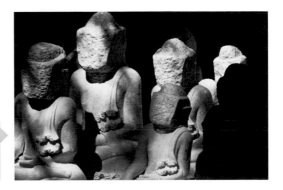

31

HARD LIGHT The Case for Black & White

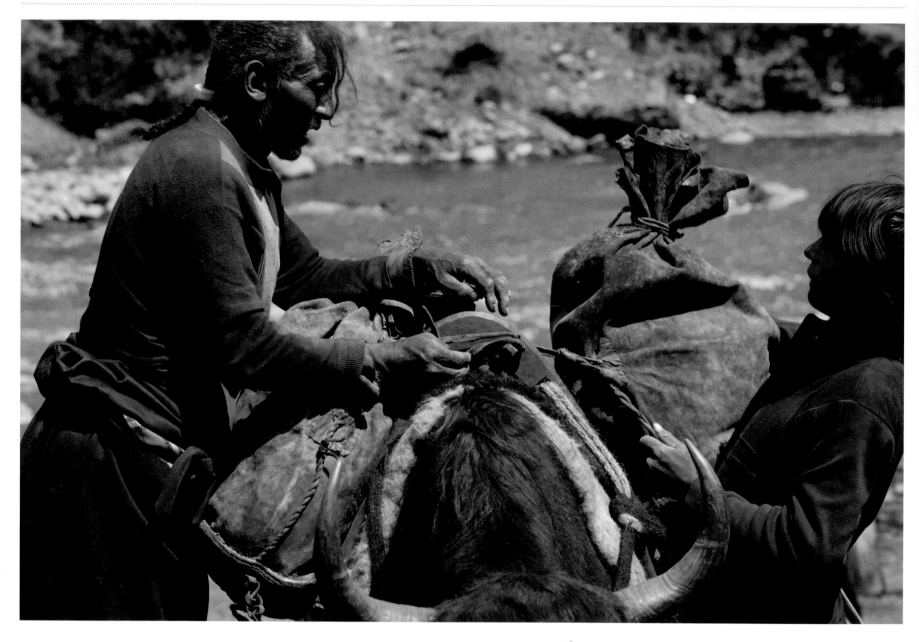

Black and white has its own particular aesthetic, quite different in many ways from shooting in color. For example, tonal gradations—from richness to nuance—are an important part of it, as the image is free from the distractions of color. But among the special values of black and white, two of them make it a very useful solution for lighting issues such as

hard light. If you're a die-hard black-and-white photographer, this will not impress, but for anyone who shoots mainly in color yet is prepared to experiment, this is one way of turning disappointing conditions into strong imagery.

The first of these two reasons is that black and white is, if not exactly immune to the time of day,

Yak caravan, Manigange, Sichuan, 2009

much less restricted by it than color photography. Just look at the many lighting situations in this book that are located in the golden and magic hours. Probably the strongest component of these two very

A choice of conversions

A range of conversion options, though not extreme because of the lack of intense colors to begin with (black and white conversion works more powerfully on strong hues).

The Raw file, unprocessed

As a color image, for me weakened by the insipid colors and hard top-lighting.

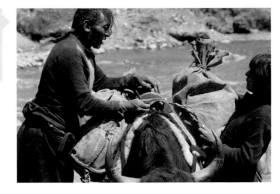

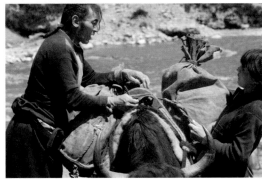

Opening up the shadows

An alternate take on a B&W conversion, aiming to deliver maximum information—and as a result, little more than a monochrome version of the color default.

popular times of day is their color, and because so many photographers prize these end-of-the-day hues, by comparison midday tends to be ignored. Black and white does not suffer from this problem (if you consider it a problem; not everyone does). The second reason is that you can push the tones to extremes much more acceptably in black and white, so a hard, contrasty treatment that might look unpleasant in color can look great in monochrome.

This shot (left) of Tibetans loading up a yak caravan for the trail used both of these black-and-white special values. It was midday in western Sichuan, at high altitude and clear, so the light was stark and the colors of the riverbed where they were camped were bland and uninteresting. They weren't going to wait for late afternoon and good light just for me, so I just had to get on with it, as usual. I quickly decided to switch my mind to black-and-white mode, and concentrate on tonality and shape. There was one tone in particular that I focused on— the leathery face of this man. Leathery is a cliché, of course, but here was a case where it was completely justified, not just because his skin was so weather-beaten, but also because of the comparison with the leather sacks they were loading. For my purposes this was wonderful—here was a yak caravan in the 21st century using traditional leather sacks, not plastic. The general lack of color made it less easy to pull off in post, but I managed to do what I wanted and use B&W conversion to get that face dark and rich. ■

The Raw file, unprocessed

In itself, acceptable as a color image, but the monochrome tint brings little to the image, suggesting a B&W conversion so as to allow concentration on the tonal nuances.

Darker alternative

Even with an apparently monochrome-yellowish original, B&W conversion by channels allows tonal values to be altered, as here, to a darker, denser version.

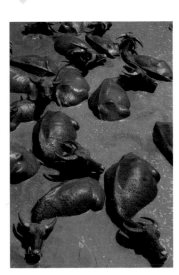

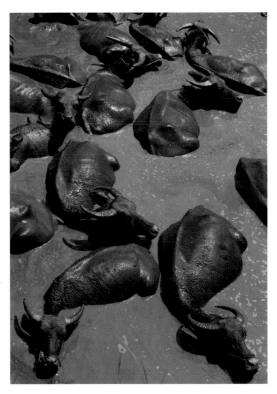

Water buffalo, Yalong River, Sichuan, 2009

HARD LIGHT Stark City Contrast

There's a reason for the order in which I've started this book, even though it might at first look a bit haphazard. The first entry, on soft sunlight, is a perennial favorite and unassailably pleasant, but I followed this with an opposite gray light. Now, with hard light, we have another group of normally rejected candidates. This is all aimed at undermining the idea that a good use of lighting is always in the service of being conventionally attractive. Mainly, perhaps, but to aim for it every time is highly questionable. More than that, it simply limits the range of what you can do.

As we just saw, one of the many things that lighting can do is to help evoke the physical sensation of a place and a time. It doesn't necessarily matter that the location may not itself be conventionally attractive. Here in Athens, though, there was something else again—I had a specific job to do. This was to be a book in a big *Time-Life* series called *Great Cities*, and the editors had made an interesting choice of approach. As much as any high-volume publishing to a wide audience can tolerate, there was a negative undercurrent running through the book. This was not to be the Athens of tourist brochures, but instead a more complicated city that had grown to be quite ugly and polluted. This ran through the text, and the choice of pictures reflected it. The editors wanted this to be an interesting book rather than just a pretty one. A particular issue was how to deal with the many famous ancient monuments. Naturally, I shot around them over the month of shooting in every way possible—including every kind of light from before dawn to dusk—yet always knowing that the editors needed an edge to it all. With so many existing beautiful images of the Acropolis, for example, it wasn't really *Time-Life*'s job to add to the store.

Temple of Olympian Zeus, Athens, 1977

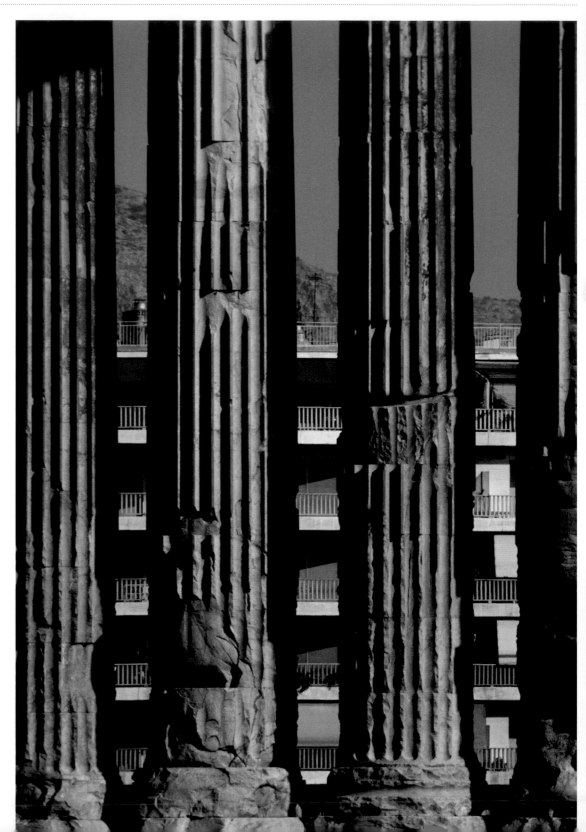

Athens cover

The picture as used.

The aerial view

Part of a photo essay in the book, the aerial view shows the monument far from impressive, hemmed in by a busy, ugly city.

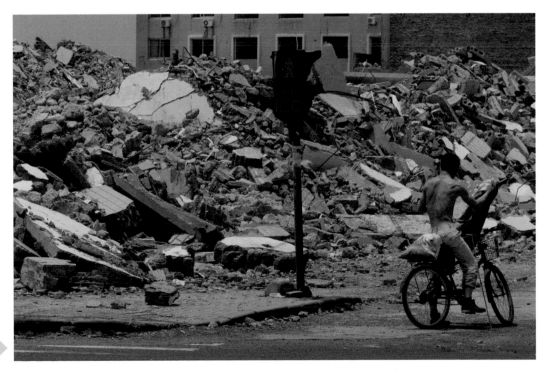

Accordingly, the monuments photo essay was conceived as an aerial, using a helicopter to show these ancient sites crowded by the spread of cheap building that makes up the modern city.

This theme turned out to be the choice for the cover, also. It meant, inevitably, a juxtaposition shot, and almost as inevitably a telephoto treatment to compress contrasting elements. The best candidate for this turned out to be the Olympeion, also known as the Temple of Olympian Zeus: 2nd-century marble columns set against a 1970s apartment block. It had the added advantage of being graphic—verticals against horizontals. What light would work best? A pretty end-of-day, or something starker and more in keeping with the idea?

I used a similar setup for the forlorn traffic junction on the right, which is not, as you may suspect, the scene of recent heavy shelling, but yet another Chinese city block in the process of redevelopment. ■

Demolished city block, Ninghai, Zhejiang, 2011

HARD LIGHT Nubian Desert

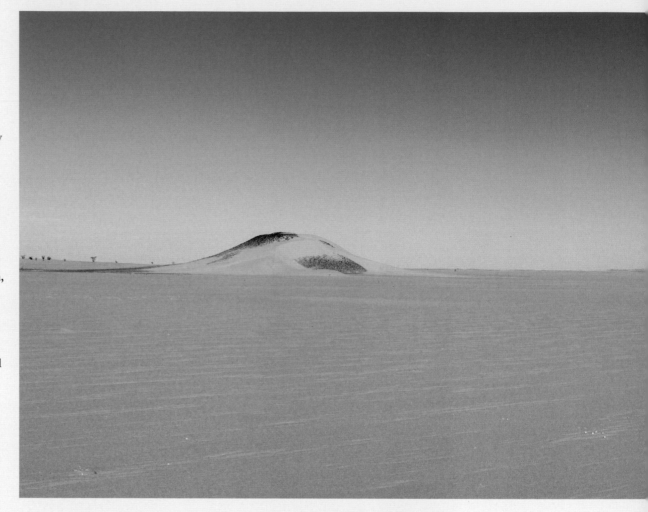

Here is another case of looking for a way to get across the physical sensation of a place—a strange place, and one of the emptiest I've ever been in. To be honest, the "flat" part of this light refers more to the land that it's falling on, but the result is certainly that. No relief to speak of, and at the time we drove across it, the sun was almost overhead with not a hint of cloud. This is in the Nubian Desert of northern Sudan, and the country is mainly desert in any case. Even within deserts (which qualify as such if they have a moisture deficit, normally taken to mean less than 10 inches [25cm] of rainfall a year) there are extremes, and this is one such. This section, called the Bayuda Desert, is exceptional in flatness and lifelessness. I wanted to get both of these qualities across, and the way to do it seemed to include just a touch of their opposites. I should explain this thinking: It's a quintessentially minimal situation, with land and sky reduced to two bands. One approach would be to present this minimally, choosing a view that had no relief at all and no life. This was an available option at the time, as we had our Land Cruisers and I could select anywhere to shoot as we drove, hour after hour. It would also be a valid choice, and for the marine equivalent see Hiroshi Sugimoto's photographs of seascapes.

But I chose the other way, which is to try and stress the featurelessness by means of contrast, namely by including a hint of relief and of life. Eventually we passed this spot, with an extremely isolated bush and two swellings of sand beyond. The remaining element in the photographic mix was the light, and here I was happy that it was so stark, and, well, flat. Now, deserts look excellent in raking light at either end of the day, and that is definitely the picturesque approach: sand dunes casting sinuous shadows and ripples standing out in the foreground. But deserts definitely look hotter and emptier— more desert-like to my mind—under flat, high, midday light like this. ■

High sun, no relief

The combination of a near-overhead sun and almost nothing on the ground to cast shadows gives a flatness in keeping with the essence of this bleak desert.

Stitched assembly

The shot was given higher resolution by taking a panorama of overlapping frames.

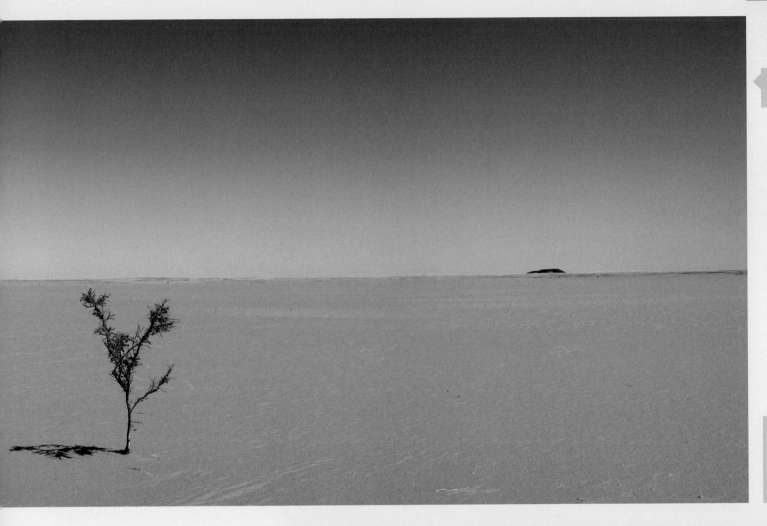

Bayud Desert, northern Sudan, 2004

An alternative

A second shot without the bush: emptier, but lacking the contrast that the isolated bush gives.

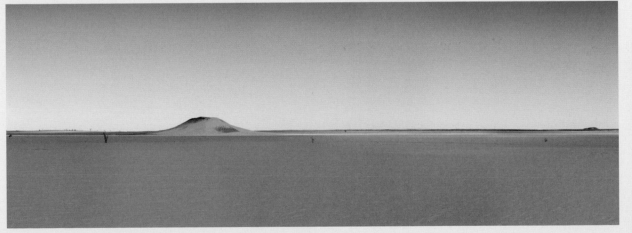

HARD LIGHT High-Altitude Blue

The higher you go, the less atmosphere there is, and so the more intense the sunlight. For most people, altitudes over about 2 miles (3km) are unfamiliar, and that alone makes this kind of shooting location interesting. The examples here are from western Tibet, higher than Lhasa and the east, and where the base of the plateau is at around 3 miles (5km). There's a simple correlation for this kind of locale: at 5,000 meters the oxygen pressure is 50% of that at sea level. Apart from breathlessness, the other effect is that sunlight is a little bit more like it is on the Moon—unremittingly hard, giving a massive dynamic range.

Bear in mind, though, that dynamic range matters only if you want to recover all the details in the shadows and highlights. And why would anyone want to do that in this special environment? What makes the Tibetan plateau here so special is exactly this hardness of light, which you can find only at altitude. In other words, this is not a problematic lighting situation, but rather one that is worth exploring for its rarity. The only pity is that a photograph cannot get across the genuinely disorienting, dreamlike sensation of not being able to breathe properly. But at least it can preserve the lunar quality of the sunlight, and way to make the most of this is to look for subjects and arrangements that are themselves contrasty: white prayer flags shot from low so as to place them against the darker sky overhead, dense shadows, snow on the south face of Mount Kailash against the sky, and so on.

Prayer flags over a chorten, Nara Pass, western Tibet, 1997

38

High-altitude hard Light

The contrast between light and shade is as high as it gets anywhere, and open shade is noticeably blue.

POLARIZING FILTER AT ALTITUDE

The darkening effect of a polarizing filter on a blue sky is strongest at right angles to the sun, and at these altitudes, is stronger than usual.

All this blue is a reminder of the very high UV content of the light, or rather the failure of the thin atmosphere to block it. How you deal with it is a matter of preference. You could simply go for it and use the blues, or make it more realistic by fitting a strong UV filter and/or taking some of the blue out in processing. Yet another approach is to us a polarizing filter to push the already-deep blue sky into an even deeper violet. High altitude encourages exaggeration, which is no bad thing. ■

Mount Kailash, western Tibet, 1997

RAKING LIGHT Façades

Football, Cathedral, Cartagena, 2009

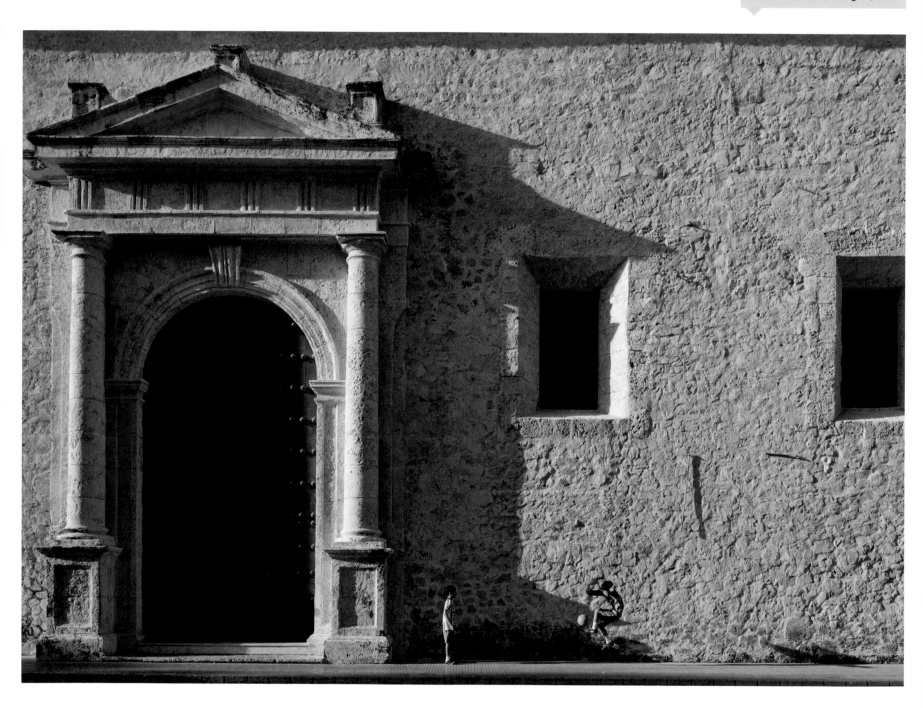

Key Points

Texture

Shadow Shapes

Precision Timing

Light can also be a collaboration between the sun and the surface, and the idea of raking light is when the source is sharp and pinpoint (like the sun on a clear day) and glancing across a surface that has some kind of delicate relief. When we come to bas-reliefs on the following pages, the relief effect that the carvers and artists intended under cross light was deliberate, but there are many more situations when it just happens to be. Here are two such cases, and in both, the façades were designed in one way, but photographed in another.

Religious buildings, like the cathedral on the left, are often aligned to the cardinal points, which naturally means that one of the sides tends to be side-on to the early and late sun. That was exactly the case here, in Cartagena, and very predictable in February, when the skies are usually clear and the sun rises and sets not quite so much toward the south as in the rest of the year. This was indeed a planned shot, for Sony, who commissioned a number of photographers to shoot pictures of football (soccer) being played around the world. With this brief, it was obvious that the setting and players were going to be important—more so than the ball itself. In particular, this was because the readers of the book would already know the subject and be looking for the variations on a theme. I needed to step back, and so needed a background that located us firmly in the colonial era of the Americas, without being cheesily obvious. The south side of Cartagena Cathedral (left) seemed good to me, especially as there was a plaza across which I could shoot without having to angle the camera steeply upward—in the end I didn't want converging verticals, and there would need to be some Photoshop perspective adjustment.

Raking light does two important things to a wall like this—and to that of the old Mexican mansion in Mérida also (right). It reveals texture,

and it adds the shapes of shadows. These are actually two quite different things. The texture enhancement simply shows more of what the subject is about—in the case of the cathedral, the coral limestone blocks and the way that the portico projects. The shadow shapes are purely graphic additions, overlaid on the rest of the image. Together, both breathe life into the wall. And a final thing, those raking shadows are very narrow, front to back, so that I could place the boys just a few feet in front and have them side-lit, standing out against the shadows, and considering that I wanted the two players small against the huge cathedral, doing this ensured they caught the eye. ■

Shadow movement over three hours

Over a period of nearly three hours, from 3:38pm to 6:12pm, this is how the shadows lengthened and moved across the south wall of Cartagena cathedral. The atmosphere was slightly hazy, with the result that the shadows weaken as the sun approaches the horizon. Only on crystal clear days do they stay sharp and solid until the end (see Golden Hour—*Last Moments* pages 100–101).

Mansion, Mérida, Yucatán, 1993

RAKING LIGHT Perfect for Bas-reliefs

I don't like getting locked into one kind of light for one kind of subject, as seems to happen, for example, with a lot of contemporary landscape photography. There's nearly always a choice of interpretation, as I'm showing throughout this book. Bas-reliefs, however, are very much made to be seen under a light that shows their details, and that really does mean raking side-lighting of one kind or another. The term means low relief, carvings, or moldings that just stand out from the surface. Deep relief is almost sculpture, where you can put your fingers into and behind some of the carvings; bas-relief works more subtly. It needs the help of lighting to do it justice—lighting from an acute angle, ideally just grazing the surface.

Here are two ancient sites famous for the excellence of their bas-reliefs: Angkor in Cambodia (right) and Persepolis in Iran (opposite). In both, the stone carvers certainly knew what they were doing, and what effect the light would have. The Persian bas-relief starts to come alive in the late afternoon, particularly in winter, as the entire complex is aligned northwest-southeast, so that with the sun setting north of west, this southwest-facing wall catches the grazing light. The Angkor carving of a devata (minor goddess) is a little different. It likewise catches late afternoon light—and early morning, too, as it is on a south-facing wall—but it also catches midday light. It was vandalized, probably during the Khmer Rouge years, as the face has been hacked into rather than removed, which thieves would have done, and I was looking to include this kind of damage for a story. The hardness of the sunlight, and its direction from above, gives a stark treatment that makes the most of the hacked-away face, leaving a deep black slash. In a way, I'm doing much the same thing here as with the marble sculptures on pages 30–31.

Vandalized devata, Thommanon, Angkor, 1989

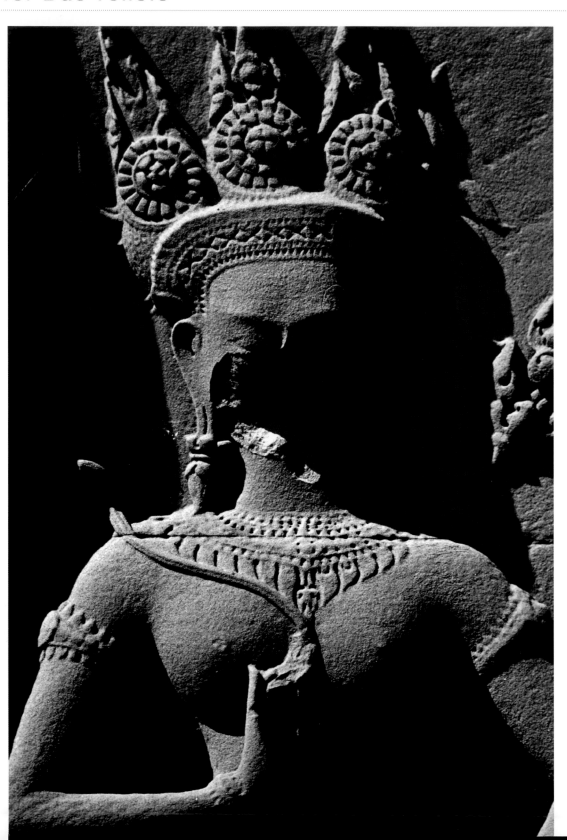

Bull in bas-relief, Persepolis, Iran, 1977

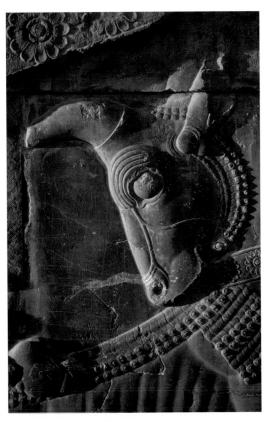

In both cases, light coming in from the side exaggerates the relief visually. Both carvings seem to stand forward much more than they really do, and compared with how they look in flatter lighting at other times, the effect is a kind of illusion. There would be almost no point in filling in shadows with a reflector (see Filled Light—*Tai Chi in a Tea Garden* pages 206–207); that would just weaken the relief. Moreover, as this is the sun rather than flash or any other kind of photographic lighting, its distance means there is no fall-off (see Window Light— *Classic Fall-off* pages 86–87) across a carved wall, even a large one like the smaller image below of the Bayon in Angkor. If you want a choice of lighting, and the sky is clear, wait until the sun is close to the horizon and the effect begins to disappear (see Golden Hour—*Last Moments*, pages 100–101). ∎

The Khmer army, Bayon, Angkor 1990

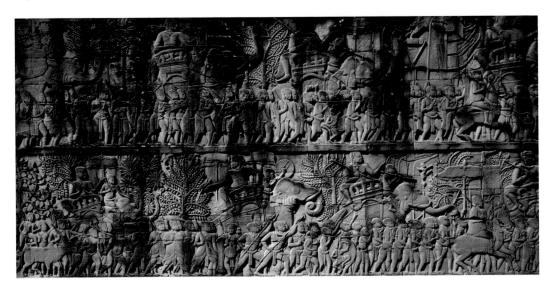

High raking light on a south-facing wall

The effect of top raking light as in the image of the devata at Angkor. With the sun high (tropical light), it moves quickly, and for just a very short time, rakes the wall from above.

RAKING LIGHT Sharpening the Landscape

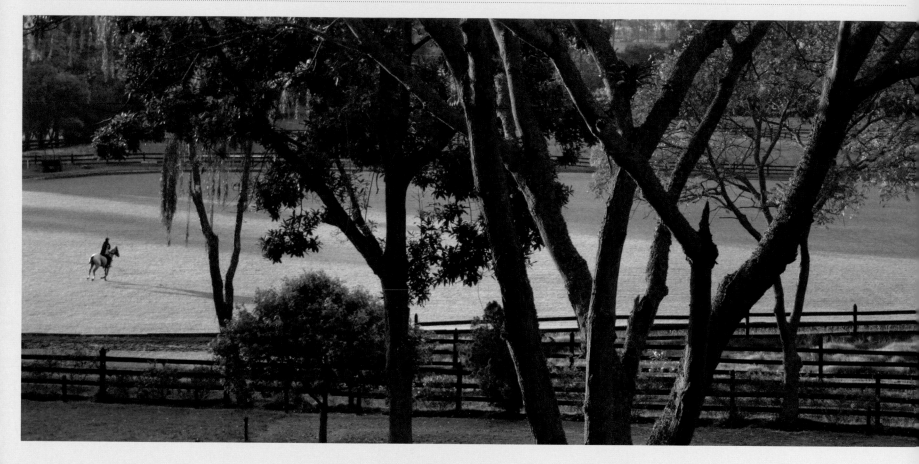

Then, of course, there's raking light bathing the entire landscape. It's also light from the golden hour, inevitably, because unlike the walls we've been looking at, there are only two times of day in most latitudes when this happens: early morning and late afternoon. Nearer the Arctic and Antarctic, on the other hand, the time for this light spreads out across the day. This type of lighting is naturally attractive and popular because of the way in which it sends long bands of light and shade across the landscape. I argued against the grain in Hard Light—*Nubian Desert* on pages 36–37, but that was for a very specific reason (showing emptiness). As I mentioned then, the raking light that throws up every ripple in sand is more conventionally appealing.

In common with the other, smaller-scale raking light situations, it depends not just on the sun being low, but also on there being really clear air. As the sun gets lower, its light has to pass through much more atmosphere than when it is shining straight down onto the land, and this acts like a softening filter. On top of this, haze and pollution tend to hug the ground, so that those last few degrees of the sun above the horizon often—I could say usually—see a rapid softening of shadow edges. In practice, it means that what looked like a bright day an hour before sunset unexpectedly becomes almost shadowless three-quarters of an hour later. The lesson learned is not to expect the crisp light to last for a moment longer than you can see it, even though hanging on until the last minute is what most of us do in these conditions. The answer is to keep shooting, because the frame you just shot may well turn out to be your best.

The main shot is from the high savannah surrounding Bogotá, where the air is usually clearer because of the altitude, nearly 9,000 feet (2600m). I've also included a shot from the Tibetan plateau at over 16,000 feet (5000m), because at this height the air is thinner, so the light is sharper, more incisive, with little of the haze that's normal elsewhere. The effect is that the same sharp shadows continue to the horizon, which can be breathtaking. Clarity covers the entire view, so that while we know from common sense that the farthest shore of the lake is really distant (a few miles), it looks as if we could reach out and touch it. I think it is this contradiction that makes lunar views like this one interesting. ■

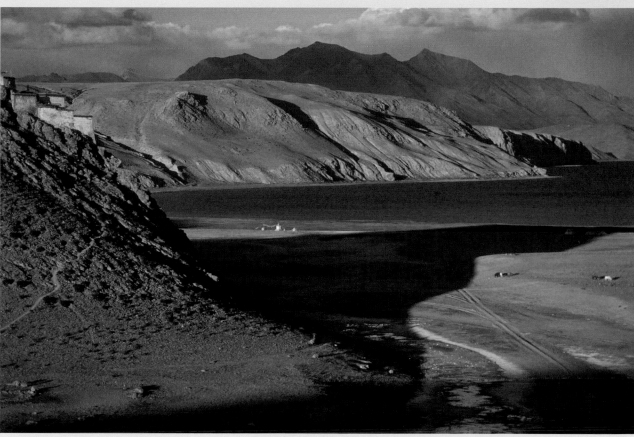

Polo pony, Gran Sabana near Bogotá,
Colombia, 2011

Lake Manasarovar, western
Tibet, 1997

SHADOWS LENGTHEN, RELIEF ACCENTUATES

Shown with directionless light at the top
for comparison, this is what happens
as the sun sets in clear light. Prominent
things sticking up, like trees, already cast
a distinct shadow, but this lengthens
spectacularly, while less obvious features
like hills eventually cast shadows that
darken the entire landscape, spreading
east rapidly toward the end.

TROPICAL HARSH Midday on Lake Inle

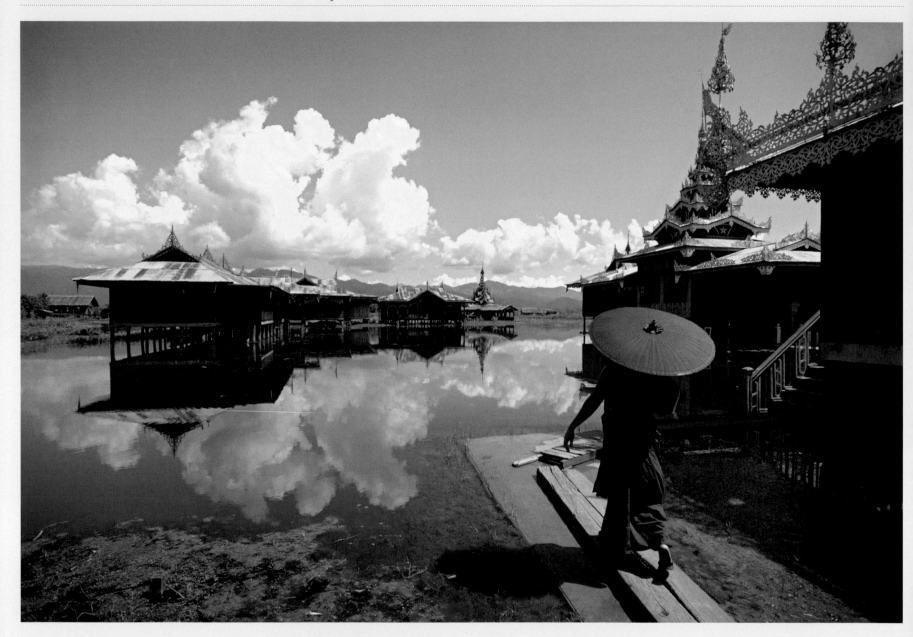

Monk & lake monastery, Ywama, Lake Inle, Myanmar, 1982

Low latitudes, around the equator and into the tropics, take the sun even higher in the middle of the day, which means that if you insist on going for traditionally "pretty" each time you shoot, your working hours are going to be quite limited. It's best to find ways of accommodating this high and harsh light into the photography.

And one more thing: Lighting can contribute to giving the experience of being somewhere, and especially somewhere different. This idea is historically quite recent, at least since large numbers of people began traveling sufficiently to actually care what the places felt like. In the 19th and 20th centuries, there was a near-universal interest in what

foreign places looked like; hence early photographers such as John Thomson, Carleton Watkins, and Edward S. Curtis traveling with plate cameras through Asia and the West of America, and the later success of magazines like Life, Picture Post and National Geographic. This is not to say that photographers were any less concerned about light, but using it for sensation was lower on the agenda than it has become recently. The tropics became a recognized destination for travel around the 1970s, when long-haul travel started to become affordable and made tropical beaches a possibility for a week's holiday. And there's no doubt that the tropics deliver a different experience to most people, quite apart from their cultures and landscapes. So, far from avoiding the tropical midday, with its top light and

often stunning heat, there's every reason to explore the lighting effects. This is Lake Inle in Myanmar, with intense and high sunlight, bouncing off the water to be almost blinding and giving those solid-looking cumulus clouds that have been building over the hot landscape for the last couple of hours their characteristically tropical look.

Everything here on this shallow body of water is built on stilts, including the Buddhist monastery at right and the walkway. The monk was approaching, and I followed him. Daily life goes on regardless of whether the light looks pretty or whatever, and this was not a case of waiting for another monk to come by later in the day, even if I wanted that. In any case, the traditional lacquered paper parasol makes the shot, and here it was very much a midday accessory. ■

Mirrored reflections emphasize clouds & deep shadows
The clouds, top-lit and very white, have a typically tropical solidity, in this case worth making something of by repeating them with their reflection in the still lake.

Tropical Harsh Light
Tropical light comes into its own in the middle of the day, when by the mid-latitude standards of Europe and North America, the sun is unusually high and the shadow footprint tiny, but intense.

TROPICAL HARSH Shade Tree

One of the qualities that a high tropical sun has going for it is that it casts shadows almost vertically, and this is something unfamiliar to anyone from the other latitudes. In particular, it means that underneath trees there will be dappled light, and this is guaranteed all the more because the tropics have more broad-spreading trees than elsewhere. In fact, such broad-spreading trees were deliberately planted in tropical towns for the very purpose of shielding parks and pavements from the sun, and are usually called "shade trees." This is what is happening here in this Caribbean island village of Baru, where the time I visited was not exactly what I would have chosen. A feature of the village is its inhabitants' clear love of color—pinks, yellows, greens, reds, and here, blue.

My first thought was that I should return when the sun was lower, because the old blue house was definitely worth shooting; so like most of us my reaction tends toward the guaranteed light that I know well, with the sun lower. But while I was here there was no point wasting the opportunity, so I scouted around for a way to handle this. It was not an architectural shot, so I was looking for some combination, which meant people, though there were few about at this time of day. Then it dawned on me, as you can see from the sequence, that the distinct pattern of dappled light and shade could become part of the composition. Rather than angle the camera upward to avoid bright ground, and then have to deal with converging verticals, I could use the pattern to counterbalance the house. I also included in the middle-distance the blue house's

Blue house, Baru, Bolívar, Colombia, 2011

companion yellow-and-red building, to add to the sense of colorfulness. I found a stone to stand on so that I could keep the camera level and the verticals more natural, and waited. Anyone passing by would also be in this dappled zone, and so mainly dark themselves, and the ideal place to have them in the frame was where the girl is—between the two colored houses, virtually in silhouette. This kind of dappling is technically chiaroscuro, which I go into in more detail on pages 132–135. ▪

Tropical shade

Overhead branches and an overhead sun create a complex and high-contrast chiaroscuro pattern.

Working toward the shot

The sequence from finding the building, wondering whether the shot could work in this harsh light, and moving to make the dappled shadows an integral part of the image.

49

SNOW LIGHT The Ultimate Reflector

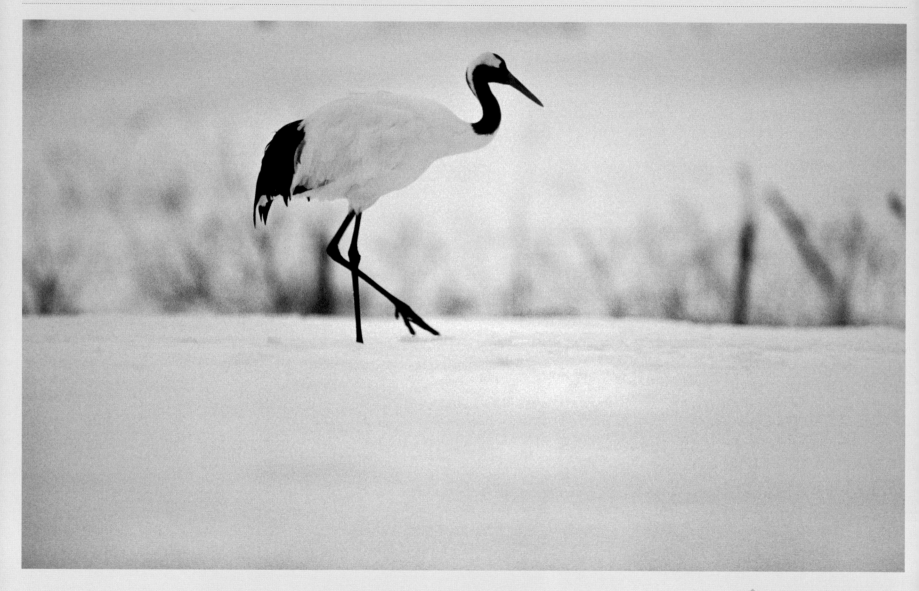

The tropical light we just saw is a kind of environmental light, depending very much on place. Another is what I call "snow light," which is when snow covers the ground and as a result has a major effect on the light overall. Snow completely changes the normal relationship between ground and sky, which tends to be dark below and bright above. In a cloudless sky, the snow-carpeted land will be much brighter than the sky, and even when cloudy, there's more of a match. This means that not only is there

much less of a sense of light coming down onto a scene from above, but that objects in the landscape receive a lot of bounced reflection from below.

Fallen snow is, in fact, unique in landscape lighting, and its nearest competitors, beaches and water, don't really come close (with the single exception I know of being White Sands in New Mexico). There are a number of things you can do with it, and one of my favorites is to use it as a kind of white canvas background for things happening in

Japanese crane, Hokkaido, 1997

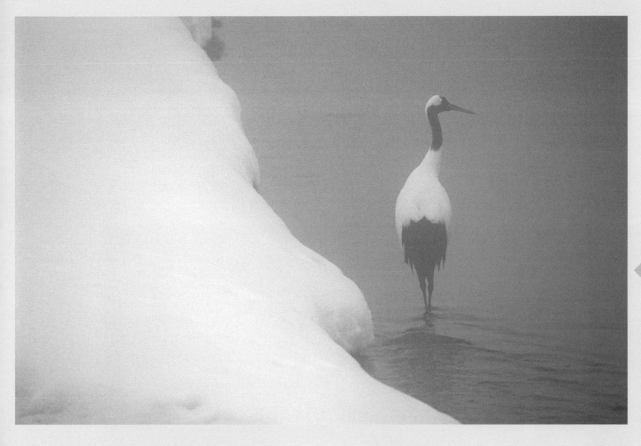

Japanese crane, Hokkaido, 1997

The sun's reflection in snow

Ordinarily, a covering of snow acts as a broad reflector, uplighting objects (below left). But near sunrise and sunset, from a low angle it picks up the pinkish glow, adding a special subtlety.

the snow. The Japanese crane standing in the shallows of a snowbound stream may not be typical of snow photography, but it gives a hint of the range of effects. This occasion happened to include some freezing fog, which only added to the ethereal bluish white light.

And when the sky is clear, one short-lived effect happens at the ends of the day, easily missed if you don't know what to look for and aren't in the right position for the several minutes that it happens. As we will see on pages 60–61 with the waterline shot of Lake Dal, the sharper the angle, the more perfect the reflection, and the same thing happens with snow— even more so if it turns to ice. In the late afternoon shot of a crane on the left, taken with a 600mm lens, the gentle rise of the slope meant that we're almost at the level of the snow, which catches the delicate pink of a weakly setting sun over Hokkaido. ■

INTO THE LIGHT Reflections & Refractions

It's one of the simplest lighting actions to take, yet with the biggest effect. Turning around from the default position, in which light shines on the subject from somewhere more or less behind you, so that you now face directly into the light, changes everything. Suddenly, from the technically efficient and simple, you're dealing with many of the things that make camerawork complicated and

unpredictable: flare, high contrast, silhouettes, and uncertain exposure. But what you can get from shooting into the light is mood, atmosphere, and creative choice. There's more room for individuality in this kind of situation, and there is certainly a choice of treatment. At one end of the treatment scale is the dense, rich silhouette. At the other is the flared, well-exposed style which opens up the

foreground shadows but lets the bright detail behind go off the register to pure white.

The conditions need to be bright and sunny, and the sun, or its reflections, needs to be low enough to

Cienaga de Cholon, Caribbean coast, Colombia, 1979

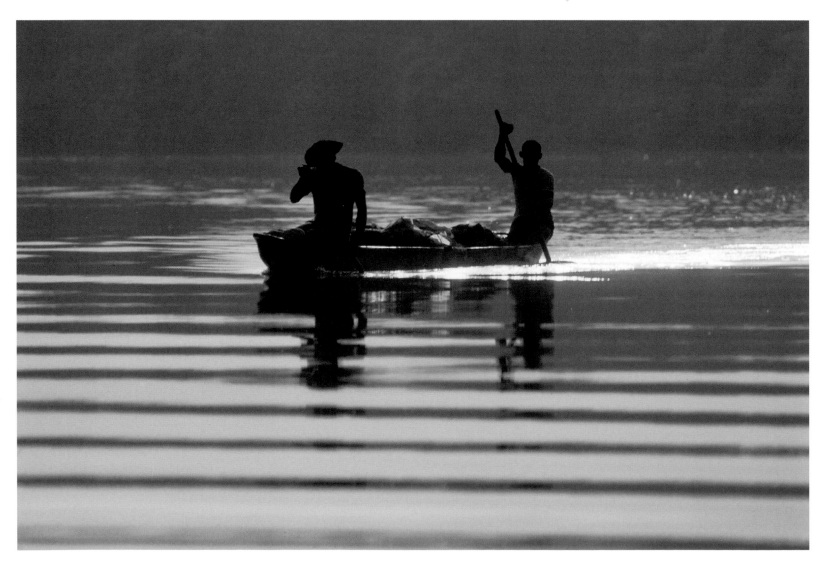

be in-frame. This happens in several other lighting situations in the book, including golden hour, reflection light, edge light, and sunstars, but even so, this is so distinctive a kind of lighting that it merits its own entry. For the next several pages I want to look at the variations of into-the-light, and there are many. Here, to introduce the theme, are two of the classic evocative effects of shooting toward the sun: reflections off of surfaces and refractions through something. The reason why they are an important part of this kind of shooting is that they bring the sun actually into the scene, rather than having it just sitting above and behind.

Reflections are about angle: your angle to the surface you're shooting, and the sun's angle to the landscape. It would be a little tedious to start talking physics at this point, but with a flat surface, like water, the lower the sun, the lower the camera position needs to be in order to catch the brightest reflection. Basically, the angle of incidence equals the angle of reflection. Under Reflection Light—*Concentrated Bands* on pages 64–65, there's a side-on illustration that shows this. The angle at which the sun strikes the surface is the same as what you could call the viewing and shooting angle. In the picture here of a canoe being slowly paddled across a lake, the sun has only just risen, which you can tell because I was shooting from another such boat, close to the surface. The ripples, however, which help make the shot, are reflecting different things, and the dark bands are from the trees out of frame behind.

Refractions are another way in which the sun interacts with the scene. To have refraction, the thing that the light shines through has to be transparent or translucent, and the many effects are because of the change of angle of the light. On the left is an obvious one, bottles (of oil) for sale in Omdurman market, Sudan. But clouds also refract light, which is why the sun behind clouds that are not too thick can make such a variety of effect. ■

Shooting toward the sun

Compare this illustration with the alternatives at the same time of day on pages 94–95.

Oil bottles, Suq Libya, Omdurman, Sudan, 2004

INTO THE LIGHT Into the Sun

Cow Close, Wharfedale, Yorkshire, 1980

Shooting directly into the sun carries its share of technical problems, simply because of the huge range between the sun's disc and foreground shadows. The term for this is dynamic range (what photographers pre-digitally used mainly to call the contrast range), which technically speaking is the ratio between the maximum and minimum light intensity in a scene. There is also the dynamic range that the camera is capable of, and the dynamic range of how you show the final image, whether on a screen or as a print, but for the time being let's discuss the scene dynamic range.

Shooting straight into the sun gives about the highest dynamic range that you can face in photography, and in fact, truly high dynamic range (HDR) means any view in which the light source itself is visible. For more on HDR see Archive Light—*What HDR Really Means* on pages 242–243. Oddly enough, dynamic range was less of a problem with film than with digital, according to my point of view (not everyone's). This might sound strange,

Key Points
HDR
Banding
Clipping

Banding & processing

A detail of an into-the-sun shot processed normally (below left) with evident banding, and with processing attention (below right) to smooth out the gradation.

given that digital images have such amazing potential for being processed any way you like, but one of the differences between film and a sensor is clipping. The way film responds to having the sun in-frame is to grade smoothly from highlights to the out-of-range white of the sun. A sensor just loses it sharply, because once each photosite on the sensor is full of photons, it delivers pure white to the processor. This is known as clipping, because there is a sharp cut-off in what the sensor can record of highlights. It also varies by channel between red, blue and green. One effect of this, when the colors go beyond the gamut of the color profile, is banding, which, as you can see from the image on the right, looks terrible. It takes some careful processing to avoid having these odd-looking bands encircling the sun. The glass-like river scene in Golden Hour—*Facing into Soft Golden Light* on pages 98–99 needed just this careful processing for the sky around the sun to look smooth.

None of this is any reason to avoid shooting into the sun, but be aware that the processing will take longer. This banding reduces if you reduce the exposure with the Raw converter's slider; also, the Raw converter's highlight-recovery slider will help. It may even be necessary to make two versions from the Raw converter and blend them later. Finally, using Replace Color in Photoshop after Raw conversion allows you to target "bands" and change their hue (yellow tending to green is common), saturation and lightness. An alternative if you have the camera locked down is to shoot a range of exposures and make an HDR image file. See pages 242–247 for more on this. ∎

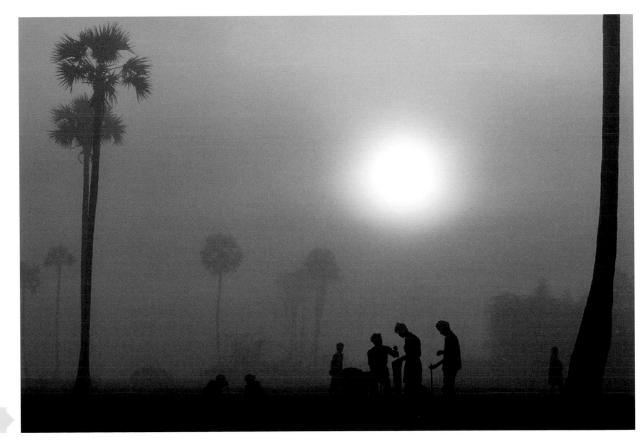

Irula rat-catchers, Tamil Nadu, India, 1992

INTO THE LIGHT Blocking the Sun

Oak Alley Plantation, Louisiana, 1978

You can shoot into the sun without having to see its disc, and avoid the dynamic range problems that we learned about in the previous pages. One useful way around the dynamic range problem is to position yourself so that something blocks the sun's image. The dynamic range is still high, but more manageable. Depending on what is doing the blocking, and on whether there is space beneath it,

there are two possible side effects, and they can be turned to advantage in making the shot more interesting. One is a cast shadow, the other a reflection of the sun on the ground or whatever other flat surface you see.

For a cast shadow, much depends on the shape of the object, and also on the texture of the ground. The example I've chosen here is a well-known antebellum

mansion on a plantation in Louisiana, on the banks of the Mississippi. Called Oak Alley Plantation, it has a long alley of 300-year old live oaks, broad-spreading and with heavy branches. Blocking the sun with one of these made it possible to use its powerful shape a second time in the image, by bringing its shadow on the light-green grass into the frame. There's a strong link to silhouettes with this way of positioning yourself, and there's more about that under Backlight—*The Silhouette* on pages 70–71. The difference is intention, because silhouette is about shape and outline and a deliberately two-dimensional cutout effect, while here the idea is more to do with light management. Nevertheless, in this image, the combination of silhouette and shadow, twisting and enclosing, has become as important to the composition as showing the mansion in the background.

The second image, of what was at the time the principal spy aircraft for the U.S., uses the reflection effect that the illustration here shows. I had spent the afternoon having the Blackbird towed around the airfield at Beale AFB, and this was to be the last shot before sunset. Of course, gauging the exact point of sunset and having the aircraft positioned exactly on the axis between sun and camera meant a lot of messing around, but it was worth it. I did not want a silhouette in this case. Instead, I needed to show detail, hence blocking the sun to pull down the dynamic range, and with the camera low on the runway pick up the red glow of the sun's reflection. If the sun had been in shot, incidentally, it would have overwhelmed this kind of reflection. ■

Two lighting effects from blocking

The floating cube stands in for any number of objects that you could put between you and the sun (this view is slightly above camera level). It both casts a shadow on the ground and, if there is any shininess to the surface, reveals the sun's colored reflection.

SR-71 Blackbird, Beale AFB, California, 1986

SHADE TO LIGHT Looking Out & Beyond

Standing back from the sunlight, either inside or in the shade, and looking out is also a classic way of framing a shot. More even than the examples we just saw, it makes use of the natural, almost unavoidable tendency of the eye to move toward the light. Added to this is some psychology, because in an image like this one, not only is the viewer firmly placed within the scene, looking out, but there is a sense of the outside sunlit scene being somehow positive and attractive. That, at any rate, was the idea behind this view of Canterbury Shaker village in New Hampshire on a bright fall day, seen from a Shaker-built rocking chair. Exposure is key to this kind of shot. If set so that there is more detail in the shadows and the outside is washed out, the eye is not invited quite so strongly to move outward. Here, the exposure was for the exterior—but then a touch lighter—so that there is everything to look at. The sun streaming in through the doorway keeps the chair and door alive, too.

This effect of pulling the eye out toward the distance, almost despite itself and working both visually and psychologically, was used in painting well before photography hit upon it. I've mentioned this before, in *The Photographer's Mind*, but it's worth re-visiting. The hugely influential Claude Lorrain, the great seventeenth-century landscape painter who first began treating landscapes as subjects in their own right, devised a way of constructing a composition that led the eye very precisely. It was one of his most distinctive treatments, and goes as follows. A dark, shadowed foreground, weighted and partly framed to one side with trees, like the wings of a theatre. On the other side, and a little beyond, another framing mass, not quite as dark, but still like a theatre wing, so that the scene

Rocking chair, Canterbury Shaker village, New Hampshire, 1985

becomes a kind of stage set. Beyond, the landscape receding to the horizon becomes lighter and lighter, and the sky lighter still, because the view is into the sun. This structure and lighting takes the eye from the foreground on one side across and beyond to the middle ground, and then toward the luminous distance and sky in the center and slightly above. The image has structure, and leads the eye.

Later painters copied these ideas, not least another great landscape painter, J.M.W. Turner, as the illustrations show. A key addition to moving the eye from shade to light was that classical landscape paintings also needed human figures, and both Lorrain and Turner used another special technique to coax the viewer's attention. They created a pool of light within the foreground-to-middle ground. Two great examples are Lorrain's "Rest on the Flight into Egypt," painted in 1644 (his "Moses Saved from the Waters," 1639 is startlingly similar) and Turner's "Crossing the Brook" from 1815. The human eye is naturally drawn to figures and faces, so this mini-scene draws the attention before it goes off into the distance. ■

Shade to Light

Looking out from a shaded area into the light reinforces our natural attraction to brightness, and so leads the eye very strongly toward the distance.

Claude Lorrain's "Rest on the Flight into Egypt," 1644

This highly influential landscape painter developed a much-copied method of leading the viewer's eye out toward the distance through a series of darker foregrounds and middle grounds.

J.M.W. Turner's "Crossing the Brook," 1815

The British painter Turner made great use of this method from Claude Lorrain, as here. The pool of light with people in the near-middle ground is typical.

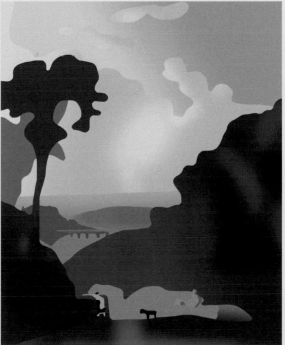

REFLECTION LIGHT Mirror Smooth

To avoid any confusion, here I'm talking about shooting into the reflections of light, rather than using reflected light to bounce up onto a subject—that's dealt with later, in Reflected Light from pages 188–197. The reflections here are of the sun and the sky around it, usually in water and bright and sparkling. Being reflected, it's a touch less bright than the sun itself, possibly around one f-stop,

Shikara on Lake Dal, Kashmir, 1984

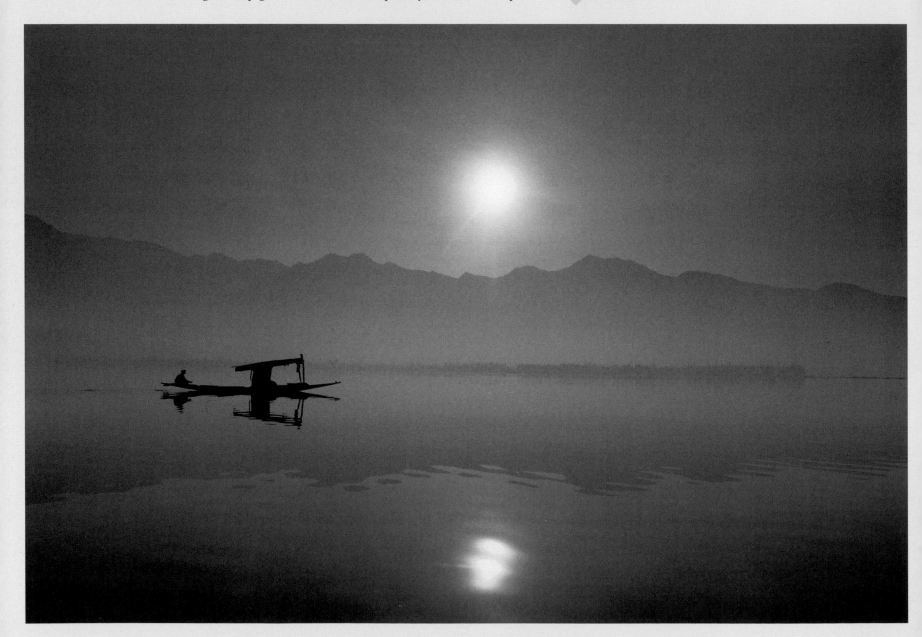

but much depends on what happens to the water, as we'll see on the following pages. Here to start with is the setting when the water is mirror calm, and the reflections are close to perfect. This is a lot more common when the water body is small and shallow, naturally, so that when there is the same effect on a lake, for example, we immediately see it as being slightly special, an unusually still day, probably an early morning before the day has really got moving. The angle to the surface is important, because the lower the camera—the sharper the angle, in other words—the stronger and brighter the reflection.

Flat water and shooting into the sun means double the trouble for exposure, and the dynamic range is almost guaranteed to be outside the camera's range. This is not necessarily a problem, but it does place a high premium on getting the exposure just right, because there is inevitably going to be a lot of recovery going on in the Raw processing—certainly of highlights and probably of shadows also. That means the processing is going to be at full stretch, and will need all of the extra dynamic range that the 14-bit or 12-bit Raw file contains. There are different opinions, but mine is, with digital, to let the sun clip to just the amount that the Raw processor can recover without having sharp banding around the

Rice paddy below Tirtagangga, with Gunung Agung, Bali, 1996

Mirrored reflections of sun & silhouette

Approximately a stop darker than the scene above water, near-perfect reflections like this catch a mirror image of the sun at the high end of the brightness scale, and the silhouette of anything floating at the dark end.

disc. Better still, if you have a neutral grad handy and there's a reasonably straight horizon, use it to bring the exposure of the sky down to the brightness of the reflection in the water. A 1 f-stop reduction from a 0.30 grad or a 2 f-stop reduction from a 0.60 grad will help, given that you are pushing the performance of the sensor in the first place. Another possibility for keeping the dynamic range down is to block the sun in some way, as suggested on pages 56–57. The shot here of rice fields in Bali uses this little technique. ∎

REFLECTION LIGHT A Broad Wash

Fish farms in the Gulf of Thailand, Songkhla, 1997

Key Points
Spreading Sunlight
Telephoto
Exact Angle

The mirror-smooth reflection on the previous pages, which in effect give you a double sun, is a real technical challenge to pull off because of the contrast. However, when the sunlight being reflected is spread out across the frame, the situation is more friendly. In fact, given a few necessary elements in the picture, these conditions can more or less guarantee you a striking result. The reflection, of course, provides an overall backlight, a bright and consistent backdrop for whatever is in front—or in the case of the Thailand shot, whatever is on the water.

I mentioned necessary elements. There are four ingredients that go into this kind of lighting. The first is a certain amount of haze, which in the direction of the sun not only softens contrast, but also spreads the light more across the sky. The hazier, or indeed cloudier, the sky, the broader the light. Thin, high cloud will do this, though without the warm glow, but the thicker it gets, the less directional the light becomes, so this kind of effect needs a kind of balance—the light spread out across just a part of the sky.

This explains the second ingredient, focal length, because the longer the lens, the tighter the framing and the better chance you have of keeping the reflected light evenly bright across the frame. Well, it's not a studio and there are no black marks for failing to get the backlight completely even, but as the Thai fish farms and boat show, it's a good effect when the light is smooth. The third ingredient is silhouette. As this is a reflection shot, and usually by the sea or a lake or river, there needs to be a subject neatly within it. The edge of a coast or a riverbank won't do it alone, so it's a matter of finding something either floating or, happily in this case, actually built in the water.

The final ingredient is elevation. The laws of physics mean that the angle at which the light

strikes the water is the same as the angle it bounces up to you and the camera. Basically, the higher the sunlight in the sky, the higher the camera has to be. Finding the viewpoint is where most of the effort usually goes in a shot like this.

Slightly different is the waterline shot of bathers in the Hooghly River in Calcutta. The sunlight is only slightly hazy here, and the sun's disc still quite intense. By positioning myself so that the bathers partially block the sun's reflection (see also the Balinese rice field shot on the previous pages), I could use the surrounding reflection of bright sky as the backlight. ■

Haze broadens the reflection
Compared with the relatively clear sun of the previous pages, a hazy or misty atmosphere broadens the light source, and equally broadens the reflection, like a softbox in a studio.

Morning bathers at the Howrah Ghat, Calcutta, 1984

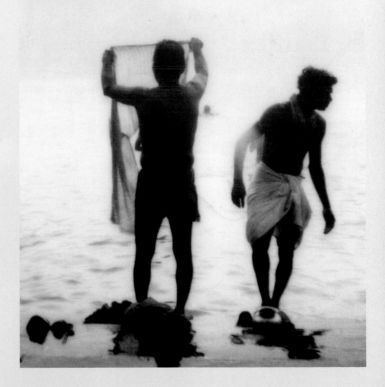

REFLECTION LIGHT Concentrated Bands

More familiar than the mirror-like image of the sun, floating and moving gently in still water, is the vertical band with a rippled, almost striped appearance. The boy wading across the shallows of the Mekong River is, dare I say it, a classic situation. Non-photographers might think, "ripples, so what?" Yet, as just this image shows, it becomes a strong compositional device. In fact, it's even more the subject of this photograph than the boy.

As in all these reflection shots on these pages, there has to be something in the water or on the ice, but the object is often a device to show off the lighting, and the two of them—object and light—usually share the billing in this kind of image. Timing, of course, was key to this particular picture. I stood on the bank of the Mekong in Vientiane, at an angle that put me facing the shallows looking toward the western sunset, and waited for an object—a person wading or a small skiff, both were around. The timing was critical in another sense, because the window of opportunity for a shot like this is narrower than you might think. Even ten minutes earlier, the sun was so strong that its reflection totally dominated the shot—look at the smaller image of the skiff (opposite), which crosses over the band of light and becomes lost in the darker water on either side. Prime time for this lasts only a few minutes, when the sun's intensity is not much greater than the surrounding water, and when its color is the deepest red. You then need to factor in the pattern of ripples, affected by the breeze, and the likelihood of getting an object conveniently in place. None of this is guaranteed, and another late afternoon in the same spot delivered no such success, despite the clear sunset.

Boy wading through shallows, Mekong River, Vientiane, 2002

How ripples break up the reflecting surface

From still water at left, through light ripples from a gentle breeze, to the beginnings of waves at right, the movement of water divides the surface into small reflectors that face in different directions.

How ripples form patterns depends mainly on the wind, and even the lightest breath of air can send a shiver across the water that breaks the image of the sun into pieces. Generally, the lightest breezes create a column of light, and this can jump up and down in height very quickly and unpredictably. All of this is exaggerated if you use a telephoto, which is usual for these kinds of shot so as to isolate the subject. A little windier and the column spreads sideways to become an area of ripples, which are also more closely packed. ■

10 minutes earlier

Timing for this kind of sunset reflection is critical. Shadows could have been recovered more from this in processing, but the effect is far from the more delicate, richer result in the main shot.

From vertical band to overall texture

Just a slight movement in the water surface changes the sun's disc into a column, and not much more movement loses this to an overall pattern of bright and dark that covers the surface.

Squid boat, Gulf of Thailand, 2007

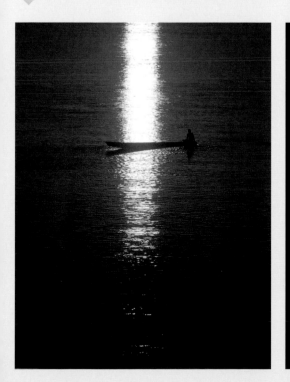

REFLECTION LIGHT Projected Ripples

A much more unusual type of reflection light is when the ripples of sunlight are themselves projected onto a surface. When it happens, the effect is very special and worth taking advantage of, with the warning that it usually looks better with the movement that you see at the time than in a still image. There always is movement, naturally, because the ripples are being created by something that is moving the water slightly—either a breeze or the flow of water.

Both of these examples happen to be from Japan, and both from the same book assignment on contemporary Japanese design, but that's a coincidence. The conditions are special, and there are two ways in which this lighting effect happens. The more obvious is when you have a translucent

Reflections on shoji screen, house in Yamaguchi, Japan, 1998

screen, which could be a ground glass pane, but here happened to be the perfect material for projection—a shoji screen made of hand-laid Japanese paper stretched across a light wooden frame (left). The illustration shows the setup, and it depends on the time of day, aspect to the sun and, of course, a very bright sun in a clear sky. The moving effect which you could capture on video is lovely, even mesmerizing, but translating this into a still image can sometimes be disappointing, because the screen itself is already light in tone. The projected ripples usually move quickly across a screen like this (the projection magnifies them), and they benefit from being sharp rather than blurred, so it's worth checking the shutter speed needed to freeze them. Also shoot many frames; like people's expressions, they vary, and there will be some moments of capture that look better than others. After all of that, it is also tempting to heighten the contrast during processing to make them stand out clearly—in Adobe Camera Raw, both the Contrast and Clarity sliders have an effect.

The second way in which ripples are projected is onto a solid dark surface. The darker it is, and in this case the wall is stone, the more intense the reflections will be. Also, a slower shutter speed does not necessarily reduce the effect, as it does on backlit screens like the shoji example. Instead, the longer exposure adds to the intensity of the reflection by superimposing the different ripple shapes onto the surface, and they can sometimes add up to an interesting wave-like effect, as here. This particular situation was unusual, comprising a shallow trough of an interior pond, open at one end to the sky and facing east, with sculpted glass blocks in the form of large stones in the center. Shortly after sunrise, the light refracted exquisitely through the glass onto the wall, which itself had a sheet of water falling down over it. All precisely calculated by the architect, the famous Kengo Kuma. ∎

Reflections on water wall, Water Glass House, Atami, Japan, 1999

Glass rocks, Water Glass House, Atami, Japan, 1999

How ripple reflections project

BACKLIGHT Translucent Windows

In Reflection Light—*A Broad Wash* on pages 62–63 we saw what happened when the sunlight is hazy enough to spread out and when you use a telephoto to keep tight in on a broad area of light. A broad light source makes a backlight, one of the favorites in studio photography because it creates a kind of blank white canvas against which you can place objects or people clearly and simply. And if the objects are themselves translucent or transparent, backlighting is indeed the lighting of choice, because it allows light to play through the object without the distraction of the things in the background. As a classic studio still-life set-up—for drinks in particular—it usually calls for special photographic lighting (see pages 84–85 Window Light—*Directional with Soft Shadows* for the

Window thickness & diffusing strength

How evenly a sheet of translucent material spreads the light depends on two things: the way in which it diffuses, and its thickness. Sandblasted glass gives a less even spread than milky Plexiglas, but both diffuse more broadly when they are thicker. Unfortunately, extra thickness transmits less light, also.

Exposure sequence for an HDR file

The peony-painted doors were of sandblasted glass, which does not spread the light evenly. To make the light even across the frame, as I wanted in this case, the solution was to shoot a sequence of different exposures and combine them using HDR techniques as explained on pages 242–247.

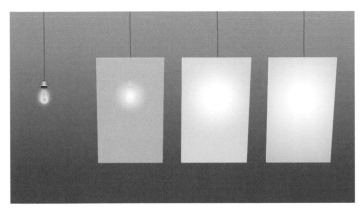

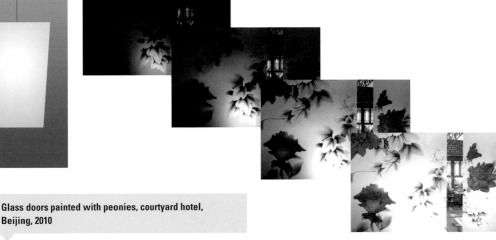

equipment), but daylight can do the job equally well. You simply need some kind of translucent screen, such as the one we saw on the previous pages. To be completely anonymous, however, a backlight is better with no texture at all, which favors materials like sandblasted glass and milky Plexiglas. In the case of the masks shot, this was a translucent window in a Hong Kong hospital. The masks look disturbing, and are. They are targeting masks worn by cancer patients for radiotherapy, made of transparent plastic. No other kind of lighting would have worked for these—reflections would have made them complicated, while like this, the extreme simplicity of the tones gives emphasis to what the eye reads into the masks as expressions.

The other photograph is of painting on glass, which looked more intense and more interesting backlit rather than frontlit. However, as the glass was sandblasted, it did not spread the backlight evenly, as the individual exposures show, and to achieve this totally even effect I had to shoot different exposures and blend them together. A single shot with light concentrated in the center would have made a good image in a different way, but here the purpose was to show the painted peonies to their best advantage. ■

Glass doors painted with peonies, courtyard hotel, Beijing, 2010

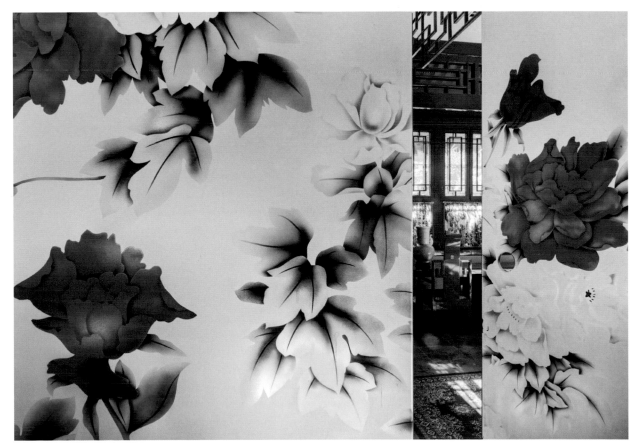

BACKLIGHT The Silhouette

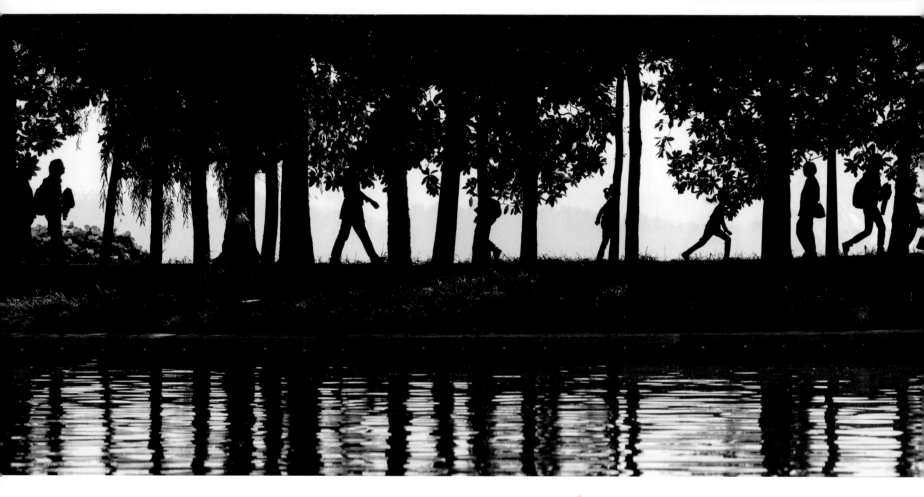

Finally, when shooting into the light, there is always the option of going for a silhouette, and this means ignoring all shadow detail, exposing for the bright background, and relying on the way that shapes and outlines of things work graphically. Some situations are natural for a silhouette, as we saw in the Thai fish farm shot on pages 62–63, while others can be pushed to work in this way by the way in which you expose for them and process them. I believe it's important, though, to see silhouettes as a graphic form in their own right rather than just an exposure choice. When they work well, it's because they follow a very particular visual way of representing something, which relies heavily on outline and, strange to say,

on the principles of caricature. This may sound a little odd, but there is something to learn from this, and it's worth going back to the height of popularity of silhouettes in the 18th and 19th centuries. There was even a connection with photography, though a contrary one, because it was the camera that took over from the cut-out black card silhouette as a cheap way of making a portrait. A silhouette relies on its outline, which means that if you want the image to read clearly, the outline has to be the right aspect and the right moment. For capturing a person, that would usually mean in profile (so that the face reads), and at a moment when gesture and stance are expressive

Xuanwu Lake, Nanjing, China, 2010

(for example, a hand outstretched, both legs clearly separated if walking). Getting that stance, that exact moment, is especially important for a silhouette, which relies entirely on this, and explains why I chose this exact frame for the shot on the Nanjing lake, particularly for the two figures at the right but also for having a few people all neatly between trees at the same time (I shot 40 frames).

Of course, just being clear and recognizable may not be as interesting as being mysterious. Silhouettes have a certain graphic attraction that has continued

70

Enhancing the silhouette effect

From left to right: unprocessed detail, black and white points closed up, converted to black and white, blacks and whites clipped.

Unprocessed exposure in hazy sunlight

The same scene as the main image, from farther back and with no processing.

Akha girls carrying grass for thatching, Chiang Rai province, Thailand, 1981

long after the original card cut-out method. This comes both from the viewer having to put a little effort in to work out what the scene is about, and from the overall neatness and precision of black against light. That is why I preferred this silhouetted version of two Akha girls carrying grass to any of the others that I shot—the first take is of a pair of very odd creatures on the skyline. In any way of shooting a silhouette, the key is to expose for the light background and keep the subject dark—even black, as in the case of the Nanjing lake shot. Silhouettes do better without depth and dimension. ∎

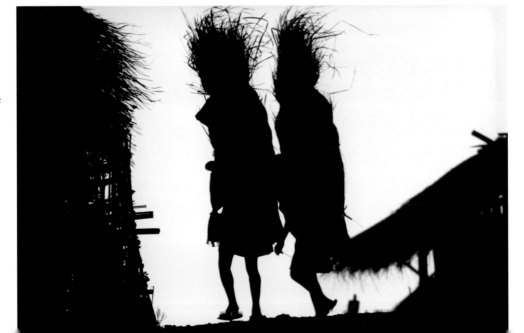

AXIAL LIGHT Low-Sun Telephoto

The Dome of the Rock, Jerusalem, 1984

Low-sun telephoto means light that follows the lens axis, looking straight down the line of sight. In the studio you need some trickery to manage this, and one method is to angle a sheet of glass at 45° in front of the lens while aiming a light at the glass from 90°. Another method, developed originally for medical use and later taken over by fashion photographers, is a ring flash, which encircles the front of the lens with a circular flash tube. The natural light equivalent is when the sun is exactly behind the camera, and that means usually when it is low on the horizon. That might not sound so unusual, but in practice it turns out that quite a few photographs are taken with this light—and the way it falls does have some unusual characteristics.

To begin with, axial light is shadowless but at the same time intense, which comes across as

unexpected. We usually associate shadowless with heavily diffused light, as on the gray days that began this section, yet this one has sparkle. Where it gets interesting is in the reflections, which naturally are also axial, bouncing straight back to the camera. And when the surfaces have some textural quality to reflect back, it can justify the entire shot, as in the picture of the Dome of the Rock in Jerusalem, from the Mount of Olives (left). Even the Thai Royal elephant's hide (above) glistens in the axial light of a morning sun, giving intricate texture without shadows, which is quite a feat for any light.

Ah, did I say shadowless? There is, in fact, one shadow that's always potentially present—that of you and the camera. Unless you're planning on a self-portrait silhouette (perfectly reasonable idea), this is quite hard to accept in a picture, and difficult to eliminate. The classic solution is to shoot from a distance with a longer lens, and without a foreground

in view. The picture of the Dome of the Rock, taken with a 400mm lens, is a perfect case, so distant that from there I would hardly be visible, let alone cast a shadow. Better still, the ground falls away from the Mount of Olives, so there was no need to raise the camera slightly—that's another solution. A third solution, slightly less satisfactory, is to move a little off-axis (see the elephant), while the fourth and last is simply to wait until the sun has risen a bit and your shadow has moved back toward you, out of frame. That's quite a frustrating process, as you watch the axial effect diminish before your eyes. With the elephant, by the way, the bounce-back of the sunlight from its hide gives a lovely textural quality. ∎

Royal elephant, Sakon Nakhon, Thailand

Axial sunlight

With the sun behind the camera, everything is lit, with just a light surrounding shadow to deep or rounded objects.

AXIAL LIGHT Open Doorway

Doorways and windows, particularly when there is one behind the camera, create conditions for axial light that, unlike the low sun on the previous pages, do not depend on the time of day. The basic situation is an enclosed space with no other light except from behind you, standing in the doorway, and the effect comes close to being shadowless. What shadows there are fall around the edges of objects in your line of sight, as the illustration shows, and this is not at all the same as the wrap-around shadowless lighting in fog and mist, or in pale gray light. The difference, as always with subtle distinctions in lighting, lies in the clues that the eye takes from the scene, especially that slight but telltale shading-off around the edges of objects. If at this point you start to think of ring flash, you wouldn't be totally wrong.

The example below is an old brick temple on the Bagan plain in Myanmar (Burma). The way in which many of these Buddhist pagodas were designed meant that on each of the four sides a large doorway opens onto a vaulted chamber, not particularly deep,

Buddha image, Sulamani temple, Bagan, Myanmar, 2003

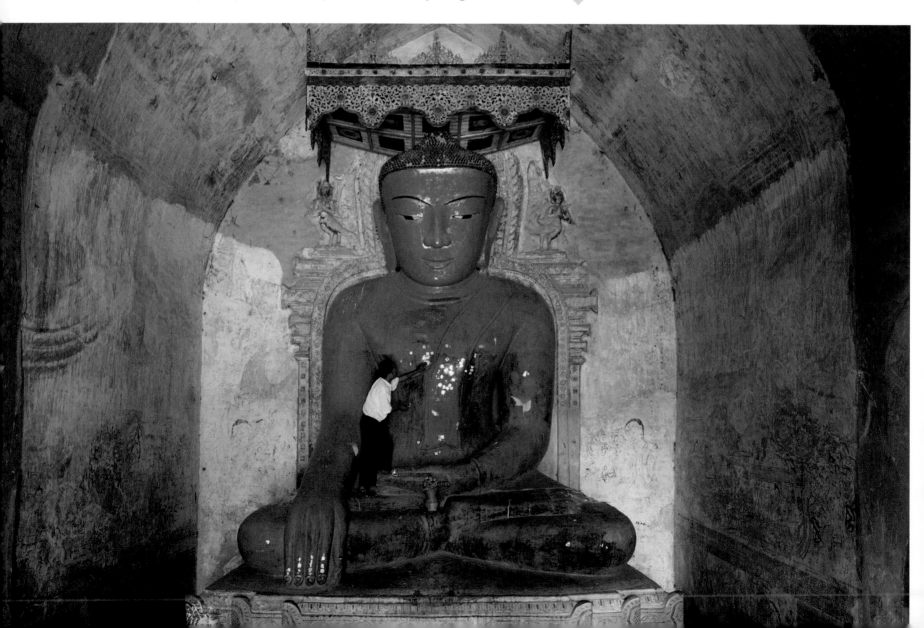

Virtually shadowless light

Seen from slightly above the camera position for clarity, the only shadows in this kind of scene are the slightly darkened edges of solid subjects.

Light from in front

An angled view of a similar temple chamber in a nearby temple, to show the frontal daylight from the large doorway out of frame at left.

Shao Fan

A painting in Beijing artist Shao Fan's "lightless" style at his 2012 solo show—the artist at right.

with a Buddha statue facing out. For many people, the very flatness of the lighting, which naturally kills any modeling, argues against it. Hence the alternative treatment from one corner, as shown in the illustration. However, another point of view— mine in this particular case—is that there's a cool, formal objectivity to this light that brings a kind of restraint to the image. At the risk of straying from photography, I want to show next to it a painting by one of China's leading artists, Shao Fan, who is also a friend. In this period of his work, Shao Fan is returning to some older principles of Chinese art, in particular to the idea of showing form without the help of light, and this is one of the key differences between the Chinese and Western art traditions. To me (my words, not Shao Fan's), there does seem to be a virtual light source in this and other paintings of his. The darkening at the edges of the horse make the light seem to come straight from the viewer. ◼

AXIAL LIGHT Ship's Hold

This is a more unusual variation on the open doorway, because here we're looking straight down into a ship's hold. The lighting quality, however, is the same as before, and what's interesting here is how the interior where the man is working reacts to this axial light, and essentially makes this particular shot work. This is the hold of a ship, and what's inside (peering down, we're curious, of course) looks like the aftermath of a catastrophe, and very dirty. In fact, this is a burned-out *dhow* on the Dubai waterfront. After a fire gutted the ship, it was towed here where an Indian crew is cleaning it out. When they have finished, it will be towed to India to be repaired. Everything is coated in black grease and soot, even the worker, who is blending into the gray mess (but note the catchlights in the eyes).

One of the qualities that I personally get from axial light is a sense of almost dissecting the subject. With everything lit, no corners concealed and no shadows, I don't think it's too fanciful to say that it's a kind of forensic view. Going back for a moment to the ring-flash effect I mentioned on the previous pages, that specialized kind of photographic lighting that fits around the front of the lens was actually first designed for medical photography. I might be pushing this insect-pinned-down feeling too far, but the fact that we're looking down on the man seems somehow to fit with this kind of lighting. Nothing is hidden, so that every grimy bit is exposed. One feature of axial lighting is that in most situations the contrast is low, simply because there are no deep shadows. The exception, which we saw a few pages ago, is when there is a highly reflective subject and sunlight bounces right back. This doesn't apply here, but it does mean that you need to think about the overall level of brightness when setting the exposure. Here, it's soot-covered, so it needs to stay dark. ■

Cleaning out a burned-out *dhow*, Dubai waterfront, 2012

An alternative framing

From the same position, zoomed back a little and horizontall framed.

The situation

From the side, a well-like effect with top-lighting as described on pages 82–83, but from the hatch opening overhead, purely axial light.

A workshop shoot

This was, in fact, part of a photography workshop, with local Dubai and Sharjah students.

SKYLIGHT Blue Shade

Park Avenue, New York, 1998

Ever since color photography became possible, photographers have had to worry about color temperature (or what now gets called white balance), and more than anything, about the dangers of a blue cast from open shade on a clear sunny day. The effect is certainly there, but whether it's a problem is questionable. What happens should be immediately obvious from the illustration. Take a cloudless day: Most of the light, in the region of 85%, comes from the sun, but some also comes from the rest of the sky, a large area reflecting sunlight, but reflecting only the blue wavelengths. For the technically curious, this is called diffuse sky radiation, and appears blue because normal atmospheric particles are smaller than the wavelength of sunlight and scatter the shortest wavelengths, which happen

How skylight works

Typically, shade on a clear sunny day makes the subject lit by the blue sky alone, with a small amount of white light bounced up from the ground.

SKYLIGHT COLOR BALANCE

Although the light intensities are very different, you can choose from the camera settings or in Raw processing how to balance the color. At the ends of the scales, neutralizing the sunlight renders the skylight blue, while neutralizing the skylight makes sunlit areas appear yellowish.

to be blue. Anywhere shaded from the sun is lit by this blue light, plus a little bouncing up from the ground or from walls.

So, what's the problem? It's a legacy of the days of film, which is color-balanced to one kind of light only. Most color film is/was daylight balanced, meaning to light from a midday sun. With this set as neutral, skylight is blue-ish, to be corrected with a film camera only by warming filters over the lens. But it is also a legacy of a mindset that promoted correctness. Portraiture more than anything carries certain expectations about lighting and color, and accurately portraying the color of skin tends to be a priority. Digitally this is simple, and tweaking color balance in or out of the camera is easy. And because it is so easy to choose color balance after the event—a normal action if you shoot Raw—I can see a shift in attitude over the years. Fewer people these days seem to worry about "correctness" of color, and I suspect it's because it is no longer fixed. If you can't do anything about a color shift, it qualifies as a problem, but if you have total freedom, it becomes a choice. The good thing about this choice is that the blue in shade can add color interest to a shot, especially when it contrasts with the warmer sunlight. We'll see more of this when we get to Magic Hour (pages 104–107), but for now here are two images that work partly because of the added blue. ∎

Woman & child, Fatahillah Square, Jakarta, 2012

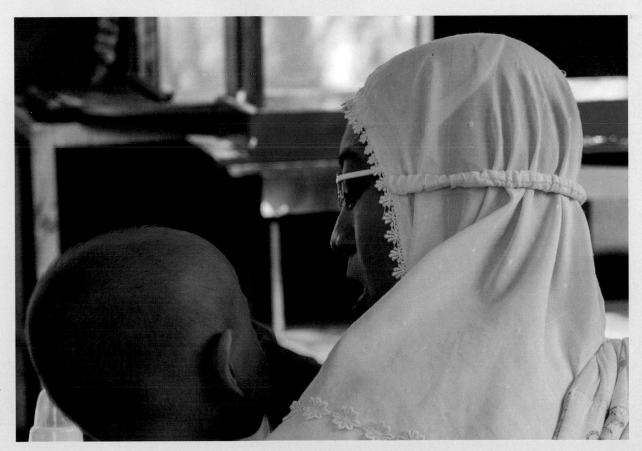

SKYLIGHT Portrait Standard

In the years between mainly black-and-white film photography and digital, when the majority of professionals were shooting color transparency, shade on a clear sunny day used to drive photographers crazy. The blue shade from skylight, which can be used as a color element in the kinds of image we just saw on the previous pages, does no favors to skin tones in a portrait. This was a pity, because in other respects the qualities of open shade, especially with some bounced reflections from brightly sunlit ground out of frame, are all to the good. Painters in their studios, always built for the north light, never had this problem, because they chose their pigments according to what they saw—or wanted to see—and the eye's famous ability to normalize the color cast took care of everything. The flexible settings in a digital camera take us back to this relaxed state of affairs, meaning that you can have any color balance you like, especially with a Raw file.

I'm exaggerating a little when I title this "portrait standard," because the naturally lit ideal is a studio with control over the reflections from walls and ceiling, but the principle holds true even in the uncontrollable outside world. On a bright clear day, move your subject to the side of a building that is blocked off from the sun, and you have instead the broad and soft light from up to 180° of sky, which generally means a downward angle of around 45°.

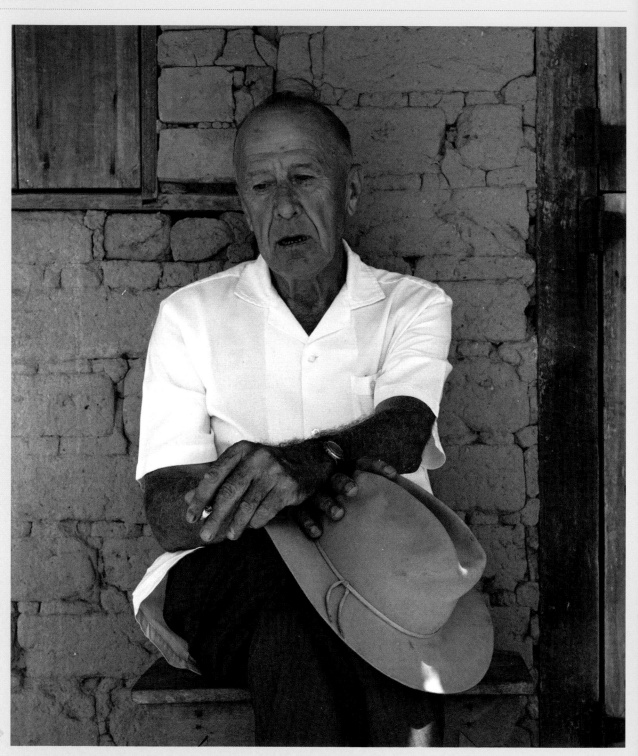

Cesar Gorinsky, rancher, Rupununi, Guyana, 1973

The moment you move from sun to shade, the immediate impression is of losing most of the light—easily a 4- to 5-stop reduction—but give your eye some seconds to adjust by facing into the shade, and its soft-yet-directional qualities become obvious. The occasional bright reflection from beyond the shade—as you can see happening in the black-and-white portrait here, taken in the tropics and with a fleck of sunlight already reaching the sitter's hat—only adds to the interest. And the color balance is no longer an issue. ■

Skylight set-up for a portrait

An effective way to use skylight for a portrait is to sit the subject just in shade, to allow bounced light from the ground to open up the shot, and even, in the case of the black-and-white portrait here, hint at some patches of sunlight.

Pathan elder, Swat Valley, 1980

TOP LIGHT Deep Forest

Logging elephant, Mae Sariang, Thailand, 1998

The skylight that we just saw is, naturally, mainly from above, but there's another, more concentrated kind of top lighting, and it happens when the surroundings are closed off in some way. The extreme version would be standing at the bottom of a well, although this is not the most likely scenario. In the situation we just saw in Axial Light—Ship's Hold, if instead of looking down on the man we were at his level, this would certainly qualify. Or an atrium of the kind popular in hotel design.

The light floods down from above, broadly rather than in the form of a spotlight or shaft of sunlight, but there is little in the way of fill lighting from the sides. Because there are relatively few situations where you find this lighting on a large scale (paradoxically, it is common in still-life studio shooting), it has a certain unusual feel to it, with even a hint of being enclosed and restricted.

Key Points

Feeling of Depth

Lighter Above

Neutral Grad Filter

Choosing the right neutral grad

Grads are available in different strengths and softness of transition. The sharp-cut 0.60 grad at left is less suitable than the smoother 0.30 at right, both because of strength and the transition.

Top light in a forest

The mass of dark tree trunks eliminate lighting from the side, leaving a flood of light from above that weakens from top to bottom.

Psychologically it usually feels more inspiring to be on top of things, like a hilltop, than at the bottom.

The location I've chosen here is forest, the deep kind with tall trees, and you can find it from tropical rainforest to the north woods. This particular example is subtropical, on the Thai-Burmese border, where elephants are used for logging. Or rather were, because this practice is now banned on the Thai side, and this elephant is working for the Forestry Department recovering illegally felled tree trunks. This is where the special atmosphere of top lighting comes in to play, because the more we sense it, illuminating the upper surfaces only, the stronger the idea is that we are deep and that these are physically impressive surroundings. The light shades from top to bottom, so there is always the possibility that the exposure may be a little too high for the upper part of the picture, but beware of over-correcting—light flooding down is part of the experience.

If you have plenty of time when shooting (not the case in this shot of the elephant), a neutral-grad filter would be worth using, or you could use the digital version when processing. But these things are easy to overdo. The illustration shows the difference between a sharper cut 2-stop grad and a soft-cut 1-stop. The smoothness of the gradation also depends on the focal length of the lens (wide-angle shows it sharper) and on the aperture (small aperture also shows it sharper). The second photograph is a still landscape that would take the grad treatment, and in fact it was shot very slowly, on 4×5-inch film with a view camera, on a tripod. ■

Hoh Rainforest, Olympic Peninsula, Washington, 1984

WINDOW LIGHT Directional with Soft Shadows

Long before softboxes were invented to make flash light gentler, in the professional world there were shaped aluminum boxes that were heavier and bulkier and did the same thing. Fronted by translucent acrylic, they became popular in the 1960s and 1970s in studios, particularly for advertising still-life shoots. They were known not only as "banks" but also as "window lights," because that was the light they mimicked—a rectangular white light source positioned close. They came in different sizes, from smaller square units around 50×50cm, through the basic workhorse of still-life shooting known as a Fish Fryer, measuring 3×2ft (0.9×0.6m), up through a Super Fish Fryer to the largest, a 6×4ft (1.8×1.2m) Swimming Pool. These names, incidentally, were actual models from the best-known manufacturer of professional studio lighting at the time, Strobe Equipment.

Though it might seem I've wandered completely off topic by talking about studio lighting, these lights were invented and became popular (they still are in the softbox collapsible versions) precisely because of the wonderful modeling qualities of north-facing windows. Go back further in the history of imaging, and north-facing skylights were preferred for painters' studios. The reason for facing north was, and is, that at no point does the sun shine directly through like a spotlight and change the nature of the lighting. Instead, the window acts as a large rectangular bank of light, and creates a very special and attractive balance between modeling and softness. What this exactly means is that the light is directional, so that it casts shadows and rounds out forms, but at the same time, the shadows have soft

Wooden Shaker bucket, Pleasant Hill, Kentucky, 1986

edges and retain some detail. Many painters, particularly the Dutch, with their affinity for northern cool light, loved this effect, and Johannes Vermeer's "The Milkmaid" is just one example. Both of the photographs here, from the same project on the Shakers, make full use of natural window light, with no need for any shadow fill. In the picture of the milk bucket, the camera angle is deliberately half toward the window, which increases the contrast and makes more of the highlighting on the beautifully curved wood. The nuances of camera angle to the window are important with this lighting. ■

No light

Minus shadows

Cloudy sky

Blue sky

Shaker man's linen shirt, Pleasant Hill, Kentucky, 1986

Vermeer & window light

Vermeer's "Het Melkmeisje" is the quintessential portrait that uses the decisive-but-soft modeling from a close window. Note that because the window is forward of the room's corner, Vermeer can use counter-shading to bring three-dimensionality—the shading on the figure runs counter to that on the wall behind, and as a result she stands out firmly.

The window becomes the source

Provided that no sunlight enters, window light is remarkably consistent in quality, though not in color. The difference between light from a cloudy sky and from a blue sky can be dealt with by adjusting the color balance.

WINDOW LIGHT Classic Fall-off

It's time for one of those opaque (if you'll excuse the term) lighting calculations that no one wants to do while they're shooting, but that can't be avoided if you're doing any serious interior photography by natural light. The key fact about windows is that they do not just let daylight through; they become the light source. This in turn means that something

called the Inverse Square Law comes into play much more noticeably. This is simply one of the laws of physics that applies when you have force or energy radiating outward, and it means that the intensity of light, for instance, doesn't just weaken with distance, but it weakens with the square of the distance. One way of visualizing this is that if you think of a sphere

Stephen Barber & Sandi Harris, lutemakers,
Elephant & Castle, London, 2012

Falloff in a typical room

Typical falloff of illumination, obeying the inverse square law. The left illustration is the reality, but our eyes are inclined to minimize the fall-off, as shown on the right.

surrounding a light and the amount of light it receives, and then imagine another surrounding sphere twice the distance away, the same amount of radiating light reaches both, but the larger sphere has much more surface area—bigger by the square of the extra distance.

This is more or less irrelevant for most natural-light photography. If the sun is low and behind you, the light bathing a foreground rock and a mountain 20 miles (32km) distant is to all intents the same. On a scale of the sun's distance from the Earth, the difference between your foreground and background is minute. However, with a light source much closer, like a window set in one wall, there's a big difference in the light halfway into the room and at the far end.

Does it even matter? Well, it depends on what you're shooting and why. Remember that we're up against the eye's ability to compensate. If you're looking across a room with light coming in from one side, you know the light falls off and that the side farthest from the window is darker, but you perceive it as being more or less equal. A sensor doesn't do that, so if you were shooting a formal architectural interior, you would definitely need to lighten one side or darken the other to some degree, just to get close to the eye's real-time view. The fall-off appears strongest in this kind of side-on view, as you would expect. You could deal with it when processing, or even take different exposures with a view to blending them later (see the final Helping section). Or you could deal with it on the spot with one or more neutral grad filters. In a planned, locked-off shoot, this is the sensible approach. And it's because of the Inverse Square Law that, if the view is wide, a single grad is unlikely to do the trick. ■

Matching grads to the fall-off

A neutral grad filter is the classic solution, but needs attention: (top) the transition on the filter is too sharp for the room, (middle) transition softened either by using a smoother-transition grad or by opening up the aperture, (bottom) two grads overlapping to smooth the effect across the room.

Applying the grad

For the lutemakers portrait, the grad was slid into position, judging by eye when the darker half was just covering the window and man.

WINDOW LIGHT Streaming Sunlight

Meeting Room, Pleasant Hill Shaker Village,
Kentucky, 1986

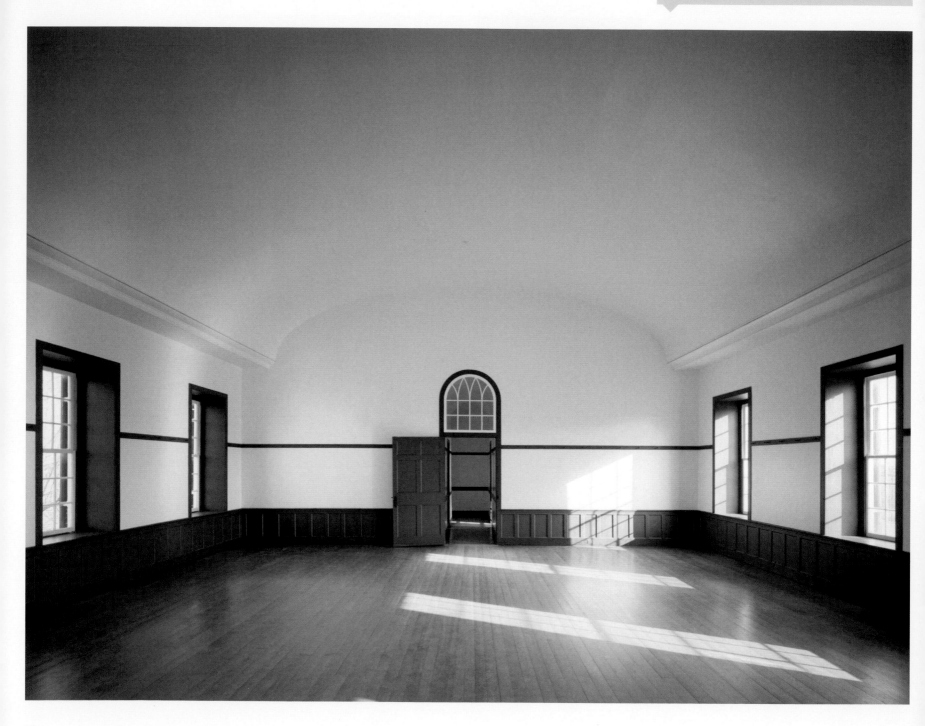

Key Points
Pattern of Light
Low Sun
Secondary Bounce

Entrance Hall, Monticello, Virginia, 1988

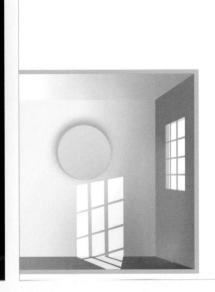

When direct sunlight does stream in through the window, the results can be almost magical, although uncontrollable. This is one of those lighting situations that could as well go in the next section, Chasing, as here, and which it is rather depends on whether you are just visiting briefly or have long-term access. In either case, it calls for quite rapid shooting, as it rarely lasts long and poses some exposure issues because of the very high contrast.

Useful and controllable window light depends, as we just saw over the last few pages, on the window facing north, or at least away from the sun. In the situation here, however, the large rectangular light source is overlaid, in a sense, with a broad shaft of much more intense sunlight. Typically, the pattern of light, which includes the grid of window muntins, moves relatively quickly across the floor and walls. Variations of this appear in the early part of Chasing, from pages 132–135 and also 192–195, because where

the sunlight hits the floor or wall, it becomes a secondary light source itself, bouncing away.

There is a built-in attractiveness to this kind of lighting because it usually occurs in or approaching Golden Hour, which we'll be looking at next. This is all to do with angle, because for sunlight to have any real reach into most rooms through a normal window, the sun needs to be fairly low, meaning lower than about 40°. In the picture of the hallway of Thomas Jefferson's home, Monticello, the sunlight was at half an hour after sunrise, which accounts for both the warmth and the glinting highlights dotting the wall. For interior photography, the appeal of this short-lived lighting is that it shows the room off in an unusual and special way. Both of these shots would have been that much more predictable and a little duller if they had been taken in more usual daylight. In the picture of the Shaker Meeting Room, not only does the sunlight punch into the floor and far wall, but also secondary reflections

An overlay of bright pattern

The projected pattern of the window brings a clear sensation of brightness to the image, an effect sometimes mimicked in studio lighting.

make the lower ceiling at left glow subtly. The brightest highlights are very likely to blow out, but if they are small, as here, that is no disadvantage at all. As with some of the flare we'll see in the next section, the extremes add a sensation of brightness that would be missing if every tone were brought under control. ■

WINDOW LIGHT Narrow Window, Dark Space

Small windows in dark rooms (the two go together, naturally) are a thing of the past, generally. Quite simply, in contemporary living, windows are getting bigger, because there is an almost universal desire for bright interiors. However, going back to the Japanese writer Jun'ichirō Tanizaki, mentioned in the introduction, white and bright Modernism may have taken over most of the world of contemporary interiors, but in photography, hidden things, only partly revealed, go a long way toward making an interesting image. So, in praise of the shadow world, let's look at under-lit interiors, where light leaks in through very small spaces. We're more likely to find this happening in an ancient style of dwelling, and it's no coincidence that two of my best examples of this are from minority communities, building in wood and bamboo.

A single small, high window
The set-up for the portrait of the Shan man.

Shan man, Lake Inle, Myanmar, 1982

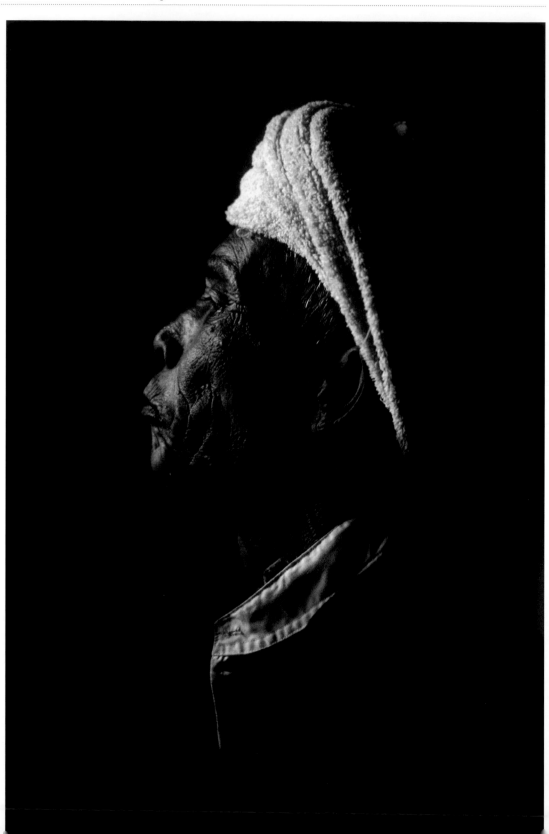

Key Points

Under-lit Interiors
Spotlighting
Chiaroscuro

Akha girl, Maw La Akha village, Chiang Rai province, Thailand, 1980

The structure

The low, overhanging eaves allow just a narrow band of bounced light into the interior, but here in the tropics this is still bright.

The isolating effect of this kind of situation—the illustrations show how the interiors were arranged—is excellent, provided that you follow a few simple guides. The effect of a single small window has something of the spotlight about it (see pages 136–143), but without the beam and concentration. The reliable way to handle this is to avoid shooting toward the window, and not attempt to show anything in the shadows. In the case of the Shan man in Myanmar, I was almost side-on to the light from the window, which was perfect for the texture of his face. I exposed for his face alone, which working quickly meant underexposing by about 1.5 *f*-stops from the camera's matrix metering. This kind of image tends to be ruined by overexposure, whereas the surroundings can go as black as anything.

The image on the right is almost a kind of axial light. This was a hill minority large bamboo house, with no windows. Instead, the light bouncing up from under the deeply overhanging eaves gave an illumination that you simply got used to when you settled in. Walking in from bright sunlight was like entering total darkness, until the eyes adjusted. I like the effect because it's not at all clear from the picture alone where the light is coming from, and the position of the girl, with most of the interior space behind her, makes her stand out from darkness, without being harshly lit. The light level was very low. ■

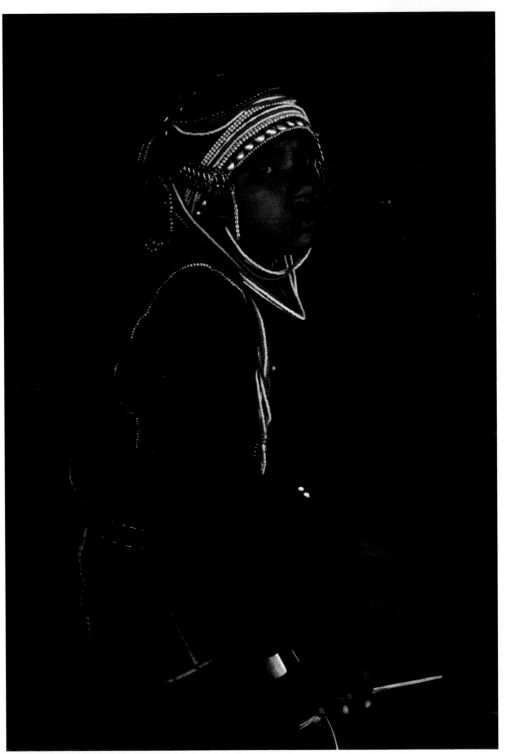

WINDOW LIGHT Managing Several Windows

Not many rooms or buildings have a number of windows opening out in different directions; as we just saw, the most typical arrangement is one or two windows in one wall, so that the light comes from a single direction, with the inevitable fall-off that is more extreme than the eye imagines. Several windows in different walls, however, offer the possibility of control. This is largely to do with size, wealth, and purpose: Mansions have bigger rooms than simple apartments, so they need better lighting. Corner rooms offer two walls with windows, projecting rooms offer three, while open-plan design and lofts often span the width of a building. In this case, a lovely teak Buddhist temple in Cambodia, the structure is a single space, freestanding with a series of windows and doors on all four sides.

When not in use, the shutters are all kept closed, and for photography that meant I could choose which to open, as if turning on a 360° bank of lights—almost a natural daylit studio. The caretakers were amenable.

All I wanted from this particular shot was to show in detail the teak pillars, painted black with stenciled gold decoration. They were a very special feature, possibly unique in Cambodia. During the genocidal years of the Khmer Rouge, almost everything of art, craft and religion that could be destroyed was, systematically. Here was an exception, because the nineteenth century building was used as a hospital, and the pillars were structural. The cadre accepted that they had to remain, but their beauty was hidden with clay, in a rare case of preservation.

The shiny surface of the pillar needed lighting care, and we lit this nearest one with two windows from the left as a main light. Then a thin catchlight from a door to the right and beyond. The plan was to shoot a close-up, but with a background that gave an idea of the number of pillars—basically dark, but with just enough side-lighting to make sense of it. The door right and beyond did the job for the pillars on the right; opening the opposite door far left lit the others. The shallow focus from a wide-aperture lens (85mm f/1.4 at full aperture) was deliberate, to keep the attention focused on the nearest pillar's details. ■

Wat Maha Leap, Kompong Cham, Cambodia, 2011

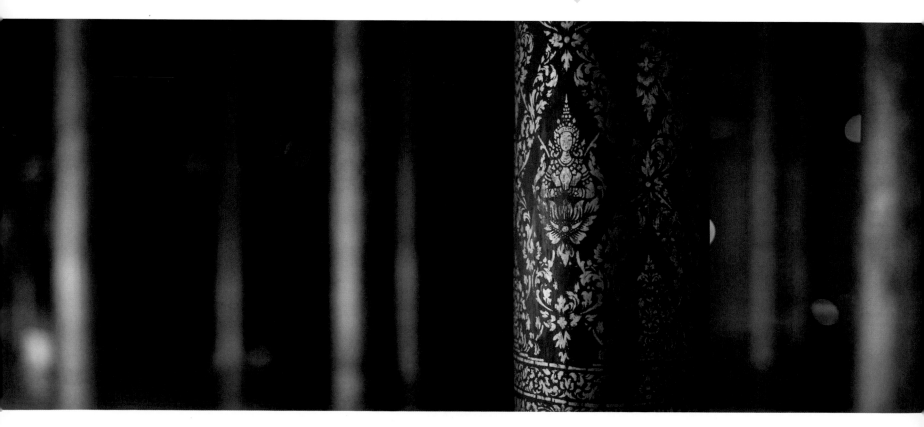

The setup

The layout and arrangement of open and closed windows and doors.

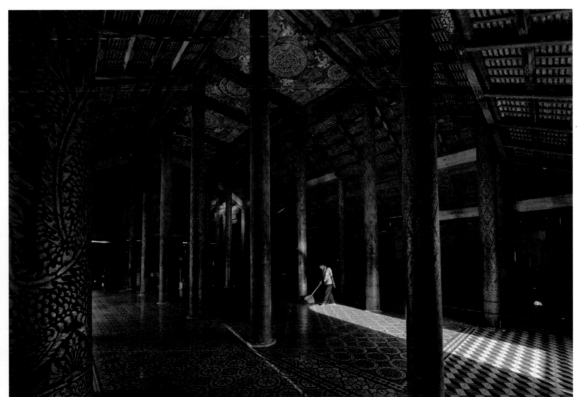

Wat Maha Leap, Kompong Cham, Cambodia, 2011

The more conventional view.

GOLDEN HOUR Basking in Warmth

Having begun this book with some of the less obvious kinds of lighting, I hesitate a little before introducing the perennial favorite. For one, it's been written up rather too much, and for another there's an almost herd-like view that this hour or two at the ends of the day is the authoritative best, a kind of ideal that all other lighting conditions aspire to. Some caution is in order. Golden Hour is excellent for photography, no doubt about it, but the more you gear your efforts toward it, the less special it becomes, little by little. Just a thought. And that thought prompted me to wonder how much photography is in fact concentrated at this time of day. I counted up the main shots in this book, where I'm consciously trying to cover the entire range of light. A third were taken at this time of day, which surprised me.

Golden Hour is quite simply when the sun is low in the sky. The end-points are sunrise and sunset, but the maximum height is a little vague. It's when the sunlight in clear sky is yellow-to-orange, and that's approximately below 20° above the horizon. Hold your hand out horizontally at arm's length, then turn the palm to face you and stick your thumb up. The tip of the thumb will be at about 15°, so when the sun is a bit above that, golden hour begins (see pages 10–11). How long does it last? That depends on the path of the sun, according to the latitude and the season. The equator is the simplest: At either solstice, June or December, the sun rises at 06:00 and sets at 18:00 in the middle of the time zone, and it takes 90 minutes to reach 20° from sunrise, and the same time from 20° to sunset. In the mid-latitudes there's

Old city, Cartagena, Colombia, 1999

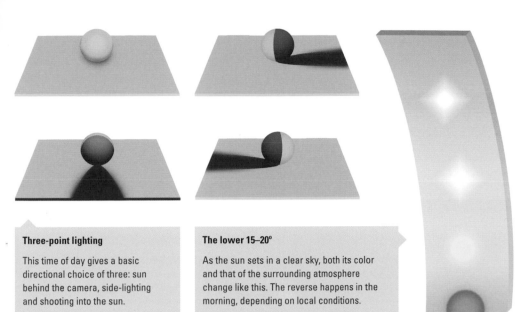

Three-point lighting

This time of day gives a basic directional choice of three: sun behind the camera, side-lighting and shooting into the sun.

The lower 15–20°

As the sun sets in a clear sky, both its color and that of the surrounding atmosphere change like this. The reverse happens in the morning, depending on local conditions.

Golden Hour equals height of sun

Because the height of the sun during the day determines its color and angle, Golden Hour lasts longer in a mid-latitude winter (lower track) than summer (upper).

much more variation throughout the year. In Washington, DC in midsummer it takes just under 60 minutes to reach 20°, and in winter 150 minutes. In Stockholm it takes 200 minutes in midsummer, but in midwinter it gets no higher than 7°, lasting all day (what there is of it).

A combination of things makes Golden Hour good for shooting. The color is warm, and people generally like that, possibly because it reminds them atavistically of fire (that could be a bit far-fetched). The angle is low, which gives all the benefits of raking light (pages 40–45). And then we have the three-point choice, which basically means that in any one spot you have three possibilities with distinctly different light situations: side-lighting, into the sun, and with the sun behind you. There are many more pages devoted to these, such as under Raking Light, Into the Sun, Backlight, and Axial Light, among others.

Above all, the Golden Hour experience is warm and fairly luxurious. There are many variations, from rich to soft, and the examples here are among the obvious, with others to follow on the next several pages. The light changes quite swiftly in all its qualities, so shooting at this time can be quite fast-paced and challenging. ■

Semois River, Bouillon, the Ardennes, Belgium, 1996

GOLDEN HOUR Three-point Lighting

Ubehebe Crater, Death Valley, California, 1982

Three-point #1—Axial

Three-point #3—Back

Three-point #2—Side

We've already seen two of these lighting directions in detail—backlight and axial light—and it's obvious that these depend on the low sun that creates the Golden Hour. What often gets overlooked is the simple, but important, practical advantage that at the same time you have a choice of different lighting effects. I call it three-point lighting, although this is really just a convenient summary of what you get from a 360° lighting system. All you have to do is keep looking around you at this time of day to realize that you have potentially a full circle of lighting. The exact opposite is a high midday sun, which gives a single lighting direction—from above. The closer the sun is to the horizon, the greater the choice of lighting.

This is really a single point that I'm making, which is to keep thinking of different lighting choices, though it's surprisingly easy to forget when you have in sight one good shot. Give or take a number of degrees, the lighting choice in Golden Hour boils down to axial (sun behind the camera), side-lighting from either left or right, and into the sun. Any one of these can be strong, but even if you hone in on just one opportunity, the others may also be waiting for you, depending on your location. It's rare, certainly, to find all three from one viewpoint, without moving a distance, and in these three examples, which are all from very different places (California, Tuscany and northern Myanmar), they were the only good scenes on offer. Nevertheless,

thinking about Golden Hour in terms of three lighting possibilities is a useful, practical way of shooting. And it might also be possible to do some scouting earlier in the day to imagine what might work from what camera position. On certain kinds of location shooting, this is standard practice. Use the down-time when the light is not as good as it will be later to plan shots and camera positions. Particularly with scenic images, early afternoon can be a time to work out the shots for the end of the day—and for the following early morning, when it's never easy finding a viewpoint in pre-dawn darkness. Always better to have thought about it earlier. ■

Sorano, Tuscany, Italy, 1991

Irrawaddy ferry, Myitkyina, Myanmar, 1995

97

GOLDEN HOUR Facing into Soft Golden Light

This is one of the kinds of light we dream about. Although the premise of this section is that you can wait for the light to come right, few things are completely predictable, and sometimes a number of elements, like the viewpoint, the clarity of the air, the subject, fall apart. At other times, like this early morning on the Yulong River near Guilin, China, instead they just fall into place, and you realize that you have nothing to do with that. It's just a privilege to be there.

The Golden Hour is often rushed for shooting, because the light changes more quickly than in the middle of the day, and also because, as we just saw, it offers different directions for shooting. This case, facing into the late sunrise with a misty wash over the landscape, is a very specific set of conditions, and the only one I wanted to pursue. The all-important soft atmosphere, which in this exact place was a condition given by the water and from the time of year—late autumn days that start cool and become warm often do the same—does several things. First, it suffuses the scene in a golden glow, because we're facing into the light. Second, it gives a gentle version of the well-known ability of real fog to separate a scene into distinct planes. Third, and very valuably, it means that we can hold the sun in view until it's quite a few degrees up above the horizon.

This was what I was banking on, that by the time the sun cleared the mountains, it would still be soft enough to be able to hold in the image—though it

Cormorant fisherman on the Yulong River, Guizhou, China, 2010

would need some recovery by the Raw processor. The time of the shot was 7:35am, exactly half an hour after sunrise. In a clear sky the sun would clip immediately, and I would have had to rely on catching just a fraction of its disk, the rest cut by the mountain top. This would in any case have captured quite a different mood.

The fishing in action

The main purpose of the exercise was not the sunrise, but the act of cormorant fishing, and so included more of the action involved as the birds dive and look for fish. Using the sun reflected in their ripples was deliberate, and I had the boatman position us for this.

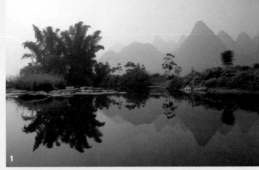

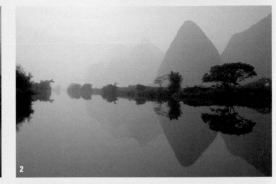

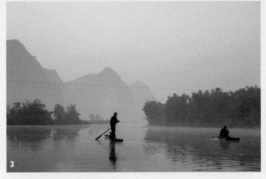

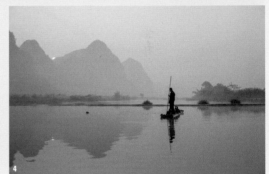

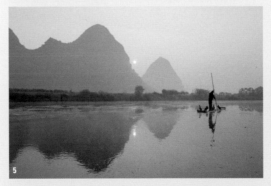

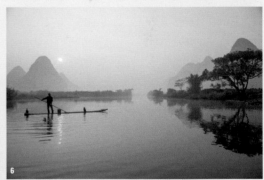

The still waters of the river were another unexpected bonus, mirroring everything, from the lovely limestone peaks for which this part of China is famous, to the delicate sky. Unexpected because it was a series of artificial weirs that created the stillness, and also provided the conditions for the local fishermen to work with their cormorants. Which brings me to the subject, because I was adding to an assignment on cormorant fishing, and that came first. I followed this fisherman for half an hour as we drifted downstream, and I hadn't predicted this particular scene with its pristine reflection, though I had intended to work on the sunrise. Would the shot have worked without the man and his birds, relying just on the beauty of the light? I don't know. For some people yes, but for me it was a case of working with the light rather than just reacting to it.

The tones were so delicate everywhere in this scene that I didn't want a hint of noise, and so shot at the camera's slowest sensitivity, ISO 100. This in turn meant shooting fairly wide on the aperture—$f/5.6$—to allow a safe shutter speed from my rather unstable raft, 1/125 second. Most of the scene is distant, so there were no problems with depth of field. Holding the sun and its subtle color meant very careful Raw processing that included local adjustment. ∎

1 Searching for locations the day before—upstream before finding the main location. Quite pretty but a little late at 8:50am, as sunrise was at 7:05am.

2 The location, found the day before—atmospheric but really late, at 9:54am.

3 On the day—floating downstream at 7:15am, still bluish though the sun had risen somewhere behind the mountains.

4 Some color coming into the sky at 7:20am, getting close to the location.

5 Almost there at 7:30am, the sun just coming out. The position of my raft is now going to be critical to keep the sun on the edge.

6 Game over at 7:40am. Still good in its way, but the sun is getting stronger and whiter.

GOLDEN HOUR Last Moments

Light moves faster during this period than at any other time of day, making it a dynamic hour or two. Toward the end, which is sunset, the angle of the sun is so acute that the pattern of shadows and highlights moves visibly. Finally, the minute or so when the sun is just touching the horizon is the shortest moment of light in a normal day, and it's special not just because we're in a place to notice it, but because it lights just one small part of the scene and nothing else. Not to get too philosophical about it, it's a brief favor bestowed on one small surface or thing. The color, too, may be special, and an intense red has a high value for many people (though can be too lurid for some, and certainly in danger of becoming a surfeit of warmth when seen more than occasionally).

The Mittens, Monument Valley, 1979

This is a countdown that can be prepared for, up to a point. With a completely clear sky, you can anticipate the trajectory of shadows, and set up a shot at least approximately. Several things happen at once. Shadows travel upward, reducing the lit area until it divides into patches and ultimately a single spot. As the lit area reduces, it affects the composition, while at the same time the exposure needs almost constant attention. Then there's the complexity of the shadow edges. The clarity of the atmosphere determines the sharpness of these edges, and the lower the sun, the more of this atmosphere its light has to travel through. What might have been a crystal-clear late afternoon half an hour before sunset can quite suddenly soften. Another accelerating effect on the edges comes from whatever is casting them. As the sun gets lower, more distant objects, like hills, come into play, and their shadow edges become softer. And allied to a softer shadow edge is falling contrast: shadows opening gradually as the lit areas become less intense. Soft edges, as in the shot of the erotic bas-relief on the Khajuraho temple in India, can have an attractive uncertainty and encapsulate the sense of the day fading away, so it's not a cause for frustration as the edges weaken.

I include the picture of Monument Valley—the Mittens framed by two curving sandstone boulders—as an example of an extreme sunset. It's extreme in color intensity, contrast, and the precision of the shadow edges. Here we're actually less than a minute away from the sun's extinction, and the air is so clear that it's almost as penetrating as at midday. Not so uncommon here, but a rarity in most of the world. The viewpoint, by the way, almost had me fooled. I knew it from an Ansel Adams picture, and later from a Volkswagen commercial that was a kind of parody. I had assumed the foreground boulders were quite large hills, and couldn't see them, until I realized they were small and on the edge of the car park right in front of me. ■

Atmosphere & shadow edges

Truly clear air at sunset is not at all common, but makes a strong difference to the shadow edge, as the sunlight is passing through more of the lower atmosphere than earlier in the day. Even a slight haze blurs the edges.

Proximity & shadow edges

The sharpness of the shadow edge also depends on how near or far is whatever is casting the shadow. The two photographs illustrate the contrast, which comes from a mixture of atmosphere and proximity.

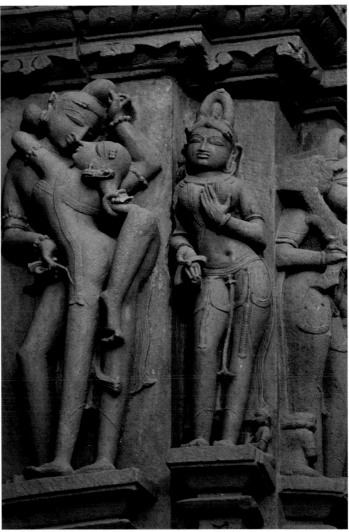

Mithuna & apsaras, Kandariya Mahadeva temple, Khajuraho, India, 2000

MAGIC HOUR Burmese Days

Sagaing, Myanmar, 1995

Pagodas among rice fields, Sinbyugyun, Myanmar, 1997

A DIFFERENT COLOR GRADIENT

As the sun dips below the horizon, and until darkness, the sky color changes in subtle and different ways (lower half of cylinder) from the Golden Hour (upper half of cylinder).

MAGIC HOUR SKIES

Four of many gradations of sky color after sunset. Pinks and mauves are common.

Magic Hour is a term from the movie industry, and it refers specifically to the short period after sunset and before nightfall. It's a fascinating time of day for light and color, both of which seem fugitive, shifting and sliding at a rate that is fast enough to affect shooting (over several minutes), yet too slow to perceive if you just watch. It's also notoriously difficult to work with, not only because the light levels are low, but also because it's missing the normal clues about time of day that we get from }the sun—even behind a cloud, we're generally aware of the sun's presence and its progress from morning through afternoon. Nevertheless, for all the difficulties, the reward is a special and delicate light, suffused with some elegant and calm colors, as the main picture here shows.

The movies also provide one of the most famous examples of a work shot mainly in the Magic Hour—Terrence Malick's *Days of Heaven*, made in 1978. The cost of crew, actors and equipment normally compel directors to shoot throughout the day, so to limit it to less than an hour each day was an unusual decision. Malick had worked out the look for the film with his first director of photography, Nestor Almendros, who said of the Magic Hour, "It is the moment when the sun sets, and after the sun sets and before it is night. The sky has light, but there is no actual sun. The light is very soft, and there is something magic about it." But he added that the name is "a euphemism, because it's not an hour but

around 25 minutes at the most. It limited us to around twenty minutes a day, but it did pay on the screen."

These old pagodas scattered across rice fields look as if they should belong to some significant site. However, as I've come almost to expect from Myanmar over the years, its time-warp status (until very recently) has meant that across the country there are gentle surprises like this, and you need only to explore. The light and colors matched the idea, and I waited until a flock of birds appeared over the spires. This is Sinbyugyun, a small town a few hours by boat downriver from Bagan. The scene may be peaceful, but the shooting was not. A Burmese friend in Bagan had suggested and organized the trip, with his own boatman, but a little too optimistically. We were looked on with a kind of horror as we disembarked the previous afternoon and walked up the dusty main street, were promptly detained by the police and the crew of two invited to the jail. We didn't have permits for this jaunt. We were put under a kind of house arrest in the community center, with an M.I. man (Military Intelligence) as a very sticky chaperone. I managed to sneak out before dawn for this walk in the fields, but it wasn't long before the M.I. man (probably a local deputed to the task) came running after me. I kept exclaiming how beautiful it all was, which perplexed him. ■

MAGIC HOUR Magic Colors

The reason why this special time of the day has its name is, as Nestor Almendros put it, "It gave some kind of magic look, a beauty and romanticism." "Magical" because it is mysterious and very unpredictable. The combinations can be unusual, as these two pictures illustrate. In each case, on quite different assignments, I was there to shoot what I came for, rather than simply reacting to the light and looking for something to shoot. I already had my subjects. Nevertheless, the colors were an unexpected bonus. The *maiko* (apprentice *geisha*, distinguishable by, among other things, her platform *geta* shoes) was in Kyoto, in the traditional entertainment district of Gion. Neither they nor

Color scheme

Here and elsewhere in the book, the colors are abstracted from the image, with the larger cylinder underneath representing the background. What makes this shot work is that all the hues ranged around violet are in the subject—the *maiko*—while the setting by contrast is more or less neutral.

Maiko, Gion, Kyoto, 1999

Color scheme

There is a delicate contrast of color between the lower and upper parts of the scene, punctuated by the color accents of the Irulas' clothes.

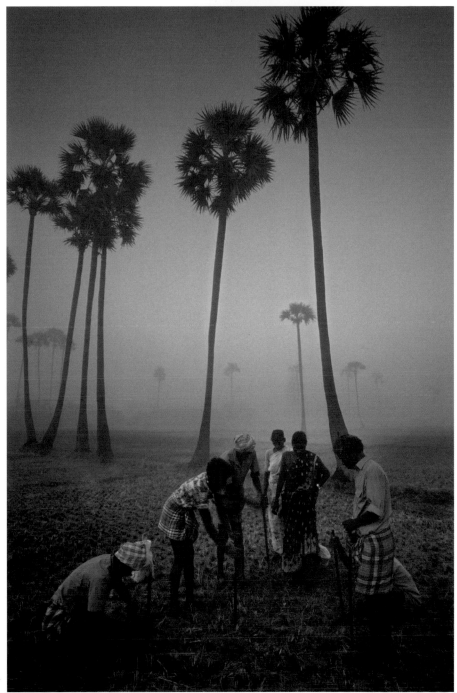

geishas are easy to find and photograph these days in a normal, candid way, as their numbers have declined, and the little trips between engagements at exclusive tea-houses, or *o-chaya*, are short and hurried, along quiet lanes. What makes the shot something of a favorite for me is the color, which has a bluish-purple-violet range, but isn't across the entire image—it's the *maiko* alone. I was facing west, and the sky in front of the camera was warm, while behind and above me it was blue-to-violet. The result was that most of the background, though dark, is fairly neutral. By contrast, the *maiko* is mainly lit by reflection from the bluish part of the sky, its color exactly visible in the traditionally thick white makeup on her face. That she happened to be wearing a purplish-violet combination was good fortune. These are subtle small points, but they add up.

A slightly foggy pre-dawn in the state of Tamil Nadu in southern India was the setting for, of all things, a rat hunt. Field rats are responsible for looting an estimated quarter of India's rice crop, and this Irula tribal group makes a living out of catching them. The work of finding nests and tunnels starts before dawn, and the slight morning mist had an almost watercolor effect of washing ground and sky colors together. As we'll see on the following pages, there are good reasons why the colors from opposite sides of the sky blend so well, and here, with the yet-to-rise sun behind the camera, the light falling on the group and the brown rice stubble is warm, while the sky beyond is slightly cool, though filtered by the mist into a chromatic gray. The wide-angle lens, a 20mm, takes in a wide range of the scene, and so also a wide spectrum of its slightly strange colors. ■

Irula rat-catchers, Tamil Nadu, India, 1992

MAGIC HOUR Subtle Oppositions

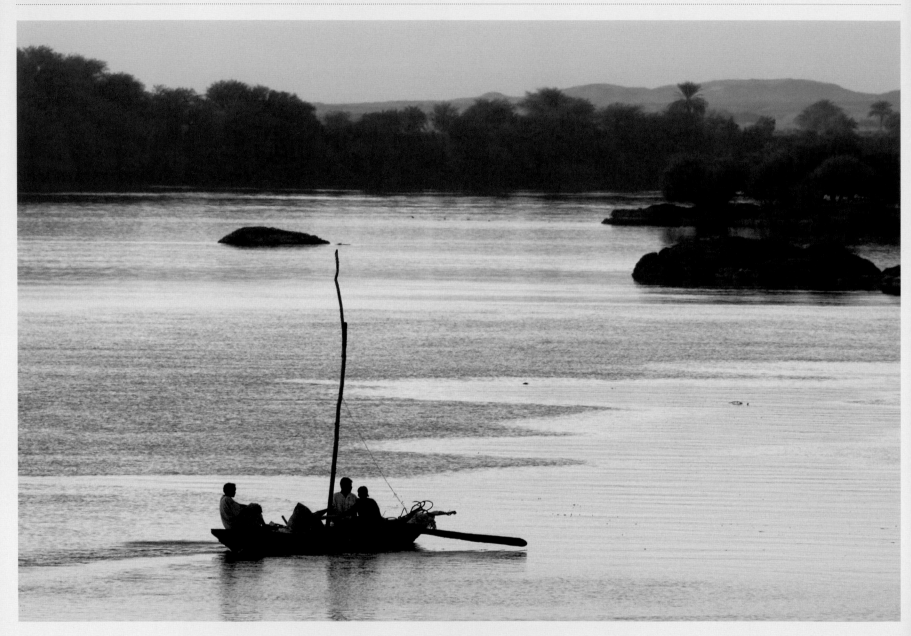

Sabaluqa, Sudan, 2004

One of the reasons why colors start to become interesting when the sun is close to the horizon is not particularly that the sunlight is yellow to red, but that the sky becomes double-hued. As we saw in Golden Hour (pages 94–102), toward sunset the light starts to fall across the land from the west, and this leaves the eastern sky blue. At the extreme, in clear air as in the photograph of The Mittens on page 100, the image fills with two opposed colors, on roughly opposite sides of the color circle. This is all to do with the scattering of wavelengths by the atmosphere—blue is a short wavelength and gets scattered first, leaving behind an orange sunlight.

An orientalist evening

Divided almost in half by color, the stiller waters of the Nile reflect the yellowish hue of the western sky, while the surface, ruffled by a light breeze, reflects the bluer tint from the sky behind the camera.

But with the sun above the horizon, there is a huge difference in the brightness of these two differently colored sides of the sky. The sunlight naturally overwhelms the shadows. This is where the Magic Hour has something different to offer. As soon as the sun sets, the intensity of light from the west and from the east are much more closely balanced. The exact colors, as we've been seeing, are difficult to predict and can certainly vary, but the western sky in the evening is always in the warmer third or half of the color circle, and the eastern sky the opposite. The contrast between the two, if you capture both in the same image, is more striking than at any other time of day, while at the same time being subtler because of the overall subdued light.

One way of making full use of this opposition is having surfaces in the frame that properly reflect the sky behind the camera. Highly reflective surfaces like water, glass, and chrome do it perfectly, but anything pale and neutral, from white to light gray, also does the job. Here, on the Nile below Khartoum, the calm waters downriver from the Sixth Cataract do a wonderful job of reflecting two sides of the sky. What I liked particularly about this scene was the very Orientalist color palette. Orientalism was a form of nineteenth century Academic painting that explored what was then the exotic Middle East for European painters. As the Tate Gallery in London explains, "Many British artists, especially those under the influence of Pre-Raphaelitism, looked carefully at the cultured shadows of dawn and dusk. These effects were most striking of all in the desert, which often appears not as dangerous, but as a beautiful wilderness containing places resonant with the ebb and flow of civilizations." ■

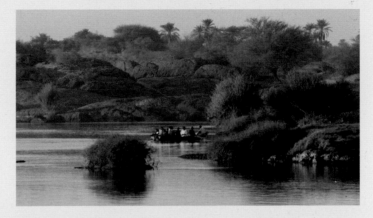

15 minutes earlier

Just before sunset, the colors are more predictable, with the setting sun overwhelming, and blue shadows.

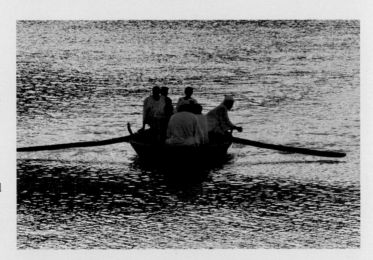

10 minutes earlier

A fraction after sunset, and there is some hint of blue in the shadowed clothes of the men, but not yet in the darker reflections of the sky.

OPPOSED COLORS

From top to bottom, the opposing sky colors at different times and in different conditions: a clear rich sunset, about 20 minutes into a typical Magic Hour, and the Nile scene shown here, at the beginning of Magic Hour.

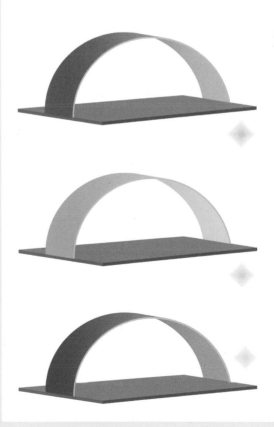

MAGIC HOUR First & Last Light Silhouettes

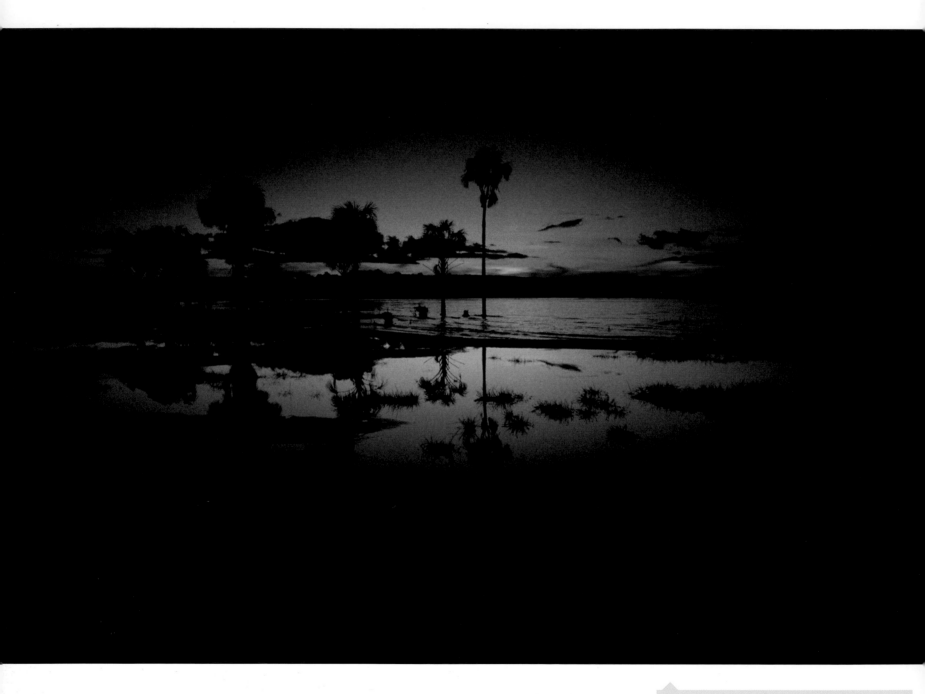

Dawn, Rio Carrao, Canaima, Venezuela, 1978

Key Points
Surprise Colors
Subject Outline
Short Timing

You can sub-divide Magic Hour as you please. It is, after all, just a transition in brightness, color, and mood, and calling it one distinct period of time is just something that photographers do for convenience. Different parts of the Magic Hour are useful in different ways, and one of my favorites is the just-visible silhouette of first light, well before the sun rises, and its counterpart at the end of the day, last light. To get technical about it, the entire Magic Hour is twilight, which simply means light coming from the atmosphere without direct sun. The period when just outlines are visible when you look toward where the sun was or will be is called nautical twilight (simply because you can take star readings against the horizon). Technically again, this is when the sun is between 12° and 6° below the horizon, though for shooting we don't need to be that precise.

For photography, the value of this very narrow slice of time is that if the sky is right and the outlines interesting enough, it can deliver simple and powerful scenes. We are back in the land of silhouettes (see pages 70–71), where a viewpoint that keeps things simple and recognizable is important. But beyond that, the shading or ramping of the sky, and the subtlety of its color, are what count in this kind of image. By comparison, silhouettes around sunrise and sunset are gaudy and a bit predictable, with none of the gentler color surprises that happened in both of these pictures. As for planning and preparing for this kind of shot, this is much easier—and perhaps possible only—at the end of the day rather than the beginning. There may be as little as 15 minutes for this subtlety of light, and setting up, framing and composing in pre-dawn darkness is difficult.

Nevertheless, the image at left, taken in the shallows of the Carrao River in Canaima, was an early-light shot. The reflections from still, shallow water on the margins of the river made it more predictable, and easier to organize the foreground, because it would obviously be partly a mirror of the sky. What makes it more interesting, from my point of view, is that there is only a hint of orange and the rest is a ramp from pale violet through dark blue to black. The Shwedagon picture has more color both in the sky—dominated by an irresistible purple—and in the foreground, lit up for the annual Festival of Lights. This was evening, but again, the presence of grays (in the clouds) gives it a more interesting color palette than a normally glowing sunset. ■

Shwedagon illuminated for full moon festival, Yangon, Myanmar, 1982

Two separate layers
Silhouetted shots of all kinds, including those on pages 70–71, graphically separate the image into the silhouette layer and the colored background layer.

BLUE EVENINGS Remains of the Day

Are late evenings really blue? It's not an easy question to answer, because color exists in the eye and mind as well as in wavelength. And the eye adapts. If you stand and wait through the sunset until darkness falls, your eye simply accepts the light as "normal," not colored. Nevertheless, this is special and highly desirable lighting, particularly on professional assignments that demand richly attractive exterior scenes that include additional lighting. This is a typical example, familiar to all photographers who shoot resorts and luxury hotels and who need to ramp up the desirability of the location.

This is toward the end of Magic Hour (or near the beginning if in the very early morning), and it's a very specific time. After the pastel and sometimes-melancholy hues after the sun has set, this is the downslope of light as it descends into night. It lasts a very short time in middle and low latitudes, and because the eye is constantly adapting to the change in color and slow extinction of light, this Blue Evening phase can seem to rush onto the scene and quickly disappear. As we'll see in the example on the following pages, for safety I allow it just 10 minutes.

This was a shoot that I happened to record as it went along: a model in a classic yoga posture at the edge of a pool and with tea mountains in the distance behind. This being yoga, a certain calmness and tranquility was called for, and while the late afternoon backlighting was soft and quiet enough, I felt it was worth waiting for the Blue Evening light—another 3 hours away. That meant taking the slot that had been planned for another shot, but it looked as if it would be worth it. Small candles were a natural prop, and to give the client a choice, we put in a high-wattage tungsten light from the side. The purpose was to create a complementary color contrast that, as we'll see in the following pages, is naturally attractive—small bright orange

Yoga, Brilliant resort, Jingmaishan, Yunnan, China, 2012

The onset of blue

Between the top and bottom images are 48 minutes, during which time the ambient light moves from almost neutral to a distinct blue.

lights counterpointing a large deep blue setting. In the end, I still can't quite decide which version I prefer—lit or unlit—but if I were forced to choose, I suppose I would go for the unlit version on the grounds that it is calmer and more in keeping with the idea of yoga. ■

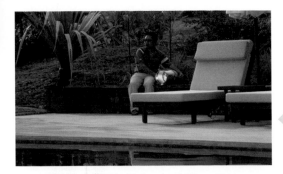

Key Points
Tranquil Blue
Color Contrast
Keep Dark

Spotlight

A theatrical tungsten spot was aimed from one side at about 20 meters for one version.

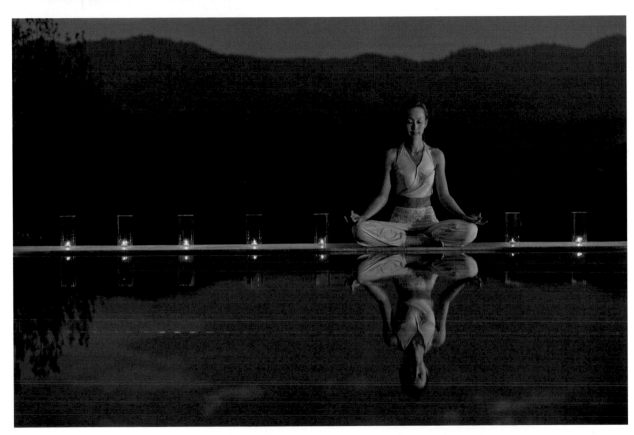

Lit & unlit versions

Shot one minute apart, the color and tonality of the two versions is different, because the exposure needed to be reduced for the tungsten light on the model. As a result, the blue evening light appears deeper in the lit version.

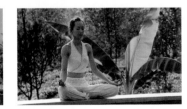

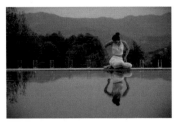

Preparing & waiting

Over a three-hour span, what began as a late afternoon backlit shot became the altogether more meditative blue final image.

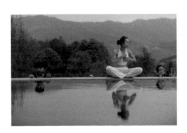

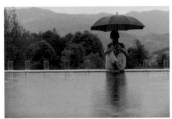

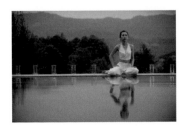

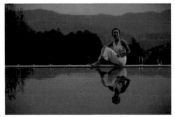

111

BLUE EVENINGS The 10-minute Window

Lakeside resort, Yangzonghai, Yunnan, China, 2012

Provided that the weather is clear and the sun kind, there are a few predictable moments during the day that have a high attractiveness index, guaranteed to help make anywhere look good. This is one of the most special, but also one of the shortest, when the skylight is a rich blue and the tungsten lights a pleasant yellow-orange—and when both are nicely balanced for brightness. As often is the case, the architect and designers here at the Brilliant Resort in Yangzonghai, China, have arranged the lighting for just this effect, in particular the concealed lights under the seating in the sunken islands, and the underwater floods. This late evening combination of light has the extra advantage, fortunately not needed here, of reducing unwanted things that would be glaringly obvious in daylight. And of course, it's a classically attractive combination of complementary colors: large blue-violet against small yellow-orange.

Watch carefully, as the magician says, because this happens faster than you might expect. In the sequence here, the first shot of the evening was taken at 7:50pm,

Daytime test

A morning snapshot as part of preparing lights and models for the evening shoot.

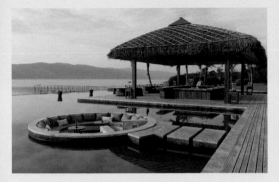

7:50pm

Half an hour after sunset. Floodlights in the middle distance just beginning to show.

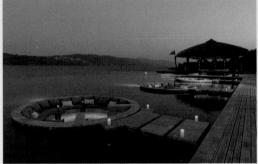

exactly 20 minutes after sunset and what seemed like a long time to go before the magic blue light set in. This was a kind of ranging shot, just to see how things were going, and the real shooting didn't begin until three minutes later. The last shot, when the balance of color and light was perfect and just before the evening sank into blackness, was at taken at 8:02pm. It took two hours to set up props, models and lighting, but only ten minutes to shoot, between the time when the blue became strong and the fading to near black. The extra floodlighting was laid on for insurance, because in ten minutes there's no time to change anything that hasn't already been installed, but this was hardly used. ∎

7:54pm

The sky just beginning to turn blue, but more of a weak cyan at this point. The floodlighting already becoming too strong.

8:00pm

Sky now a rich blue. Middle distance floodlighting reduced to suit, but it's already several minutes too late for foreground lighting.

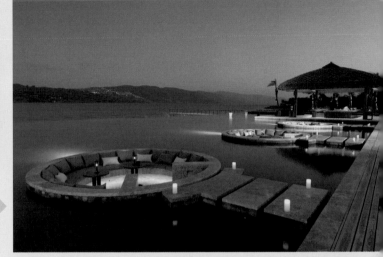

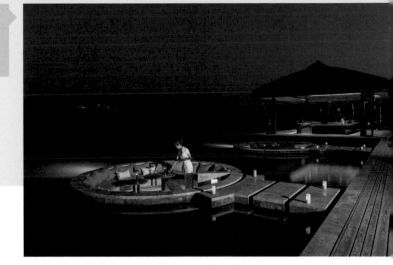

THE SHIFTING BALANCE OF COLOR AND LIGHT

This sequence shows how the relationship between the sky and artificial tungsten lights appears to change at the end of the day. The larger cube is the sky, the smaller is tungsten light. In daytime, the light is hardly visible, very weak against the surroundings, with little color showing. This persists through sunset, when the color temperatures briefly match. As the sky deepens after sunset, so the tungsten light becomes not only more prominent, but it also seems richer in color. This is at its most intense in the brief window of deep blue, before night sets in, removing color from the sky; at this point the tungsten light dominates, but also appears less colorful to our eyes.

Daytime **Late afternoon** **Sunset** **Magic hour** **Blue evening** **Night**

BLUE EVENINGS An Architectural Choice

The shoot detailed on the previous pages hinged on the relationship between the descending blue from the sky and the rising small orange tungsten lights. This is what makes blue evenings so reliable for architectural photography, because as long as the day is clear enough to deliver a rich blue to the sky and you have control over the lighting, this will happen.

In fact, even if the day is overcast, much of the same effect will come through, which often makes it a fail-safe time for a planned architectural shoot when the weather is not behaving itself.

It's worth mentioning that the color relationship between large blue and small orange is a happy coincidence, because the human vision system is

I.M. Pei's Suzhou Museum, Suzhou, 2007

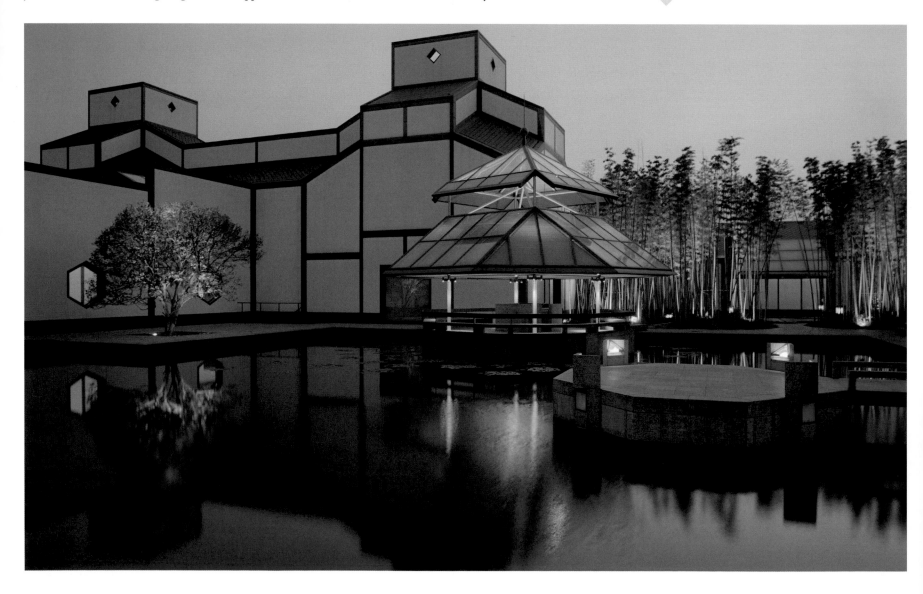

conditioned to "see" complementary colors as naturally satisfying. To be strictly accurate, across the color circle the matching hues are blue tending toward violet together with a yellowish orange. It was the German philosopher, poet, and general polymath J. W. Goethe who in 1810 came up with this theory, and more than this, suggested that opposing colors complement each other best when their brightness is taken into account. Violet, for example, is the darkest color, and yellow the lightest, so they combine in a natural way to the eye when the yellow takes up much less space than the violet. Incidentally, there is no light violet, just as there is no dark yellow. We call them by different names instead—such as mauve and ochre. Buildings in blue evening light showcase all of this perfectly.

In this case, I was shooting one of architect I.M. Pei's last projects, the new Suzhou Museum (left), both for my own book and for the architect's, so I had instructions to follow. The design referenced a traditional Suzhou style of white geometric shapes edged with gray, and with these strong graphic qualities, the building photographed well in sunlight also. However, on an assignment like this, there is a need for a few to several overall shots, not just a single best one, so extending the shoot throughout the day was inevitable. All the shots work, which you prefer is really a matter of personal preference. ■

Tent, Aman-i-Khas, Ranthambore, Rajasthan, 2004

In morning light

Perfectly acceptable, a morning shot in sunlight appears more restrained than the richer colors of evening.

The meeting point

The critical color moment is when the darkening sky reaches a deep blue that contrasts to the maximum with the yellowish tungsten lamps.

CITY LIGHT Street Lights

From a technical point of view, the kind of lighting used in streets is about as unsatisfactory as it could be for shooting. Lamps in shot, pools of light, a strangled color spectrum, none of it is good for color balance or for any kind of portraiture. On the other hand, as a color display in its own right, street lighting as a lot to offer. The colors are: long-spectrum orange from old-fashioned tungsten (increasingly rare in street lighting); uncorrectable narrow-spectrum yellow-orange from sodium; blue-green (usually) from fluorescent; blue-to-white from mercury vapor; and a similarly blue-tinted light from metal halide. Now that digital images can be given whatever color balance you choose, and this chosen after the event when you process a Raw file, these colors need to be qualified. The camera assumes a basic 5000k to 5500k setting, but if the street scene contains at least a couple of these different sources, as in the Sharjah picture, this basically neutral setting shows these color differences. And working on the color balance of each of these kinds of lamp has varied success. Tungsten light, because it is incandescent and comes from burning, has a continuous spectrum over its range, and so processes well in the sense that it has a "rounded" appearance. At the other end of the scale, sodium lighting is sharp-cut and narrow, and simply does not embrace any other wavelengths beyond a narrow spike at just over 589nm. It is essentially monochromatic; there are no other colors to pull in.

In both of these images, it was the play of street-light colors that motivated the shot. Villa de Leyva is an historic small town in Colombia—widely regarded as one of the finest colonial settlements in the country, and its architecture has been protected since the 1950s. The large old cobbled plaza is, thankfully, neither floodlit nor full of traffic, and just the line of cold, greenish fluorescent lamps along the far wall set up a color counterpoint for the slight warmth of sunset leaking very slightly through the mountain clouds. In Sharjah, it is the distinct color contrast between three different lights that makes the shot: a tungsten streetlamp, a cold vapor streetlamp just out of frame, and the blue evening sky beyond. ■

Plaza, Villa de Leyva, Boyacá, Colombia, 1979

Color schema

An abstracted representation of the color and light relationships.

**Sharjah Heritage Area,
Emirates, 2012**

Color schema

The same kind of abstract for this
image. The fluorescent light at left
is off camera.

CITY LIGHT Shanghai Bund

The Bund (Waitan), Shanghai, 2011

Cities at night are getting brighter, particularly downtown areas of big cities. More energy is being devoted to lighting up public and commercial buildings, while display advertising is extending to huge areas covering the sides of buildings. Maybe a couple of decades ago, lighting simply added some sparkle to a long view of a city. Now, in cities like Shanghai, the view is transformed between day and night, and it's deliberate. There are several ways of dealing with it, and this is just my take on big city light.

The unspoken first step is to find the right viewpoint, which in this case was researched beforehand—the roof terrace of a building just beyond the southern end of the Bund, offering a view of the full curve and, importantly, high enough to take in

Getting closer

Five minutes before final shooting.

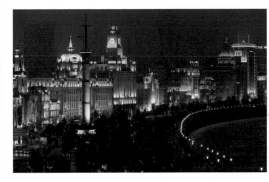

Earlier light

Just 15 minutes earlier, hazy and humid with no blue yet apparent.

Default

The default (unprocessed) appearance of a single exposure.

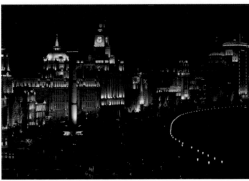

Auto

The same single image with Auto settings applied in Photoshop's ACR.

Key Points

Viewpoint
Planning
HDR

Shooting

Some minutes before the actual shot, preparing the camera on the roof terrace.

Basic construction

In depth, the scene breaks down into three distances: the nearer column, the curve of waterfront buildings, and the high-rise blocks of the city behind.

ground level and the Huangpu River. It always helps to have a plan, and mine in this case was to go for good visibility throughout the scene. That suggested two light-related techniques. One was to time the shot for Blue Evenings (see pages 110–115), which gives both a slight shadow fill and a pleasant color contrast with the streetlights and floodlighting. The other was to bracket a sequence of exposures and blend them using one of the methods detailed in the last section, pages 242–247.

All of this called for—calls for in general—plenty of planning and preparation, beginning with being on site early, before or around sunset. The weather was poor, in the sense that it was cloudy and with a muggy haze, not perfect for a long-distance view,

but this is where nighttime shooting can save the picture. The lights raise the contrast, and this continues to rise as the ambient light level goes down. You can choose the exact amount of contrast that makes it into the final image with the timing of the shot, and also by how you combine the sequence of exposures. Here, there were just three, beginning with the darkest at ƒ/8 and 1/4 second, at which setting there is no clipping of lights, so that their color is captured. Then 1.5 stops brighter for the second, and another 1.5 stops brighter for the third. ■

CITY LIGHTS Display Lights

Big city centers like London, New York, and Tokyo, have an extra bonus for nighttime photography—display advertising. In the fight to get people's attention, displays are getting bigger and brighter, and it all makes for more shooting opportunities. The light levels in some concentrated areas, especially in Asian cities, are intense. Size matters in the search for spectacular imagery, and both the Tokyo and Beijing examples here are giants, though it's unwise to say "biggest" because there is always something bigger being planned or even nearly finished. The principles for shooting are much the same as on the previous pages, with much to recommend Blue Evening Light as prime time for shooting, so that the sky stays alive and doesn't just disappear into blackness.

Sadly, neon display lighting may have had its day, although it's doing quite well as contemporary installation art in galleries. The sheer scale and motion possibilities of LCD displays is making it old-fashioned, and it's a pity because neon displays are very physical and light up their immediate surroundings in a kind of unintentional way, as the very well exposed version in the strip of three here shows. One curious thing about neon displays is that you can photograph them at a wide range of exposure settings—up to several f-stops—and they still look good. Or rather, they look different. At a short exposure, the setting disappears into darkness, and their color is very saturated, while at the opposite end of the exposure scale they appear to glow more, though paler in color, and their setting becomes more visible. The choice is yours. ■

Neon sign, Bangkok, 1982

Key Points
Light As Subject
Exposure
Timing

The Place, shopping mall in Central Business District, Beijing, 2007

Exposure & effect

Colored neon displays tolerate a wide variation in exposure. What changes is the effect, varying from a darker version that looks like an illustration rather than a light, to a bright and glowing treatment that lights up its surroundings.

Display screen, Shibuya Crossing, Tokyo, 2002

CANDLE LIGHT Spheres of Illumination

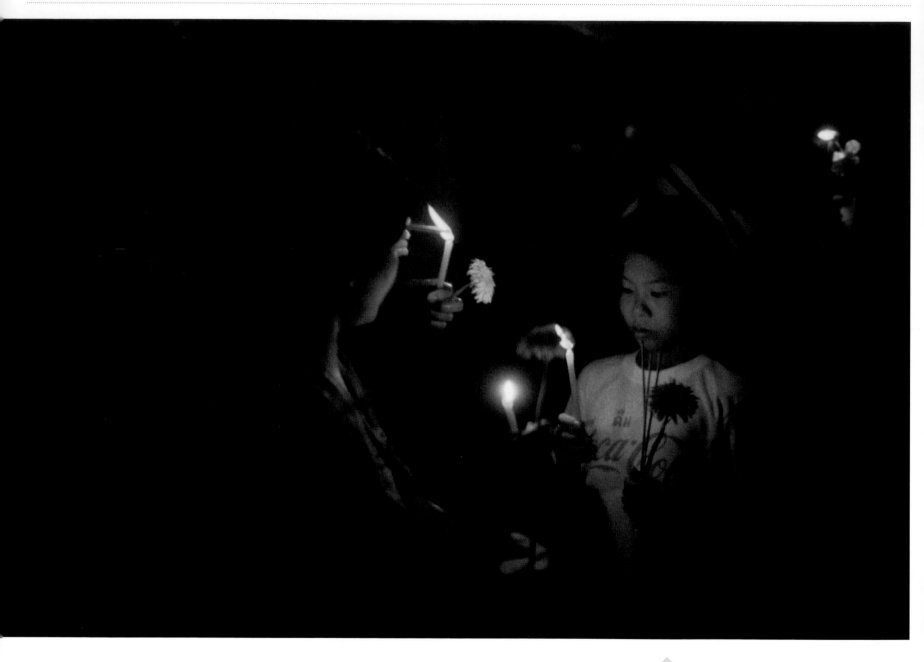

Visakha Puja, Wat Benjamabophit, Bangkok, 1983

Spheres of illumination

Candles are normally placed at a consistent distance from the people who are using them, and the key sphere of illumination is the one that covers the face. The smaller one, immediately around the flame, can overexpose quite happily. Tiny catchlights in eyes are also important.

Loi Krathong, the November full moon festival, Mekong River, Thailand, 2011

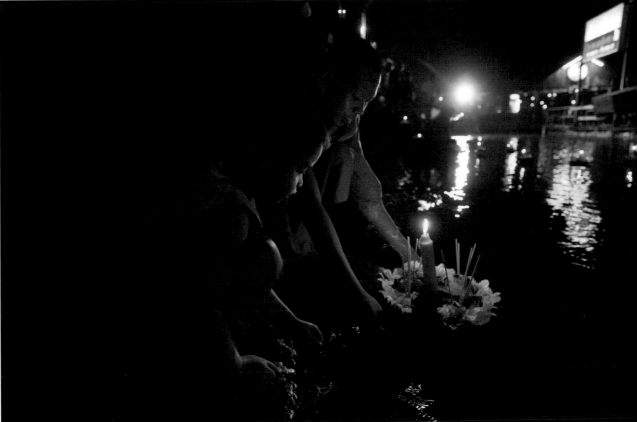

Candles are special, in that they not only give light, but they're the focus of attention in a candle-lit room. Not many light sources are both a pleasantly viewable subject as well as a method of illuminating the space. In the introduction, I mentioned the book *In Praise of Shadows* by the early twentieth-century Japanese writer Jun'ichirō Tanizaki, and it's time to return to it here. Among other things, in it he praised the effect of a flickering candle flame as its light passed over half-seen surfaces such as gilt lacquer. Candlelight takes us back in time and presents a warm, flickering, enclosed world. And it's possible to shoot entirely by candlelight, without flash or any other extra fill. The key thing to remember is that practically, we are dealing with a sphere of illumination. The light falls off rapidly away from the flame (the inverse square law), but in the way that candles are normally used, they are usually half a meter or less from people's faces. Within this, there is the immediate surrounding of the flame, a few centimeters, which lights up the top of the candleholder. With this in mind, you need simply expose always for the face, but include the flame in shot and let it expose out of range—as it's usual to shoot candlelight with a wide aperture, the flame will usually be out of focus, too.

There is a famous example that is well worth seeing. When Stanley Kubrick made *Barry Lyndon*

in 1975, he went to his usual meticulous lengths to research not just the period, the eighteenth century, but also its imagery. One of the effects he wanted to capture was the pre-electric experience of nighttime interiors (shades of Tanizaki!), something we rarely experience now. For key scenes, set in a castle at night (a card game and a conversation over dinner), he was determined to film entirely by the light of candles, to give the feeling of the period. Candles are *par excellence* for what are called "practical lights" in movie terminology, meaning a light source that is actually in view as well as illuminating the scene. For this reason, using film was difficult without the help of the high-ISO sensitivities we now take for granted with modern digital sensors. To solve the problem, Kubrick bought and had modified a Zeiss 50mm Planar lens with the exceptional aperture of

ƒ/0.7. More usually in filmmaking, the practical light is subtly enhanced by an out-of-scene light that enhances the practical's illumination, but Kubrick chose to stay pure and film with the candles alone.

And so can we. The faster the lens, the more beautiful the effect, because only the face—sometimes only an eye—needs to be sharply focused. The range of brightness between face and flame is considerable, but always go for the face. The flame will tolerate more overexposure than you might think, not least because it is always small relative to the scene. There are no guides for this kind of exposure, but fortunately testing and previewing on the camera's LCD screen is a perfectly workable method. ■

GLOWING LIGHT Things Burning

Candlelight brings us logically to other, larger things that burn intensely, like fires in general and materials heated to the point of melting. Here we have one example of each, and the lighting effect is different from that of candles, or for that matter, the sun and other intentional light sources. This kind of glowing light actually has dimension. We're no longer dealing with a point source of light, but something that is pretty much the subject itself. Any photograph that includes the light source is automatically going to be outside the range of a sensor. As we'll see in the third section, Helping, on pages 242–243 Archived Light—*What HDR Really Means*, scenes including the light source are inevitably high dynamic range. With point sources of light, it hardly matters if they blow out, simply because they are so small, and expected by the viewer to be over-bright. Here, however, both the fire that's roasting the pig and the crucible full of melting gold are significant in size, and the focus of everyone's attention.

The core problem is highlight clipping, because any exposure dark enough to hold all three channels in the center of the fire will be too dark to show anything useful of the surroundings. Bracketing is normal and recommended in any situation like this, because you may well change your mind about which way to go when it comes to the processing. The two opposite directions are: allow the burning area to blow out brightly, or make a darker, more abstract version exposed for the rich color of the burning area. These two are shown here, with the cooking fire treated more expressively and strongly glowing, and the gold bars made into a more abstract image, a kind of inverted silhouette. When going for a brighter look, the clipping problem surfaces in the processing, because normal techniques, like exposure reduction and highlight recovery, simply show up the clipping edge. The solution, counterintuitively, is to use local control in two steps. The area of yellow immediately surrounding the clipped center of the fire is taken down a little in exposure, but the center itself has its exposure raised, to destroy any clipping edge. A slight addition of pale yellow to the center makes it more natural. ■

Roasting piglet, Maw La Akha village, Chiang Rai province, Thailand, 1980

Key Points
Highlight Clipping
Bracketing
Color Temperature

Smelting 20-kilo ingots, gold refinery, Chessington, England, 1983

COLOR TEMPERATURE

Strictly speaking, color temperature applies to light sources that burn. From a wooden building burning through an oxy-acetylene torch to sunlight, the hotter the burning, the higher (less orange) the color temperature.

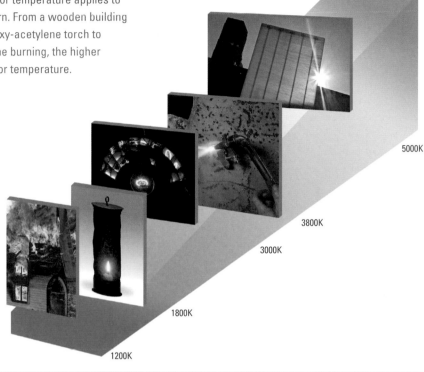

5000K

3800K

3000K

1800K

1200K

Default

This is a tight crop from a larger image, and locally overexposed. The center of the flame is clipped and featureless.

Exposure reduced

This worsens the problem by accentuating the sharp edge where clipping begins.

Recovering highlights & whites

Using the Highlighters and Whites sliders also enhances the clipping edge.

Local exposure control

This produces the best possible result, given that the centre is featureless. Conrast increased overall, but no exposure change. Then locally, the area of yellow immediately surrounding the white center is reduced in exposure to strengthen it. Next, the white center, including its edge, is given a slight exposure increase, and a slight yellow tint.

CHASING

2

Yes, chasing light is a real expression used by photographers. Magnum photographer Trent Parke, for example, defines his work this way ("I am forever chasing light"), and it means the search for special lighting conditions falling on a subject that deserves it and responds to it. Or, as Parke continues, "Light turns the ordinary into the magical." This is the flip side of waiting for the type of lighting that you can fairly confidently plan for, and it carries with it a different attitude and a different way of working.

The lighting conditions that we explore in this second section of the book are on the whole more short-lived and liable to appear at short notice. They include, for example, storm light, the light through ground fog, edge light and light shafts. The varieties of storm light, for example, are elusive and momentary, because storms by definition are fast-changing and unpredictable events. And the thing about unpredictability and rarity is that it tends to carry a premium. We value the special simply because it is special and stands out from the normal run of things. When sunlight bursts through heavy storm clouds, perhaps illuminating a sheet of falling rain, even the least light-sensitive person feels the sudden difference, the vision made all the more valuable because we know it is not going to last for long.

This is opportunistic, serendipitous light that's basically unpredictable. Practically, shooting these more fugitive moments of light calls for a more reactive response from the planned efforts that we saw under Waiting in the previous pages. The first light in this section provides an interesting, and perhaps surprising, explanation—the first moments of the Golden Hour as the rising sun just clears the horizon. If it surprises, it is because a low sun is a low sun is a low sun, and from the evidence of just a photograph, there is usually no way of telling whether it was taken early in the day or late—unless you are familiar with the location. Sunrise looks like sunset, but on the ground it is totally different. You can plan for the sun setting because you can watch its path, but unless you've made a reconnaissance the day before, it's very difficult to make the same kind of planning in pre-dawn darkness, when you can't even be sure, without technical assistance, exactly where the sun will rise. Hence, shooting first light and last light calls for different working methods, and that's something I want to concentrate on. There is certainly the need to think faster and move faster when you are chasing light.

There is a borderland between Waiting and Chasing that's a little porous, an occasionally gray area where the two different approaches merge. One practical reason is that if you live where you are shooting, then not only do you have more familiarity with the way light works throughout the day and the seasons, but you can indeed wait for an uncommon lighting condition. It's just that you'll have to wait longer or with less predictability. Things are very different, though, if you are traveling or just passing through on a schedule that discourages changes. And more than that, light that may seem special in one part of the world can be more common in another. So, a few of the lighting types mentioned here could possibly have been treated in the first section, Waiting. But if you find yourself thinking that any of these types of lighting is easy, a useful antidote is to go out and try to find them. This is almost universally light that you train and prepare for rather than order off the menu.

GOLDEN HOUR First Moments

The real difference between the day's first glimpse of sunshine and its last is that, unless you've been up watching from the same spot day after day, there's a mystery about where it will strike. By complete contrast, the last rays of the sun move across the land in a very predictable way. To me, this sums up nicely the relationship between two events that are indistinguishable to anyone looking at an image, but are totally different experiences to the person doing the shooting. And they need very different working methods to capture them, hence the way I've split them here—one in the previous section, because you wait and plan for the falling sun, the other here, leading this section on chasing light. Capturing the first strike of sunlight in the day in a place you're visiting for the first time is a very challenging proposition, and you need the reactions of a street photographer.

I'm writing this on a Caribbean island called Baru, at sunrise, and on one side I have the sea with choppy waves on a windy day and a line of clouds moving fast and picking up a reddish glow. On the other side exactly, because we're near the equator, the sun has just risen behind the trees called locally *mata ratón*. I haven't seen it yet, and I can only guess that it will first pick out some of the leaves somewhere. In just under twelve hours the scene will be completely different, with the sun setting out to sea. But a photograph, if there were one (though there isn't from right here), would give no clue.

Black-necked Storks, Bharatpur, India, 1976

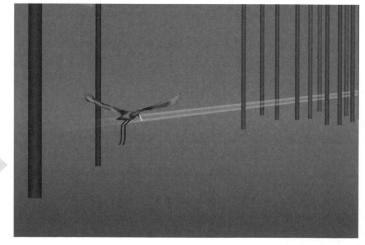

Just a glimpse of sunlight

Although the shaft itself is invisible in the photograph, the way it lights up just the beak of the bird as it takes off makes all the difference, because just from this small clue, the eye understands that the sun is just breaking through.

Cerro Venado mesa with cloud, Canaima, Venezuela, 1978

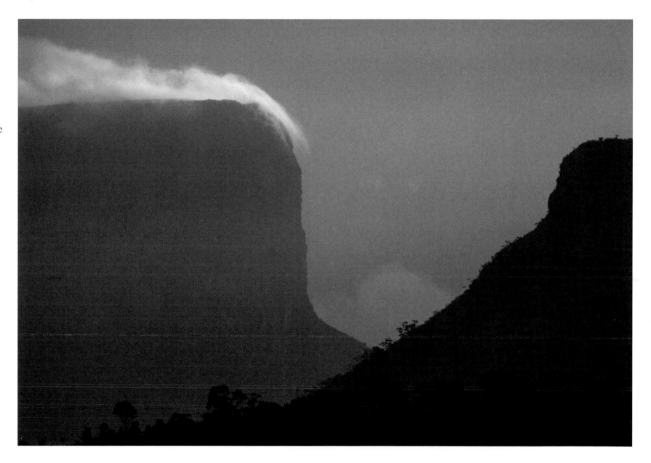

The situation in Bharatpur, Rajasthan (left) was different. I was walking in silence through the Keoladeo Ghana bird sanctuary knowing that very soon the first light would appear. On what I had no idea. But then I had no idea what birds I would come across, although with the lens I had on, a 180mm, they would have to be large in order to make an appearance in the frame. I knew the sort of shot I wanted: a forest view with a bird or two putting in a guest appearance, rather than a close-up. Then I saw this pair of black-necked storks. I knew that as I walked toward them they would take off, and a view up the tail feathers is rarely ideal, but I might be lucky. And I was, because of two simple things. The first shaft of sunlight came through, and I managed to catch the bird with its wings up, revealing beak, eye and head—and sunlit.

In the Guiana Highlands of Venezuela, I had in front of me the huge flat-topped mesas, and a long lens (400mm), but again little idea of how the sun would strike the landscape. The long lens meant I had quite a wide choice of framing details. A standing cloud was rolling up over the cliff edge, which added something. And then the light struck, for a few minutes only on that cloud. ■

Light transforms

A second case of first light adding a special, and brief, touch to an otherwise gray scene. The cliff-edge cloud itself is a little unusual, and it being the exact feature that the first sunlight struck was a special bonus. The sunlight lasted for only a few minutes before the heavy cloud cover cut it off.

EDGE LIGHT Elusive & Special

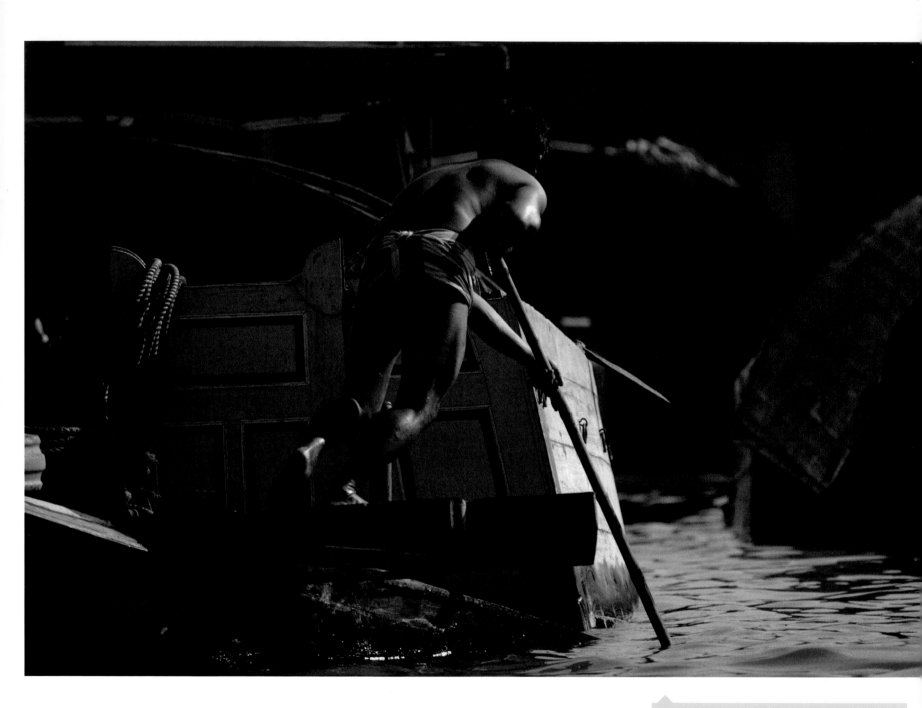

Boatman poling barge through *klong*, Bangkok, 1981

Basic conditions

In principle, this is what creates edge lighting: bright sun from behind, but out of frame, with all but the subject shaded.

Two basic treatments

The two alternatives are to expose for texture and detail in the edge-lit area (left), or to let it go bright and white (right).

Hard to find, hard to handle, edge light or rim light is a test of photographic skill, both visual and technical. As the picture shows, it's very familiar, but what makes it rare is that it needs a combination of circumstances. First, the setting needs a dark background, then the light has to be filtered somehow into a beam or wedge, which means that it's blocked at the edges somewhere above or behind, and finally, it needs a single subject, normally passing through. This is such an unpredictable kind of lighting, because the rest of the surroundings also determine how much shadow fill there is. And also because the edge can be thin or thick, and that alone will make you think whether to treat it as a totally white halo, or darken the exposure to reveal its details. There's actually a lot going on here, conceptually, visually, and technically. Do you want to see the foreground shadow detail or rely purely graphically on the brightly lit outline? Do you want both, with everything visible (digitally possible with careful processing)? Do you know, instinctively, the exposure settings to get these?

As the images here show, edge light can be several things, and the exposure very much needs to match your idea of what part it plays in the image. With many variations, I would say that there are two different kinds of edge-lit photograph. In one, there is a highlight to the edge of a subject that is already perfectly readable, adding visual attraction—a sort of hero-lighting effect, as in the shot of the man poling a barge (left), where the sunlight accentuates the straining of his muscles. In the other (right), only the edge light registers, and all else is in deep shadow, so that for a fraction of a second the subject may not be completely obvious. The example here is a Burmese man with spectacles, in which the edge dominates the image and everything else has to be inferred from it.

These two different treatments of edge light can sometimes be chosen simply by the exposure, but it's more likely that the situation pushes you to one or

the other. The intensity of light is another factor: If the contrast between edge light and shadow is very high, that will tend to push you toward the second option, where the edge-lit parts are all that read and the rest is blackness. As for exposure, in normal situations shooting people, there is usually not much time to work things out carefully. Every situation is different, but the best rule-of-thumb I can give is to use matrix metering and reduce by 2 *f*-stops. ∎

Burmese man in café, Yangon, 1982

CHIAROSCURO The Play of Light & Shadow

Terme di Saturnia, Tuscany, 1991

Chiaroscuro (Italian for light-dark) is the art term that has carried over probably the most effectively from painting to photography. At the same time, it has come to mean something rather different from its original sense. It basically means using the contrast between light and shade to create a sense of three-dimensional modeling—something that now we take almost completely for granted, particularly in photography. It might even seem strange to give a name to something so obvious, but that's only because we are so thoroughly accustomed to seeing pictures of

scenes, in any form, which clearly have light falling on them. It was not always so, even though in art the use of light and shade goes back to ancient Greece. There are other techniques for showing things realistically that don't need shading, from Russian icons through Japanese woodblock prints to present-day cartoons and illustrations. As we saw under Axial Light in the first chapter, my painter friend Shao Fan from Beijing works deliberately in a "lightless" way.

Chiaroscuro really got going in the sixteenth century, and gradually became a major feature of

composition and entire sense of the image. The Italian painter Caravaggio made his name with chiaroscuro, and it was taken up by the Flemish. Rembrandt in particular used it powerfully. As this happened, the word came to be used not just for light and shade, which became taken for granted, but also for an exaggerated use of it. And so with photography, where modeling with light is hard to escape, although better

used by some photographers than others. This is where we are now, light and shade used strongly and to the point where they is a main part of the image, and even sometimes takes over.

The shot on the left was taken in a Tuscan hot spring called the *Terme di Saturnia*, well packed at weekends, when this was taken. The sun is quite high, and the surrounding trees create an effect similar to the tropical-harsh situation seen on pages 48–49, and also, in a way, the shaft of light illuminating the cavern pool on pages 143. Now, one way to use chiaroscuro is when a spotlight fires up the action and inescapably pulls the eye to the main subject. Another way, here, is let action play out in the shadows, though then you need to have the viewpoint and framing so that the eye travels there after it focuses on the brightest light. ■

Rembrandt's St Peter in Prison, 1631

A classically powerful chiaroscuro that both spotlights part of the subject while leaving part shadowed to blend with the dark background. The spill of light at lower right, pointedly focused by the keys, is important to the effect.

Chartres Cathedral crypt, 1983

Rembrandt's St Peter is in a prison, but in typically crypt-like surroundings like these—spotlit, but fundamentally dark.

Action in the shadows

A light shaft from upper right through the trees strikes the intense blue of the hot spring pool, but leaves the people partly in shadow. Nevertheless, the viewpoint makes the foreground couple prominent, partly silhouetted yet with shadow detail visible. More importantly, their action points in the same direction as the light.

133

CHIAROSCURO Dividing & Abstracting

Iban man in longhouse, Rajah River, Sarawak, 1990

As I mentioned on the previous pages, these days, for the word "chiaroscuro" to be worth using, the lighting effect has to be extreme, way beyond the normal use of light and shade to show relief and shape. Spotlights of one kind or another are probably the most responsible for extreme contrast, and there are a number of examples elsewhere in this book that would qualify. I've chosen this one, of an Iban farmer asleep in a longhouse deep in a Sarawak forest, because it illustrates quite well one of the qualities of chiaroscuro as the word is used today— how it tends to abstract the image. It does this by dividing the frame into distinct areas of brightness and deep shadow, almost like blocks, and these don't necessarily correspond with the sense of the subject. So, in this case, as the illustrations explain better than the photograph, the light from the high open window lights up the man's face, the conical straw hat he is holding, and the upper part of one leg, together with an area of the matting on the floor. It depended on the camera angle, but the result is that it takes a little while to recognize what the picture is about. That would be too unclear for some people, but I happen to like this initial uncertainty about the picture. The extreme chiaroscuro gives it a kind of built-in conceptual delay.

The photograph was shot on film, which meant that I had to decide that I wanted this high-contrast effect with blocked shadows as I shot it. I got exactly what I wanted: the brightest highlights slightly blown out and no detail in the shadows, and an abstract effect. If it had been shot on digital, there would have been a processing choice that would have varied from more detail visible in the highlights to opening up the shadows. In fact, you could have both. Would this have been a temptation, to make the image more immediately understandable? For me it wouldn't. Explaining everything does not necessarily make for a better photograph, and in this instance the picture would have been more about what was happening in the scene, and frankly I doubt there was enough of interest to sustain more detail. Better, I think, to make this an image about light and shade. ■

High single window

Shown here without the high contrast, the subject is a man sleeping after returning from work. The light is not direct, but bright and tropical, contrasting strongly with the otherwise dark interior, a communal longhouse in wood. The light catches just the upper parts.

Abstract blocks of light & shade

At first glance, the chiaroscuro divides the image so extremely that it becomes almost blocks of bright and dark, symbolized here. Because the lit areas do not follow the form of the subject, a man, they abstract the image.

SPOTLIGHT Focusing Attention

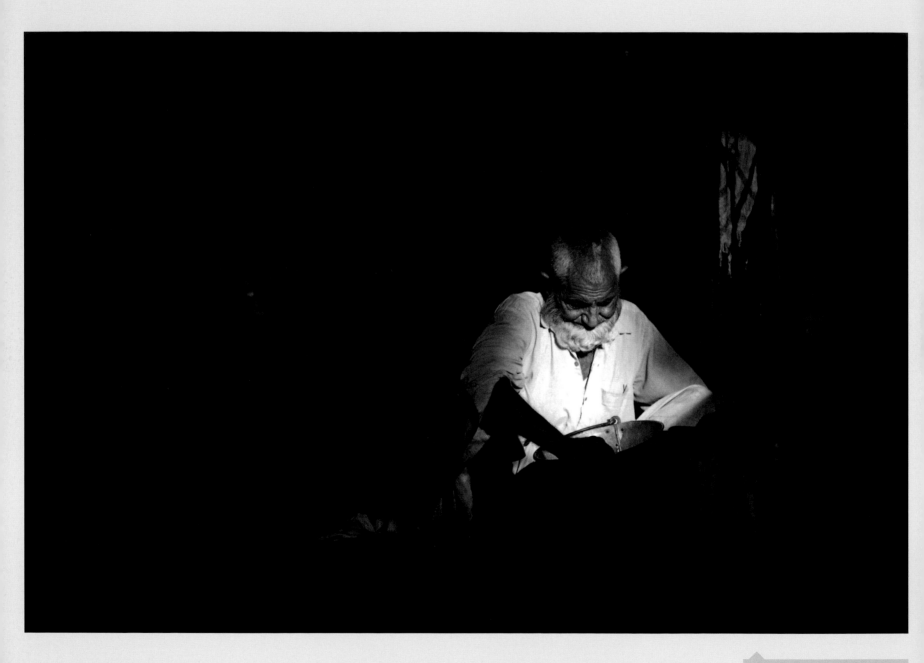

Peshawar Bazaar, Pakistan, 1980

Key Points

Points to Subject
Glow of Light
Chiaroscuro

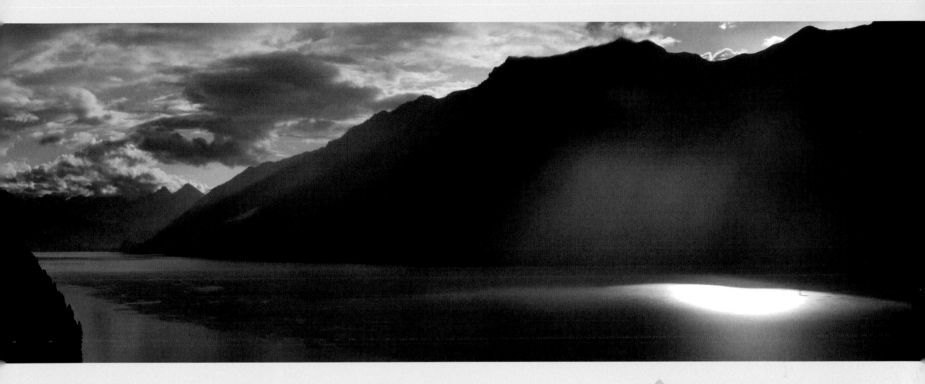

Brienzersee, Bernese Oberland, Switzerland, 2011

Spotlights do what they say on the label, whether they come from a lamp in a theatre or from the sky. They light up the subject and focus attention on it to the exclusion of pretty well everything else. This begs the question of exactly what is the subject, and as always, the photographer can decide, but a spotlight very much forces the issue. The eye is compelled to whatever the spot falls on, and if this happens to be a well-defined thing that just fits in the beam of light, then it's a done deal. This is the case with the stallholder in the famous old bazaar in Peshawar on Pakistan's Northwest Frontier, bathed exactly in a beam of sunlight controlled by a gap in the roof. A little earlier or later, with the spot falling on either side of the man, and there would have been no picture—or at least no conventional picture. It's perfect timing for the light, and you could even

claim that the timing is too perfect, so conventionally precise that it leaves no room for disagreement. Nevertheless, when unexpected spotlights fall like this, it's hard for a photographer to resist.

The intense spotlight falling on the Swiss lake of Brienzersee on a summer's evening, on the other hand, is not falling on anything notable, just the water. Yet it makes an attractive image, probably for two reasons. It has been exposed, and positioned in the frame, as being the subject itself—just the glowing patch of light. Treated like this, it works better glowing and overexposed, as this leaves everything else in-frame visible and readable. Off-centering it allows the light to balance the heavily shadowed mountains. ■

SPOTLIGHT Pinpointing the Action

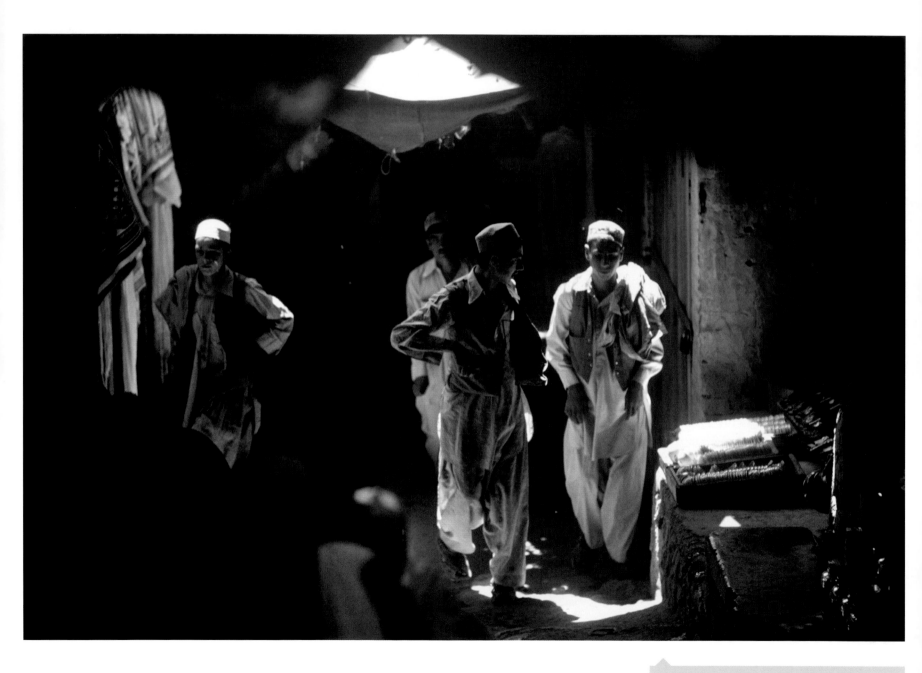

Arms and drugs bazaar at Landi Khotal, Khyber Pass, Pakistan, 1980

Tibetan woman sorting potatoes, Daofu, Sichuan, China, 2009

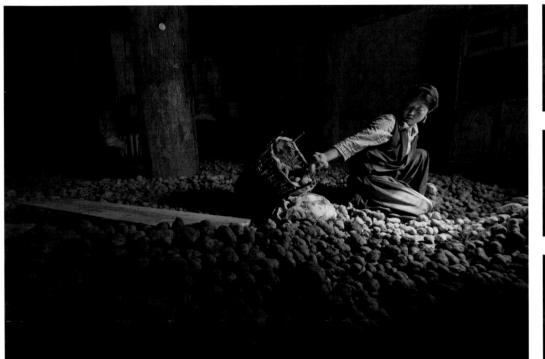

Spotlighting becomes even more vital and effective when there is action in the frame, or passing through it. There's a sense, and it's completely valid, that a brief moment has been caught, rather than, as in the spotlights on the previous pages, a fairly static scene just found. Action in photography, and especially good moments, has added value in most viewers' eyes. This is not only what photography is good at, it is what only photography can do—capture one slice of an action and preserve it forever. Say what you like about beautiful scenery and an artful still-life arrangement, there is something uniquely satisfying about a well-caught moment, and to have it spotlit, all the more so.

What makes a good moment? It's gesture, stance, a certain alignment of limbs, an expression, something just touching or about to touch, elegance,

the peak of an action—all of these are candidates, and more. Ultimately it comes down to what the photographers chooses and, it has to be said, on whether this meets or exceeds the viewers' expectations. For it to happen just so and at the very moment that the subject—let's say a figure—happens to be passing through a beam of light, adds to the specialness. Moments of the kind in the Pakistan bazaar are completely out of the control of a photographer, and so capturing them means using skills like anticipation, quick reaction, and quite often patience (as we know from the first section, waiting can be a skill). And with a spotlit shot, such as this one on the left, where the midday sun slices down between sheets of tarpaulin that shade the market, a good judgment of exposure. Digitally you could shoot a test frame of a less interesting figure

Choosing the moment

There was time here to find the best moment in a repetitive action, and I chose the one with outstretched arm and just-falling potatoes.

passing through the light to confirm the speed and aperture. This was shot on film, however, so the calculation had to be right. The answer was to use the setting for a scene in full sunlight. The Tibetan woman sorting her potato crop was a more controllable situation, because it was repetitive action and she was comfortable with me shooting. ■

SPOT BACKLIGHT Light Against Dark

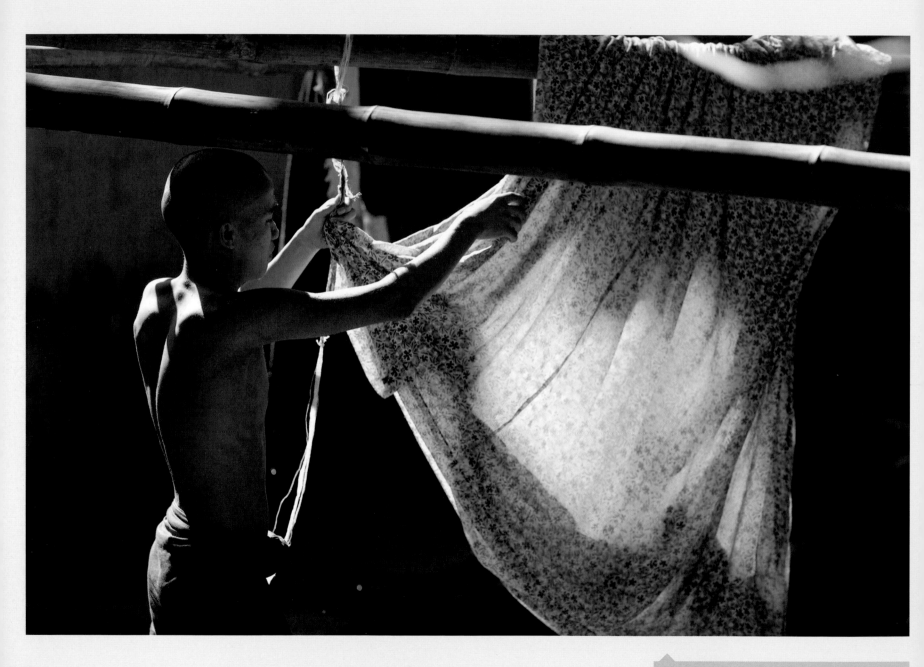

Monk, Mahagandayon monastery, Amarapura, Myanmar, 2008

I could as well have called this Back Spotlight, because in a sense it's a type of spotlight that you face into. What sets it apart from ordinary spotlight is the nature of the subject, and what's implied here is that the subject is lit up. For that to happen, the material being shot has to have some degree of translucency, or even transparency—for example, a thin cloth or a dried fish. If not, we'd probably be dealing with a kind of edge lighting or rim lighting. The idea of lighting up a subject from behind is that it acquires some kind of glow, and this is a little special in the repertoire of lighting conditions. In common with almost all of the lighting conditions in this Chasing section, the fact that it is uncommon adds to its appeal.

Apart from facing into the sun, two conditions are needed to make this kind of lighting situation work. The background has to be dark, to make the contrast, and the sun needs to be both out of frame and obscured by something. In the studio we'd call this being "flagged off" (see pages 230–231). Here the flag (usually a flat dark sheet used to hide the light from shining directly on the lens) can be a building, a tree, anything tall enough, really. And as the sky around the sun is also bright, the whole effect is stronger when most of the sky in front of the camera is blocked. You can help this by using your hand, or someone else's, or a card, to shield the lens from any stray light, and indeed this is one of the Helping techniques in the third section of the book. ■

Fish drying on clothes line, Song-rup Ri village, Cheju, South Korea, 1989

Shining through the subject

The two essential ingredients for this kind of lighting are backlighting from the sun that is flagged off by something, such as buildings and a wall, and translucency in the subject, allowing it to glow.

LIGHT SHAFTS Caverns & Cathedrals

A beam of light, carving its way visibly through the atmosphere, has always been the most melodramatic kind of lighting, from painting (used for example by Caspar David Friedrich) to movies and still images. Not for nothing is this known as the Finger of God—especially when it pours from the clouds and strikes a subject on the ground. This is a version of the spotlights we've just been looking at, but graphically underlined. There's nothing subtle about it, but the melodrama is saved by it being rare outdoors and very limited in interiors. The conditions are similar to what's needed for an ordinary spotlight effect, an opening of some kind to limit the sunlight to a beam, plus an atmosphere thick enough to make the beam visible. In the case of an interior, there also needs to be space. The beam glows softly white because of particles scattering the light—water vapor in the underground cavern as the sun heats up the pool (opposite), and also in the huge basilica (right), in this case the vapor probably coming from the thousands of visitors.

It would be a waste to have nothing at the end of the pool of light. Lighting this special gives the impression that it's always intentional, even more so than the spotlights we saw on pages 136–137 Spotlight—*Focusing Attention*. It's easy to argue that the entire subterranean pool is the focus of the light shaft in the Mexican photograph, especially as it all lights up and glows with a rich turquoise, but with the light in the Basilica of St. Peter's, something was definitely needed. It was a matter of waiting for a figure to walk into the shaft. This early in the morning, just after opening, there were thankfully none of the crowds that normally clog up the view, but I still wanted someone more interesting than a vaguely wandering tourist. It wasn't long before these scouts and a cowled leader walked on stage. ■

St. Peter's Basilica, Vatican, 2009

A higher sun

Light shafts need large and high spaces to show themselves, and this inevitably means that they appear when the sun is high.

Cenote de Dzitnup, Yucatán, Mexico, 1993

143

BARRED LIGHT Spotlights with Shape

Unusually, this is one light better known for its artificial creation, in studios and on film sets. Even then, it's not common and is these days frankly out of fashion. When you see an actor in a slightly darkened setting with a soft bar of light just across the eyes, this is called an eye bar, and it's one specific kind of eye light (another is a catch light, used to put a sparkle into the eyes). Fans of the original *Star Trek* will probably be more familiar than most with this; Captain Kirk among others was often given this treatment. Replicants, too, in *Blade Runner*. Its history goes back further, to Hollywood portrait lighting in the 1930s which, in the hands of photographers like George Hoyningen-Heune and Horst P. Horst, featured many lights aimed at different parts of the sitter and the setting. *Film noir* lighting in the 1940s and 1950s also often made use of light bars to add drama in scenes that were typically dark (*noir*).

Not surprisingly, this effect is even more uncommon in the real world, but if you have bright sunlight and some kind of rectangular gap, these ingredients may produce the effect at some time of day. The bar of light needs to be quite slim for it to work, so possibilities are a door ajar, a window at an acute angle to the sun, or Venetian blinds (very common in film noir). In fact, openings in walls like these are generally the best bet. Being vertical, they produce light bars, if at all, when the sun is very low. This in turn means that the light bars move across surfaces surprisingly fast—just think about the relative positions of the sun, the gap, and the surface that it's illuminating.

Follower of Vishnu, Jagannath Ghat, Calcutta, 1984

Key Points
Narrow Gap
Low Sun
Moves Fast

In photography, shaped spotlights tend to be unexpected, which is why I've put them in this Chasing section, but if the weather is consistently clear day after day, then of course they are highly predictable. If you see one a little too late, because it just passed over your subject, it will return almost the same and almost at the same time tomorrow. That's what happened here, at Angkor Wat (right), which I was photographing day after day for a book. It was December, so the sky was cloudless, and I was gradually building up a mental list of which locations looked best at which times of the day, as you do in this kind of shoot. There were bas-reliefs that caught raking light for just several minutes (see pages 42–43), there were others that bathed in bounced light from sunlit ground for an hour or two (see pages 188–189), and so on. A timetable grew for each temple, so that after a week it was as organized as a Swiss railway. Then I spotted this, which I liked a lot because it combined two temple features in one shot: the apsaras, or celestial dancers, for which Angkor Wat is famous, and the stone window balusters, which are very characteristic of this twelfth-century architecture. In a way, this was the inverse of Cast-shadow Light—*Projected Shapes* on pages 150–151. The light bars had moved too far when I came across them, so I simply rescheduled for the next day. ■

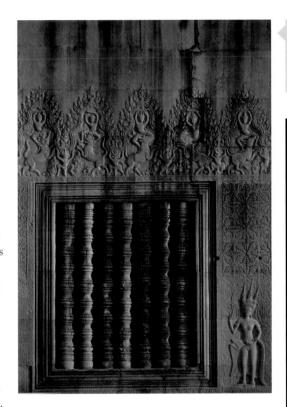

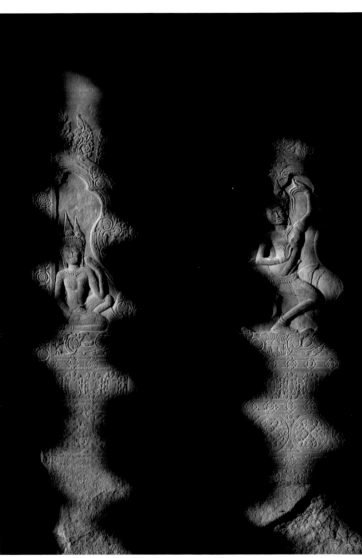

Balustered window

Stone balusters, turned on a lathe in imitation of earlier wooden ones, are characteristic of ancient Khmer temples, and responsible for the shape of the light bars.

Light bars

The ingredients are a clear, unfiltered sun, usually low in the sky, a shaped opening onto a dark interior, and a viewpoint other than through the same gap.

Apsaras, Angkor Wat, 1989

PATTERNED LIGHT Foliage

We already saw a very tropical lighting effect on pages 48–49, where midday light is filtered by shade trees into a strongly dappled pattern. This also makes a very strong impression in some interiors when the sun is much lower. It depends on having trees or bushes right outside a window, and also very much on the time of day, but when it happens it is a concentrated and striking effect—more so when it falls across an interior scene than outside, because the window constricts the light.

In the scene on the right with a chair made out of an old Tibetan chest and a black painting (this is a Chinese artist's house), early morning sunlight is heavily masked by the branches and leaves of a tree just outside the window, and becomes a major element in the image. In fact, this is a classic example of light as subject. The overlay of patterned light is every bit as much an element in the image as the section of painting and the chair. Compare it with the other version (opposite), photographed on an earlier occasion with much softer lighting. This other image was used as the cover of the book I was shooting. Both images work, but work in very different ways. It's not a matter of one being better than the other, although you could strongly prefer one over the other. I like both, for different purposes. One makes a good, simple book cover, with space for type; the other makes an atmospheric image. ■

Works by artist Shao Fan, Beijing, 2007

Controlling the strength of the pattern

With digital processing, this kind of overlaid pattern can be managed to a high degree. These four variations, from weak to intense, were made with the controls in Adobe Camera Raw, as follows.

1 Lowest Contrast setting, Highlights slightly reduced, Shadows raised.

2 Default settings, but converted to black and white as all the others, using Default settings.

3 Highest Contrast setting, Blacks raised slightly to avoid clipping.

4 As the high-contrast version, with Clarity raised to +50 and Blacks raised slightly more to avoid clipping.

In soft light

The same scene on another occasion, with no direct sunlight. More simply organized, this ran as the book cover in preference to the other version.

PATTERNED LIGHT Windows & Blinds

Windows themselves also create patterns of light, though whether or not they are interesting or attractive depends on fittings such as blinds, the muntins (these are the slats that separate the individual panes), the glass itself, and even more so on the time of day at which the pattern of light falls across the wall or other surface. The oval box (right) is Shaker, and the location Hancock Shaker village in Massachusetts. The special touch was provided by the early nineteenth-century windowpanes, which threw a liquid pattern across the cabinet. Lighting like this, obviously short-lived as the sun moves, adds a sense of occasion to still-life details, which would have been pleasant enough in a more even light, but not nearly as interesting.

A quite different visual effect, but special for the same reason, is the dotted light across the wall of a half-room in one of the better known old gardens in Suzhou, China. Chinese gardens of the Ming and Qing dynasties were designed to offer a complex and constantly changing experience to the visitor, who is guided along paths and corridors, through pavilions and rooms. Some windows were designed to frame views, while others were given intricate patterns. At both ends of the day, when the sun is low and warm, these latter inevitably throw patterns of light across nearby walls—an effect that was almost certainly intentional. At this lower level of intensity toward sunset, the pattern appears to be more of color than light. ■

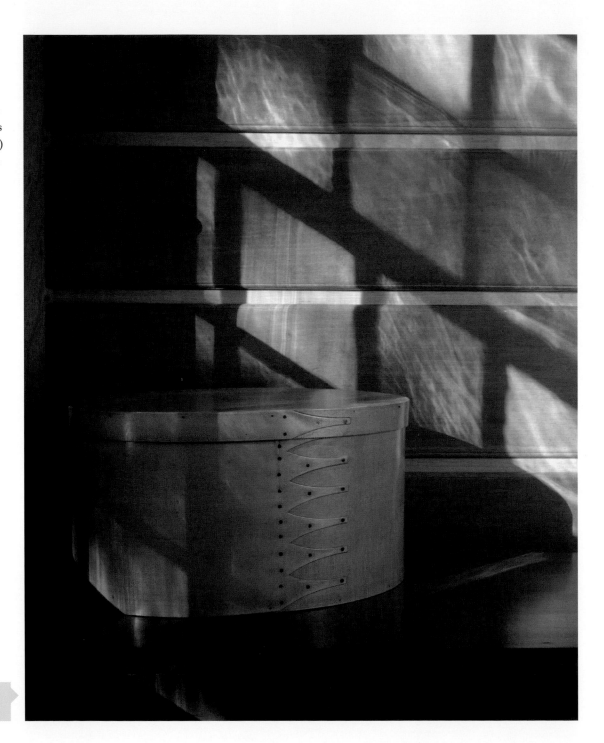

Shaker box by window, Hancock Shaker Village, Massachusetts, 1985

Earlier & later

Window light falls across a wall when the sun is low, and so the pattern moves quite quickly. These two images, before and after the main shot, show how completely the image depends on timing.

Scholar's Rock, The Humble Administrator's Garden, Suzhou, China, 2010

CAST-SHADOW LIGHT Projected Shapes

The patterned light that we just saw has been shaped and enclosed by something, like a window or the branches of a tree, and we see it as light falling on a surface, surrounded by shadow. The roles can easily be reversed, however, so that light encloses a shape, and if this is recognizable and makes sense to the eye, like a silhouette, we get this effect. Sunlight and shadow are still mixed as they fall on a surface, but the eye sees them in a very different way, as the outline of an object or a person. This is shade out of light, rather than light out of shade, and it becomes much more about subject. This cast-shadow effect is almost always useful and worth trying, because for one, it is fairly special—it needs just the right combination of an appropriate angle of bright sunlight, plain surface for projection, and a subject with a meaningful outline. More than that, you can sometimes make the shadow stand in for the object that's casting it, and turn a workmanlike image into one that shows an extra spark of imagination. That was the case with the Javanese puppeteer scraping a hide (right). From the other side it worked perfectly well, but from here, it was simply more interesting because it combined the man scraping with the skin all in one plane.

A similar thought was behind the pointing finger in St. Peter's, Rome, opposite (the famous "Finger of God" by Michelangelo is located in the Sistine Chapel, and that's not far away). The camera angle and framing were important: the shadow of the arm and hand had to fill the frame as much as possible, but I also wanted a hint of the actual marble hand, which had to be there in frame, but be the second thing the eye saw after the shadow. This shadow also moved very fast, and we first saw it as it was disappearing—so returned the next day at the same time. ■

Scraping buffalo hide for shadow puppets, Yogyakarta, 1985

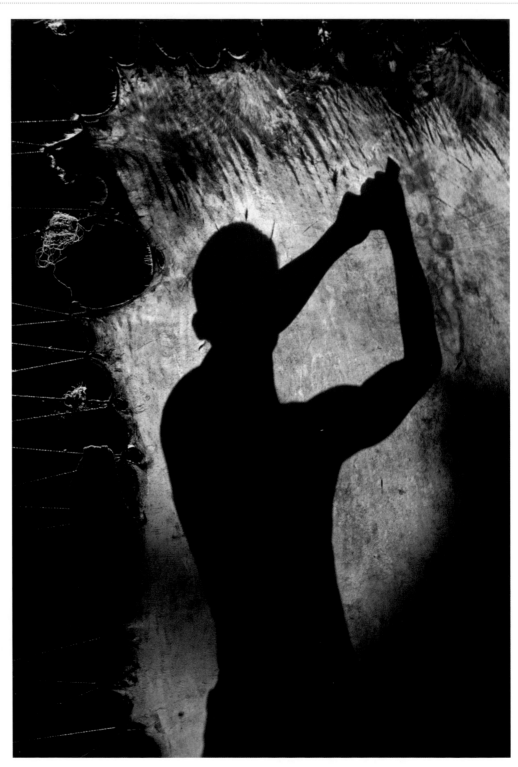

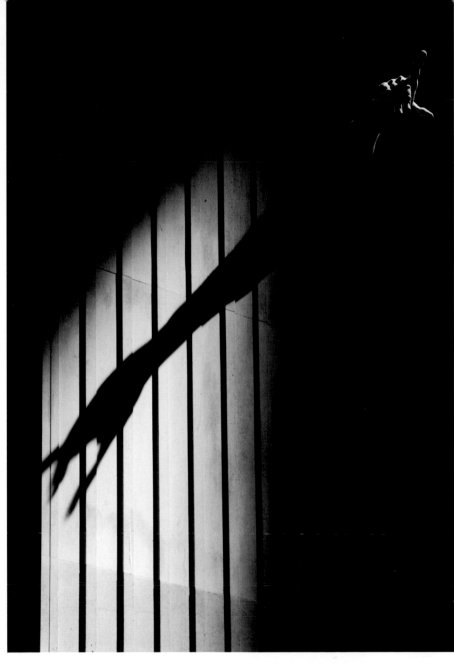

Statue, St Peter's, Vatican, 2009

Brief shadows

Just four minutes elapsed between the first and fourth images, as the extremely long throw of the window frame's shadow moved quickly down the wall.

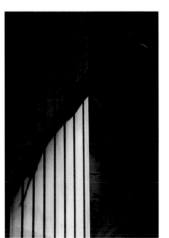

STORM LIGHT Brief Spotlight

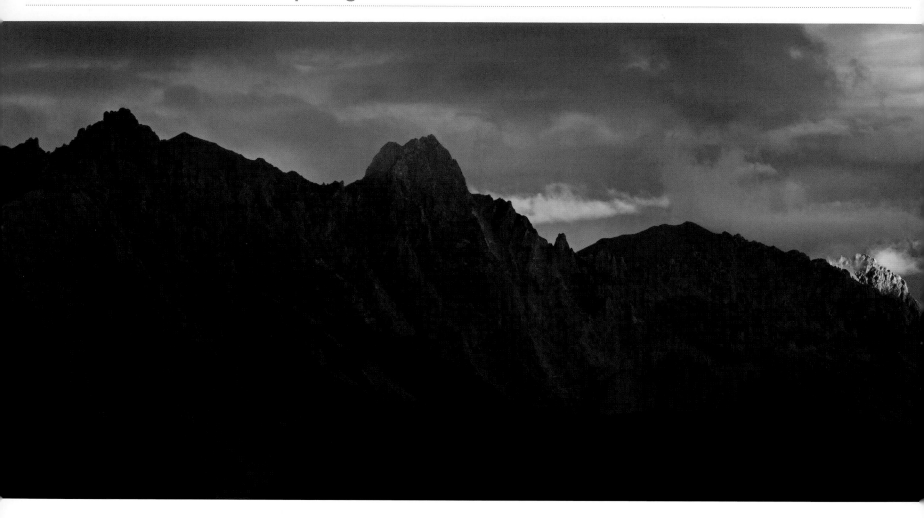

This is the king of fleeting light that breaks through during a storm—or at least, during particularly heavy and cloudy weather. Storm systems and thunderclouds being what they are, this kind of break (in both senses, in the clouds and in luck) is virtually impossible to predict, and it remains one of the classic chasing-the-light scenarios. It transforms a scene from one with almost zero possibilities into the opposite, an image with focus, drama, and contrast. The only planning that goes into this kind of shot is being prepared to move and shoot very quickly, and being confident in how to handle that always-tricky exposure situation of small bright subject against large dark background.

When it happens, it's similar to a light being switched on suddenly. Thick, heavy storm clouds like those in both of these pictures are unlikely to leave any but the smallest gaps, hence the spotlight effect illuminating just a small part of the scene. Overexposing is a real and disastrous danger, and even though shooting continuous is a sloppy way of dealing with a landscape, if there are any doubts about the exposure, it's better to bracket heavily than lose the shot. In the case of the shot of Ipswich Marshes (opposite) that was not possible, as I was shooting roll film on a 4×5-inch view camera—always a slow process. There was time to expose only three frames. Brief time to work within

is the other problem with storm light. The clouds are almost always too thick and moving too fast to allow anything but a short gap in their cover, sometimes seconds, rarely more than a very few minutes. That often means moving quickly to find a clear viewpoint—for the Tibetan shot this meant first driving fast and then running to get an empty foreground. ■

Stormlight off

The difference between this brief spotlight on a mountain range in Tibet and the evening light immediately before and after is enormous—and the difference between an image and no image.

The Ye Pass, Eastern Tibet, 2009

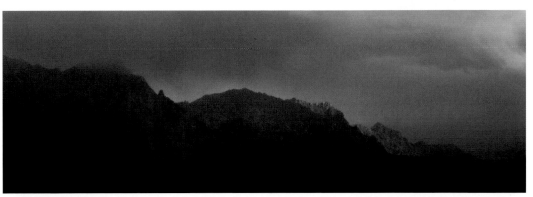

An hour earlier

The same view as below, earlier in the afternoon.

Ipswich Marshes, Massachusetts, 1987

See how the spotlight is so bright that to expose for it brings the foreground shadows down almost to black.

STORM LIGHT A Break on the Horizon

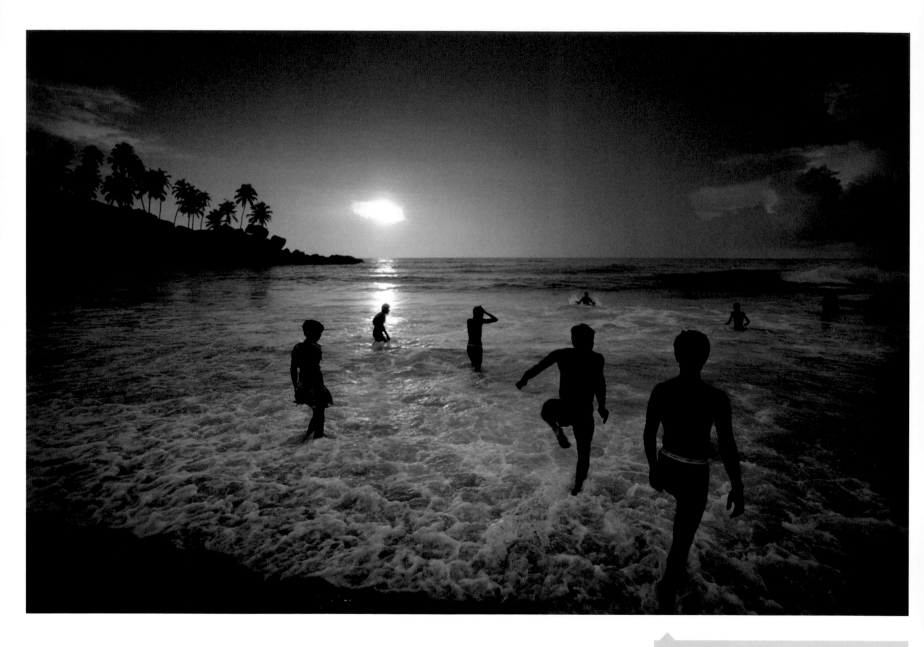

Bathers, Kovalam Beach, Kerala, India, 1985

Similar to the kind of storm light we saw, but located right on the horizon, this kind of lighting often works best by shooting toward the light. The reason is that it is rarely powerful enough to light things up intensely, for much the same reasons that spotlighting variety of storm light is usually so small and brief. Cloud thickness and fast movement due to storm activity tend to keep the gap small and brief, and there is an even greater thickness of cloud stretching horizontally than upwards. As with all these kinds of storm light, it works because of the contrast between dark and light. This is light that seems as if it doesn't belong in the overall scene. These two examples were taken at different ends of the day: sunset for the Indian bathers in Kerala (opposite), and sunrise in Cornwall (right). In both cases, it was simple perseverance without much expectation of things working out. The sudden break on the horizon is rare, but the only way of capturing it is to be there on the off chance. What you don't see here are all the occasions where nothing happened and the clouds stayed solid.

The Kerala shot was taken during the monsoon, so certainly not expected, but I had to shoot the story anyway. It was a little unusual in that people were happy to go bathing under thick cloud and occasional rain. It wasn't that they saw the sun and rushed into the sea. Dozmary Pool is the site where, in Arthurian legend, the sword Excalibur first appeared, and where it was returned. Again, this shot was taken for a story, on Camelot, but due to bad weather the day before I was tempted to give up and return some other time. The problem was that it looked pathetic and unimpressive in rain and cloud, whereas the story demanded that it have some presence. I returned for dawn the next day, fully prepared to wait for a while and then leave. Then the light broke for about ten minutes, and all changed. Luck, of course, but you have to give luck a chance. ■

Dozmary Pool, Bodmin Moor, Cornwall, 1991

155

STORM LIGHT From Under the Cloud Bank

Baliem Valley, Papua, 2000

This particular, and dramatic, variety of storm light is an early-morning or late-afternoon feature, when it happens at all. The conditions are a thick or busy cloud bank at a medium height, but not continuous all the way to the horizon, so that there is a gap for the sun. It often comes from a frontal system, which has bands of weather moving across the landscape; the cold fronts generally have the sharpest edge to cloud banks. It also sometimes happens as here in mountains, where the weather is more complex and harder to anticipate, and you can usually expect rapid changes after the sun has risen and starts to create thermals in the valleys. This location was Papua, in the central highlands, which has an especially rugged topography. The basic effect is a narrow sheet of sunlight, and is exaggerated by mountains or hills on the sun side, because they not only narrow the horizontal gap, but also cast much of the landscape into shadow.

I had the advantage here of shooting from a small helicopter, which put me at the level of the sun's position, but in fact, standing on the ridge of the hills just below would have been just as good.

It helps this kind of image to be shooting from some elevation, because some of the effects are best seen looking downward. In particular, when there are individual wispy clouds at a low level, they get lit up by the near-horizontal rays, and so stand out clearly, with great contrast, when you can see them against a hillside in shadow. Another effect that comes into play from a high viewpoint is the bright reflection of the sky in any water body, such as a river, lake, or a string of ponds. In fact, both of these effects, illuminated clouds and water reflections, contribute strongly to what is ultimately the great appeal of this kind of light—rich local contrast. ■

Baliem Valley, Papua, 2000

A horizontal band

A narrow gap between a thick cloud bank and the hills allows the sun, for a few minutes, to light up features in a horizontal sheet.

STORM LIGHT Dark-Cloud Backdrop

One lighting situation that is always striking and worth seizing on is the mixture of sunlight and dark clouds. In summer, and in the tropics in particular, thunderstorms can build up during the afternoon—it depends on local conditions. It tends to be at this time of the day because the land takes time to heat up, and the rising warm air, if it's moist, develops into the tall clouds that mature into a storm. On average, thunderstorms take only about half an hour to form, so you can see it happening and get prepared. The other kind of weather that is likely to produce dark clouds at the same time as sunshine is a frontal system—the kind that is very common over the British Isles, for example. The timing is important, and this light is most likely when the front is approaching or clearing. What makes photography dramatic at these times is the contrast between bright subject and dark backdrop, so the blacker the clouds, the better; intense thunderstorms are always the most spectacular.

Putting this light to good use takes a little planning, because you need a camera position that pitches a side-lit or frontally lit subject clearly and in a well-framed way against the darkest part of the sky. This is certainly not a guaranteed combination by any means, and chasing the right viewpoint in the short time that the clouds take to build up is a little like hunting for a position that fits a rainbow over a useful part of the landscape (see below, pages 162–163). A low camera position helps, because the effect is strongest when most of the background is sky. Also, a useful technique to remember is that using a longer focal length allows you to concentrate on a smaller area of sky, making it easier to choose the darkest clouds. This was the case with the picture

Eucalyptus, Gran Sabana, Colombia, 2009

of the pelicans in flight. This was taken by the shore of Lake Manyara in Tanzania. There were large numbers of pelicans, and so some choice of birds flying overhead. The lens' focal length was extreme, 600mm, and by panning as I shot, I could choose the point at which this pair was set against very dark thunderclouds. The contrast in the photograph of the eucalyptus tree was helped considerably by the camera's specially adapted sensor, as I was shooting with a camera converted to infrared. This rendered the leaves very bright (chlorophyll in healthy foliage reflects infrared strongly), and I allowed full contrast when processing the image in black and white. ■

A stage set lit for contrast

This is the classic setup, with low sunlight from the side (in both cases these were late afternoon thunderclouds) and the storm still in action in the distance.

Pelicans, Lake Manyara, Tanzania, 1982

STORM LIGHT Cities at Night

Night in the city makes an unusual and often powerful setting for storms, as the increasing amount of illumination in major cities (see pages 118–119) creates a kind of backlighting for the rain, snow, or swirling mist, and the resulting glow can be ethereal and even mysterious. Like any of the atmospheric effects that we'll be looking at shortly, from haze through mist and fog, depth and distance are critical for getting the exact look, and this depends as much on how close the camera is to the lit-up buildings as on the thickness of the storm itself. Another essential factor is how a building is lit, and with large downtown structures, there may be floodlighting as well as internal lights. High-rise buildings are especially good value, because they have the potential to appear poking out from the storm-like islands. Both of these examples were high and relatively isolated: one of Manhattan's oldest skyscrapers, the 1913 Woolworth Building, and the 88-story Jinmao Tower in Shanghai, the fifth tallest building in the world until 2007, when it was surpassed by the nextdoor Shanghai World Financial Center, from which the picture opposite was taken, looking down. In both cases, the top is floodlit, which adds to the isolated effect of a glowing island of light surrounded by swirling and shifting weather. On this scale, the buildings themselves add to the shifting unpredictability of the storm as they block and divert the winds, so things tend to move fast. In seconds, the view can change from a vague glow to parts of the building standing out clearly. Generally, the most effective moment is when enough of the building's lights can be seen to make sense of it, yet it is still surrounded by a swirling glow. ∎

Woolworth Building, Lower Manhattan, New York, 2011

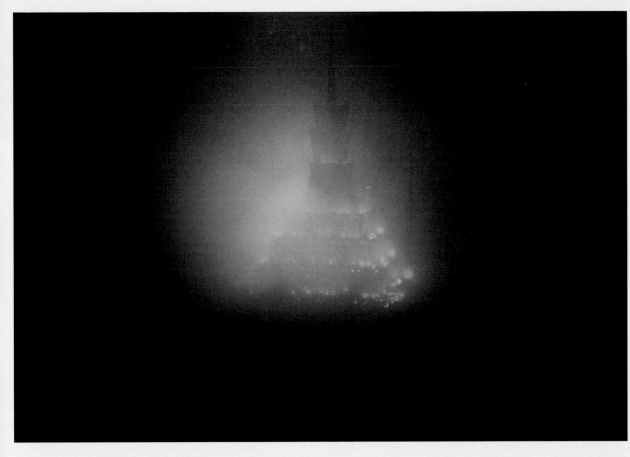

Rapidly shifting weather

With an afternoon shot included for reference, the nighttime views varied dramatically over just four minutes.

Jinmao Tower from above, Pudong, Shanghai, 2010

Backlighting a storm

All the elements of a storm, such as low cloud and rain or snow, have the effect of being lit from within.

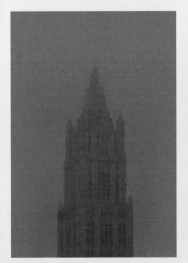

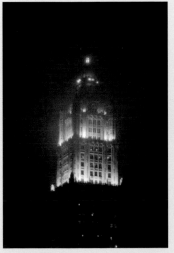

RAIN LIGHT Shower in a Sculpture Park

After pages spent in praise of bad weather and getting wet, the most sought-after rain-chasing light situation is the one shown here. As we saw in Wet Gray Light—*Falling Rain* on pages 22–23, it usually takes a heavy downpour for the falling rain to register at all distinctly in a photograph. This is hardly surprising when the light is gray and the contrast low. However, put together falling rain and sunlight, which is far from common, and the light situation becomes very different indeed.

Rain light is not simply any time at all when it's raining. We already looked at that in the first section on pages 22–23. It's a more special and interesting condition. Rain light (my term for it) is when rain is sheeting down as sun breaks through. It works when you're shooting into the light, and it's the combination of three things—catching the moment, usually brief, plus a good subject framed well, plus camera placed into the light—that makes it rare and good. It's one variety of Storm Light, but with a bit more action, and the sudden breakthrough of light through sheets of rain is never predictable. So, this is extremely opportunistic lighting, and normally the best you can do is to hope that you have a workable scene in front of you that you can frame attractively. This happened here, in a sculpture park called Roche Court in southern England, and I take no credit for any kind of fast reaction, as we had been filming from this location, and I'd left the camera set up on its tripod while I walked off to scout a new location. My assistant called me back! There are no special exposure issues in this kind of situation.

And where there's rain and sunlight together, but facing in the opposite direction, there will usually be a rainbow. In the case of the sculpture park, there was a wooded hill behind, so no chance, but out in an open landscape, always turn on your antennae when you get a rain-sunlight combination. Rainbows are related to the viewer—you—and so "move" as you move. This makes it possible, if you're quick, to change the camera position so as to place the rainbow differently within the landscape. As with the pelicans and eucalyptus tree on pages 158–159, rainbows appear strongest and most colorful against a dark backdrop—worth bearing in mind if you can move to place it against darker clouds. ∎

Roche Court Sculpture Park, Wiltshire, 2012

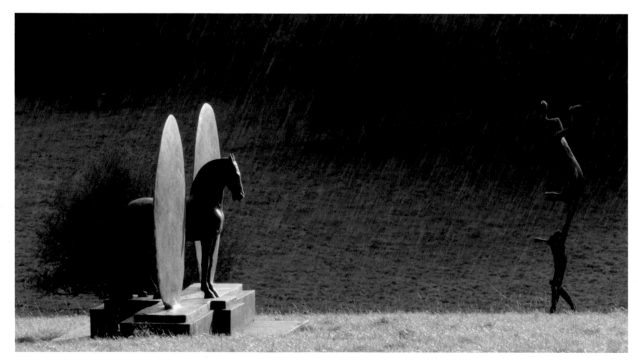

Sunlight breaking through rain

As with other kinds of storm light, this combines two weather conditions in one scene, and works facing into the light.

Waterfall & rainbow, Bernese Oberland, Switzerland, 2011

CAUSTICS Burning Patterns

Water bottle & shoes, 2010

There is a special kind of concentration of light, by reflection or refraction, that creates curved shapes with cusps, and often with spectral colors, and while not all that common, this condition happens often enough to be worth paying attention to, not least because it adds attractive lighting drama to a scene. The most well-known occurrence is when bright sunlight shines through a drinking glass onto a white tablecloth, and another is the curved net-like bright pattern projected by waves through clear water, as in a swimming pool. These complex and intense curves and intersections of light are called caustics, after the Greek word for burnt—highly concentrated light, as through a focused magnifying glass, can burn, after all. Perhaps unexpectedly, a much more familiar kind of caustic is a rainbow, as on pages 162–163. The same processes are at work in creating the curved arcs, each wavelength (color) with a slightly different radius.

The ingredients are: a point source of light (for which it's hard to improve on the sun); a transparent material to refract the light (glass, lens, water); and a nearby surface on which to project the caustic. Although all this can be worked out from the laws of optics, in practice it's not easy to predict the shapes that result from the setup, which depend on how the glass or water is configured. In the end, it usually comes down to taking the opportunity to try it, perhaps making some adjustment by moving whatever the object is that is dong the refracting to improve your result.

That said, in the kind of situation where you're likely to come across these burning cusps and curves of light, there ought to be sufficient time to bracket exposures. The way the refractions fall, and on what kind of surface, makes them unpredictable for exposure, and having a selection of different exposures to choose from for processing is worthwhile. Color fringing and chromatic highlights—all the things most of us do not want in our lenses—here become desirable, as the close-up of the embossed hotel letterhead shows, and color, as always, appears richer when slightly underexposed rather than overexposed. ■

Curves & cusps of light

A typical pattern of projected light, with the searing highlights where the curves intersect that gives caustics their name.

Caustics as a deliberate lighting effect

Part of a shoot for a grand old Swiss hotel involved the embossed letterhead, and a simple glass of water was turned into a kind of color-fringed spotlight to add interest.

SUNSTARS Sun in View & Under Control

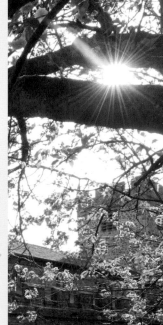

Sedbergh Church & blossoms, Cumbria, 2011

HDR capture sequence

An automated handheld burst of exposures,
1 *f*-stop apart.

You can't have both

A crop of two exposures, one shot at 1/30 sec and good
for the blossoms (below), the other at 1/500 sec and right
for the sunstar (above). They are so far apart that the only
solution is some kind of exposure blending.

Key Points
Small Aperture
Cut Into the Sun
HDR

FRAUNHOFER DIFFRACTION

Computer simulations of 4-point and 5-point diffraction patterns, responsible for the streaks in a sunstar. Most lenses have many blades, producing a multiplied effect, and at the smallest aperture the shape is less circular, more angular.

Here is something else that we don't actually see directly (and looking at the sun directly is not a good idea in any case). Even so, we recognize it perfectly well and even think it's natural. And most people like the effect. A sunstar is photography slang for an image of the sun with star-like beams radiating from it, and in reality is a diffraction effect caused by the lens. Indeed, it's a diffraction artifact, which strictly speaking means it has nothing to do with what's being photographed and shouldn't be there. But I like them occasionally, when they happen without too much artificial help. Managing sunstars is one of the most elegant ways of keeping the sun in view in the frame, while at the same time controlling it so that it doesn't overwhelm everything else.

Here are the technicals. A sunstar is one type of Fraunhofer diffraction, which is the kind where the light from a point source hits a sharp edge, which in turn causes scattering of a special kind—perpendicular, at right angles to the edge. The right angle is the key to this effect, because if there are several straight edges, close together, surrounding an image of the sun about to be photographed, these diffraction streaks will appear to spread out from the sun. This is exactly what the aperture blades in a lens look like and do, as the illustration shows. More to the point, the effect is obviously going to be stronger when the edges of the blades are very close together around the sun's image. What's needed first is a point source of light, a very small aperture, a dark surround against which the radiating beams can show up, and a short focal length that will render the sun small in the frame.

One of the problems that I'm usually trying to solve by doing this sunstar technique is keep at least

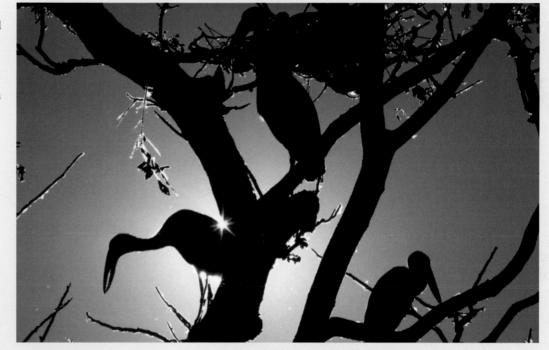

Openbill storks, central Thailand, 1981

part of the subject that's against the light open and visible. This is not easy, facing directly into the sun and keeping the sun visible as well, but there are two ways to help things. One is to cut into the edge of the sun with something, like a branch, the edge of a building or a leaf. This simply makes the sun's image smaller, even more of a pinpoint, and there's a case example of this on the following pages. The other way, which you can use in combination with this, is to use HDR. I'll deal with HDR techniques in the third and last section of the book, Helping, but here's a foretaste. The place was a churchyard in Sedbergh in the north of England, and the reason the spring blossoms. One single exposure could not capture the

delicate pink of the blossoms and an intense sunstar. Instead, I shot a burst sequence, of 9 frames each spaced 1 *f*-stop apart—overkill actually, but just to be safe—and then made a single HDR file from the sequence. Careful and naturalistic exposure blending brought the different demands of the scene together. It all depends on the processing, which offers a wide choice of tone-mapping results. ■

SUNSTARS An Afternoon on Mount Tam

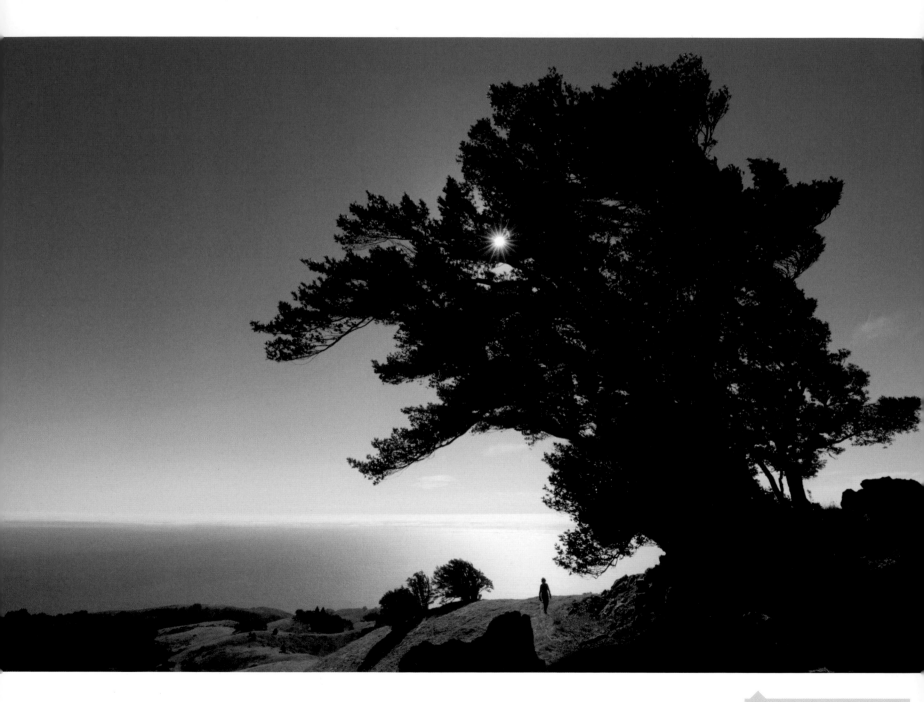

Mount Tam, October 2011

Late afternoon on Mount Tam, a short drive from San Francisco and looking out over the Pacific. Searching for a way to use the clear light, I needed a subject, and finally found this lovely tree, dark and shapely, which reminded me of those painted by the seventeenth century master of landscape, Claude Lorrain, dense and clean-edged, a very solid-looking tree when seen like this against the light. Claude Lorrain usually arranged his scenes into the light; we saw this and the reason for it under Shade to Light—*Looking Out & Beyond* on pages 58–59 in the first section. With this in mind, I decided to treat it as a silhouette, holding the highlights in the sea as well as I could. That was fine, but as I moved around trying to find the best combination of wide-angle focal length and viewpoint, I noticed the flickering of the sun in small gaps between the packed leaves. A sunstar would be the perfect way to bring life to the dense silhouette, and I had all the ingredients: bright sun, wide-angle lens, and a simple way of controlling how bright and how large the sun would appear in the photograph.

This was simply positioning myself so that some of the leaves and branches cut into the sun's disc. With a wide-angle lens—here I was shooting at *f*/22 and at 14mm—the sun looked more like a point than a disc, and this indeed was the idea. The smaller the sun appears in the frame, the more pronounced is the sunstar. Why is this important? Because the good exposure for a sunstar, as we saw with the churchyard on the previous pages, is usually quite a bit less than for the scene itself. Here on Mount Tam I wanted a silhouette, but there was still the rest of the scene to think about, in particular the area of brown grass underneath. This had to stay light, or at least an average tone, so that the small figure walking toward me would be visible.

Cutting the sun slightly like this would make it less bright, and so the sunstar more obvious. Also more colorful, as the darker surrounds of the sun usually show a warm tone, which bleaches out when brighter. One important thing with this technique is to take care over your exact position. At this distance with such a wide-angle lens, the slightest movement makes all the difference between a sunstar and nothing. There was a slight breeze, and it was changing several times a second, so I shot many frames. ■

The shooting

The breeze moving the leaves and branches meant my moving slightly and shooting many frames—over 60—to be certain.

Bigger & smaller from different cuts

The smallest movement of leaves has an effect on the sunstar's appearance as they partly mask it. For choice and certainty, a large number of exposures were made.

FLARED LIGHT Expressive Faults

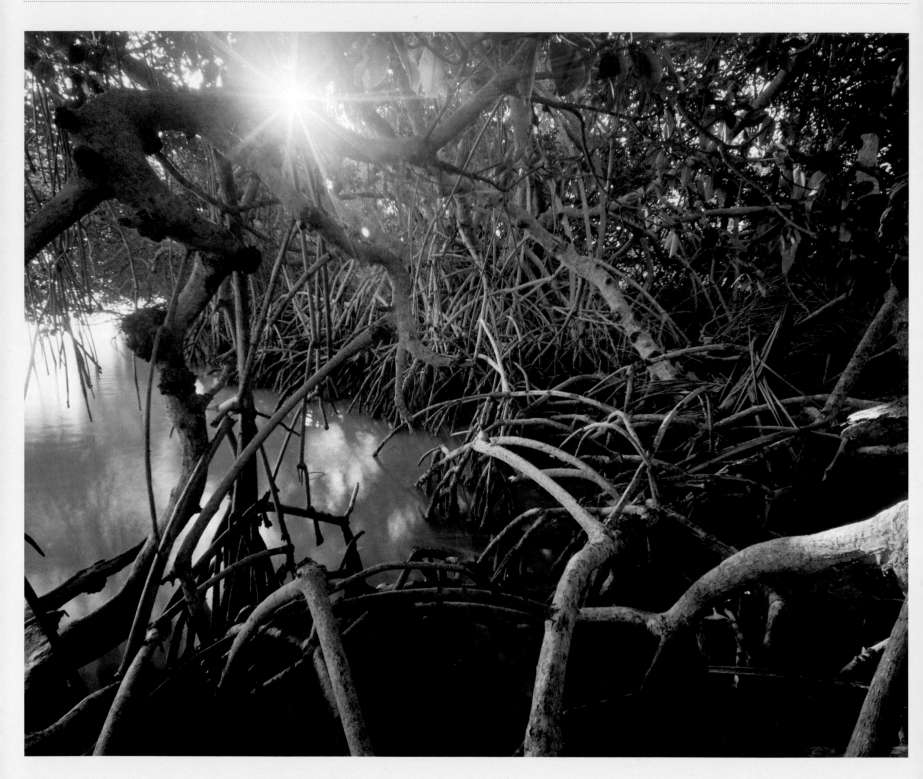

Iceberg Lake, Glacier National Park, Montana, 1976

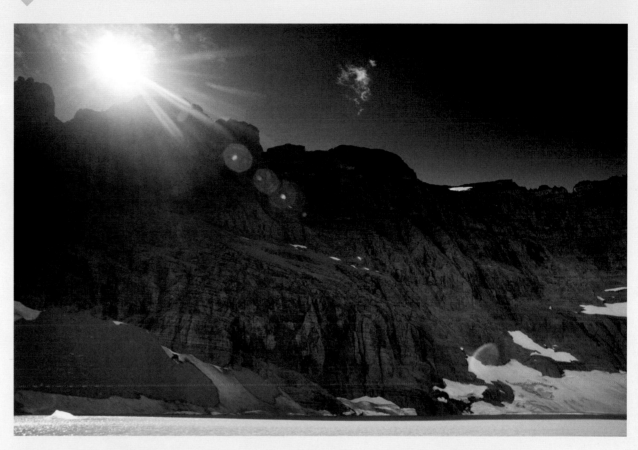

The argument here is that, despite everything, flare can be useful in certain circumstances, and for some people. Certainly, it's an imaging artifact in that it has nothing to do with the scene and subjects being photographed. Instead, it happens in the lens and shows itself as a general lightening and lowering of contrast across parts of the image, and also as bright polygons and streaks. It overlays the image in a sense, and technically is something to avoid and prevent. The cause is bright light getting reflected from lens surfaces rather than entering the glass and being refracted in the way it should. Ultimately, the lens manufacturers have the most work to do, in design and in the materials used for the glass, and in coatings.

But is lens flare always a bad thing? To many photographers this will seem a strange question. It's a fault, after all, so what good could come of it? Well, if photography is all about clear representation, flare contributes nothing, it's true. But photography means different things to different people, and over at the expressive end of the spectrum of photography, things like motion blur, color washes, and flare have value because they help to create mood and play with the graphics of the image, as opposed to telling a clear-cut documentary story.

There are two ways to go about bringing flare into the image. One is the experimental method—basically shoot into the sun and see what happens. The other paradoxically takes more effort than eliminating flare, because first you have to know exactly what conditions cause it, and the different varieties of flare, so that you can use the right lens and settings, and shoot from the appropriate viewpoint. In a sense, the sunstars on the previous pages are a flare element, but they are also another case of knowing the technology in order

Lens flare from direct sunlight

The precise mixture of streaks, rings, and polygon spreads depends as much on the lens design as on the camera angle.

to create and control them. Cutting into the disc of the sun (with leaves, branches, building edges and so on) is one controlling technique. Another is placing the sun in an upper corner so that the polygon spread streams diagonally across the image. Another is composing so that the flare elements stand out against background shadow rather than get confused with lit foreground subjects. ■

Mangroves, Rio Lagartos, Yucatán, Mexico, 1993

WHITE LIGHT Peach Blossom Scroll Painting

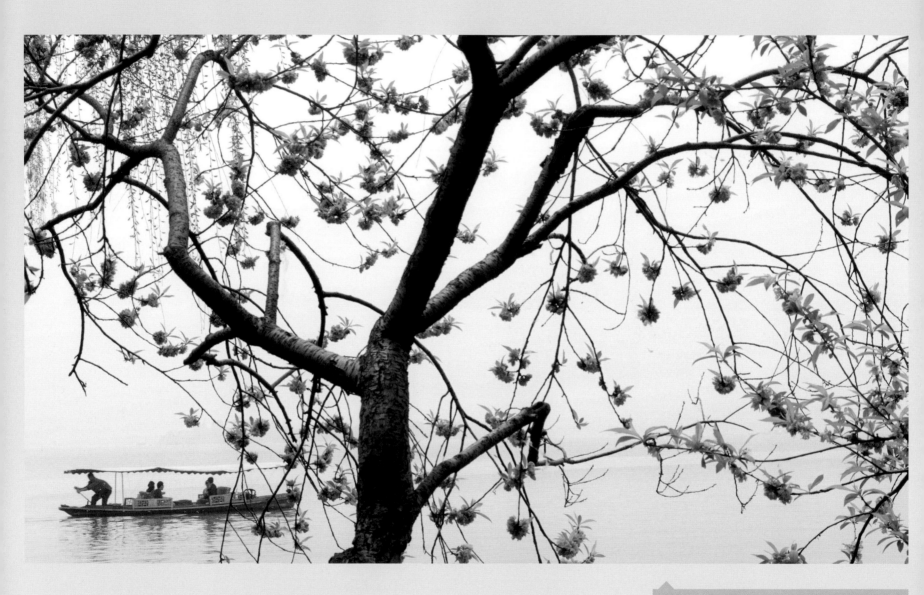

Peach blossom on West Lake, Hangzhou, 2012

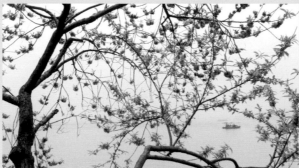
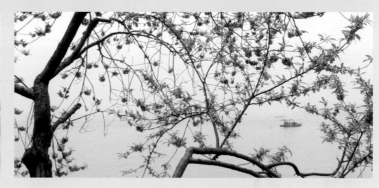

It's not exactly a scroll painting, but this April scene on West Lake follows the same line. We're re-visiting the site of the gray light image in Soft Gray Light—*On West Lake* on pages 18–19, but in different light and with a different intention, and while the subject matter is pretty much the same, the images are quite different in atmosphere. In fact, this shot was taken a month earlier than the gray light image, when two things were conspicuously different: it was spring blossom time, and the enveloping very thin mist gave what I call white light. The term describes exactly the sensation of being surrounded by a high level of illumination, and it is not a very common situation. It depends not just on the weather conditions, but also on the place, and to an extent, as we'll see on the following pages, on how you choose to interpret it. The weather conditions are a light mist or fog under an otherwise clear sky, but no deeper than a very few hundred feet, so that the light levels are high. It's a delicate balance between sufficient atmosphere to hide the background, and so much that it has a gray feeling. Processing appropriately helps, of course.

Now seems the right time to introduce the graphic idea of white space, also called negative space. Here, much more than in Gray Light—On West Lake, I was interested to follow some Chinese ideas about imagery, in particular the careful, and sparse,

placement of elements on a white background. Of course, white paper or silk offers this by default, but in more than 1,500 years of scroll painting, Chinese artists developed a fine sensibility toward the process. Placing things in relation to each other, and with a sense of their proportions to the white space, helped define the art form. It's not at all the same for photography, which depends on your "finding" rather than "constructing" (outside the studio, at least). But when the occasion happens, it can be good to know the tradition for dealing with it. The difference between this image and what a painter would compose it to be is that the pattern of branches— and the all-important positioning of the boat in one of the enclosed spaces—cannot themselves be altered, and need to be manipulated by camera position and focal length. A painter would consider more, but then would take all the responsibility for the decisions. Photography outside is always allowed some latitude because it is understood that it has to deal with real, unpredictable life. In photography, you can also quickly try different compositions and moments, and choose between them later. ■

Later alternatives

As the boat moved out into the lake, I stayed to recompose until it was quite distant. The final choice is personal, influenced by the more dynamic attitude of the boatman.

White light

A combination of atmosphere, setting (a body of water helps), and full exposure takes gray light to a lighter, purer plane.

WHITE LIGHT Interpreting the Light

The color white is not quite so cut and dried as it sounds. Certainly it's neutral and maximum lightness, and we all know it instinctively when we see it, but what exactly does "maximum" mean? This matters for both exposure and processing. To show white, does it have to be just below overexposure and clipping? Or can you actually have a dark white, illogical though that sounds?

There are, in fact, two kinds of white in photography. There is the top end of the tonal range in the image as you expose it and process it. Indeed, just before it clips into "featureless" white. And then there are the objects and surfaces that we know to be white, even if they don't achieve this in the photograph. Snow is white, so is milk, and the plumage of an egret. And, of course, white paint. The difference is that in the first sense, we're measuring the image, while in the second it's a matter of perception. Let me prove the case with the picture here of the church at Litchfield. It's magic hour again, on a clear winter evening after a fresh fall of snow across New England. And the color of the church is what? Yes, confusingly it's both blue and white. Blue if you think literally about the image on the page or on a screen, but white if you think about the church.

The second image, of an interior where we sense immediately that everything is painted white— deliberately so to make a design statement—is clearly open to interpretation when it comes to setting the exposure for shooting and working on the processing. How white can it be? Should it be? As it turns out, there is an acceptable range of interpretation, and quite a generous one. I'm showing just two versions here. This is obviously a white-designed interior, so we could get away with a fairly gray interpretation, as long as it is pale gray. Or, we could take it up to the limit of almost clipping. The difference between the two versions is purely one of taste. They both communicate "white." ■

Key Points
Exposure Control
Known White
Shades of White

PROCESSING WHITER

The difference between the two versions of this interior scene lie in the processing, which below is compressed into the right half of the range—with the deliberate exception of the dark cloth.

Tea House, Beijing, 2006—version 1

Tea House, Beijing, 2006—version 2

Congregationalist church, Litchfield, Connecticut, 1979

DUSTY LIGHT Particles & Pollution

Anafiotika, Athens, 1977

From the almost lunar quality of light at high altitude in bone-dry weather that we saw on pages 38–39 Hard Light—*High-altitude Blue*, to the thick fog that we'll be working toward over the next several pages, there is an infinite and subtle range of thickening in the atmosphere. It matters more to photographers than to almost anyone else, because it is about more than just visibility: It controls the sense of depth in a scene, alters the shadows, and spreads the light source. And on top of all these measurable qualities, it has an effect on mood and sense that is very hard to pin down, but still critical to any image.

Near the beginning of the scale is haze. Unlike mist and fog, it is dry, and caused by microscopic particles of dust and smoke. Also unlike mist and fog, which are white and colorless, haze often has a brownish or yellowish tinge, for the same reason that Golden Hour is golden and a clear sky is blue: really small particles scatter the light selectively, and so bounce away some of the blue. The shot in Athens was many years ago, when the city's notorious pollution was at its height (not that it's perfect now). It was so bad that carvings on the Acropolis were being obliterated, but paradoxically, it gave atmospheric and photogenic sunsets, which I took advantage of here. This hardly looks like a city. The assignment was a photo essay called "Village in the City," featuring small community oases in the metropolis, and light suited this opening shot well, obscuring details on the hillside beyond as a 400mm telephoto picked out the "village" of Anafiotika on the lower slopes of the Acropolis. A different source of haze is responsible for the white, dusty light enveloping the middle Nile in Sudan, in the wake of a dust storm. The dust particles remaining in the air for two or three days were larger, and so scattered the light without favoring any wavelength—hence the milky appearance. Shooting into the light as always exaggerates the atmospheric effect. ■

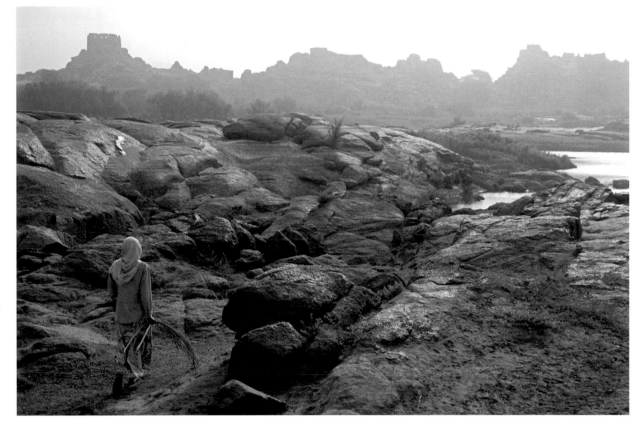

Ruins of Mameluke fort, middle Nile near Tumbus, Sudan, 2004

177

MISTY LIGHT Early Mornings

Wat Phra Si Rattana Mahathat, Chalieng, Si Satchanalai,
Thailand, 1991

The difference between mist and fog is visibility, and over the course of the next several pages, the atmosphere will be getting thicker. There is actually an international definition because of aircraft and airports, with 1 kilometer being the dividing point (mist less than, fog more than), but photography doesn't need to be that precise. Mist is less tangible than fog and gives the appearance of softening the view rather than hiding some of it. One of the commonest situations, not exactly predictable, but a possibility to think about all the same, is early morning in clear, dry weather.

Here in the north-central part of Thailand in the winter, conditions were just right, with a river nearby for water vapor, which built up during the night. This kind of very light mist can last well into the day, and generally gives more time for shooting than the more definite fog that we'll come to next. My preferred way of handling this lovely, atmospheric light is to use it to enhance the depth in a scene, and this means using a wide-angle lens, well stopped down, and finding a viewpoint that shows a full scale of subjects from foreground to distance. The mist exaggerates the scale of depth by progressively lowering the contrast and the color saturation. Even better from my point of view is when there are distinct distances in-frame, because the mist then tends to separate them into distinct layers away from the camera. Here, at the thirteenth-century temple of Wat Mahathat, I found a position that divided the view into the three planes shown in the illustration, and kept the camera very low, almost at ground level. ■

A scene in layers
The progressive effect of mist has the effect of dividing the scene into receding planes.

Misty light
Noticeable atmosphere and softened light, but almost everything remains visible.

MISTY LIGHT Ground Mist

Power lines, Gloucestershire, 1976

The next stage of thickening, after the early morning mist we just saw on the previous pages, is a ground-hugging layer that almost always adds a special element to landscapes. At this point the difference between mist and fog is simply a matter of appearance, and frankly academic. Technically this is known as radiation fog, because at night under clear skies the ground cools by radiating heat. Cold air can hold less moisture than warm air, so if the ground is wet and the air above it moist, mist or fog forms in the cooled layer just above the ground. A lot has to do with movement in the air, because any hint of a breeze will move the layer and make it deeper. But if the air at dawn is absolutely still, this is what happens, as these two images show.

The meteorology is much less important than the appearance, and in any case, the precise effect is not predictable. The key is the way in which such a thin layer separates structures from the ground, so that they can seem to float above it in their own plane. Radiation fog varies in depth from three feet to about 1,000 feet, is always found at ground level, and usually remains stationary. Being so thin, it usually burns off quickly, so when you come across it, it's important to shoot quickly. When there are close surrounding hills, cold air can continue to sink, especially on the side in shadow from the low morning sun, and this variety, called valley fog, can persist longer. ■

Nan Myin, the leaning watch tower, Ava, near Mandalay, Myanmar, 1996

Floating the scene

A thin layer of mist hugs the ground, allowing objects like buildings and trees to appear to float.

FOGGY LIGHT Soft Shaker Style

Fog is never just fog. It's a complete condition, both visual and physical, that submerges and takes over the landscape. Its density determines how far you can see, and its depth as it lies over the ground decides not just the amount of light, but also whether there is any sense of the light's direction. Thick fog is a gray blanket that spreads its limited light everywhere, without a hint of highlight or shadow. A little less so, and there is the hint of one side of the sky being brighter. There are endless degrees of fogginess, and what it does most for photography, apart from cloaking and hiding, is to layer the landscape.

It does this by thickness and distance, as on this morning at Sabbathday Lake, one of the original Shaker communities in Maine. The otherwise empty spaces between things are now filled with what is essentially a soft gray filter. The deeper the distance, the stronger the filter. Look at the difference between using a wide-angle lens (20mm) and a medium telephoto (180mm), which were the two lenses I shot with here.

Add to this the uncertainty of when and how the fog will clear. This kind of weather condition is difficult to forecast, which means being prepared for anything between the fog persisting all day to it clearing in the next few minutes. The period when it clears is as valuable as any of the other changing conditions of light, such as sunrise and sunset, because it offers the possibility of subtle shifts and movements. Foggy light has that unpredictability that compels you to go out and do something with it whenever it arrives—but at the same time, it also gives you the opportunity wait, just to see how things will be as it starts to clear. ■

Sabbathday Lake, Maine, 1986

It's all about distance

Fog is like a softening gray filter in three dimensions, represented here as two blocks on the left. The distance between the iron bell and the building is significant only from close to the bell, near the tip of the arrow, and from there the fog puts the building at a softened distance. But from way back—the start of the arrow—the depth of fog gives both bell and building more or less the same treatment. See the difference between wide-angle and telephoto treatments.

Walking closer with a wide-angle lens

Moving toward the bell and buildings with a 20mm lens, the separation into layers becomes stronger. When finally the bell is just a few feet away, it stands out sharply from the distance, which is filtered by much more depth of fog.

As it clears

Within minutes of the main shot, the fog gradually began to clear, revealing more, but altering the mood.

FOGGY LIGHT In the Clouds

Mengdingshan Tea Mountain, Sichuan, China, 2009

Similar distance means less depth

The same wall photographed frontally gives less feeling of depth because of weaker perspective.

Fog actually is a kind of cloud, although most of the time close to the ground and not connected to the airborne variety. Mountains and hilltops, however, do sometimes offer the chance to be in the clouds, literally.

One difference for the light is that the topography is likely to give you a bigger choice of view and less predictable shading. We've already seen the depth effect of fog in the Shaker village on the previous pages, and how it acts as a kind of layered filter. In mountains, this is anything but straightforward as the slopes and ridges rise and fall around you. The example I'm using here is a tea mountain in Sichuan, China, with ancient pathways, walls, and gates. As with all kinds of fog, turning this kind of light into a picture relies very much on having at least one definite and close subject, and the old walls were it. In the main shot, which was the best of the morning's shoot, I'm deliberately making the most of the depth by shooting from close to the large dragon roundel with a wide-angle lens. Compare this with the picture of the same wall head-on from a little way down the slope. In this second shot, the wall is all at the same distance from the camera, and so the effect is much flatter. This is a matter of taste, of course, but by shooting so that the wall snakes away from the camera, from very close at the right across and up the forested hill, I get not only a more dynamic composition, but the increasing depth of the fog as well. In a way, this is getting the best of both worlds. The other difference for the light compared with ground fog is the way the cloud moves. Hilltop clouds have more movement, because usually they have formed by air being pushed up the slopes (which is why it's also called upslope fog), and they can as easily swirl to disappear as to thicken. Here, after about an hour it suddenly cleared, but not to sunshine; the day continued gray and flat. ∎

Atmosphere in depth

Thicker than mist, fog obscures the distance and sets the depth limits of the scene in front of the camera.

Perspective with dark foreground

The same wall again, but photographed looking down with the foreground in deeper shadow.

FOGGY LIGHT Over Water

All kinds of fog have something to do with water. Just like clouds (the only difference between the two is that clouds are higher), they form from tiny droplets, precipitated because air becomes too cold to hold them as invisible moisture. No surprise, then, that fog forms quite easily over water, provided the other conditions are right. It's the daily cycle of warm to cool as the sun sets, and when the skies are clear, land and water cool even more quickly at night. The air above the water absorbs moisture, and during the night becomes foggy as it cools and can no longer hold the moisture.

This small lake in Austria, surrounded by steep mountains on three sides, is perfect for summer fog, which doesn't begin to clear until at least an hour after sunrise because the mountains delay the moment when the sun strikes it. Once this happens, low fog disappears quickly as the sun heats up the air—this is the critical time for shooting. As the sequence of frames shows, the fog clears from the top down as the sun warms it, and the image can change in seconds. There are no rule-driven perfect moments for photographing fog as it clears, but in this case the point at which the peaks had just become clearly visible seemed right, with the vertical scale (deliberately long as I was shooting 16:9) containing two completely different kinds of light. As before, there is never any guarantee of what will appear and when, as there are too many variables at work, and fog over the water one day does not mean that it will happen the same on the next. ∎

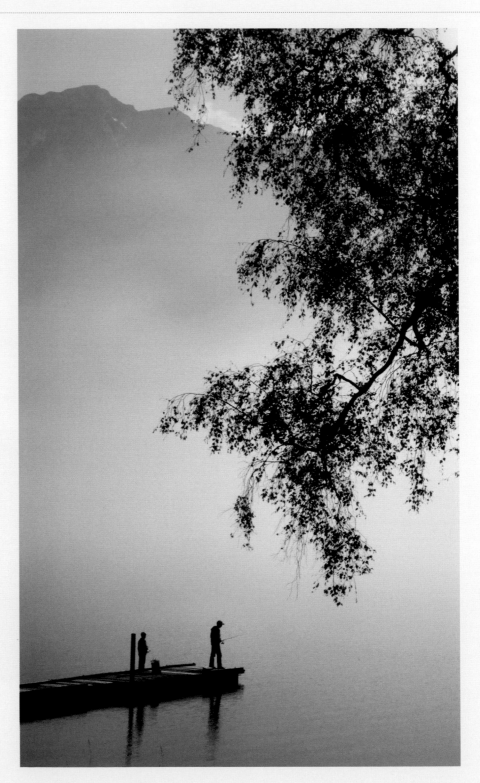

Altausseer See, Salzkammergut, Austria, 2008

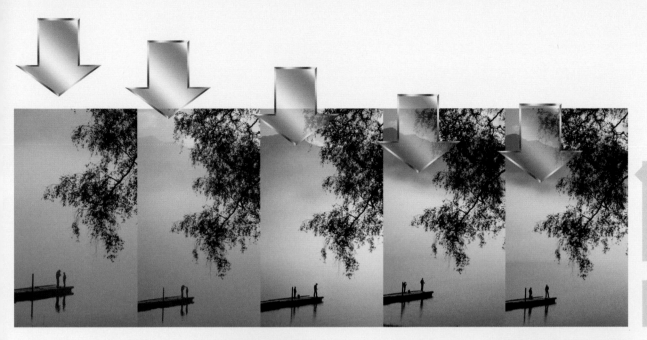

Rapidly clearing fog

At some point the sun burns off the fog, and here it happened rapidly and from the top, taking exactly ten minutes from the first to the last of the these five shots. The balance between foggy and clear is always delicate in situations like this.

A shifting band

A typical pattern of shifting, eventually dispersing.

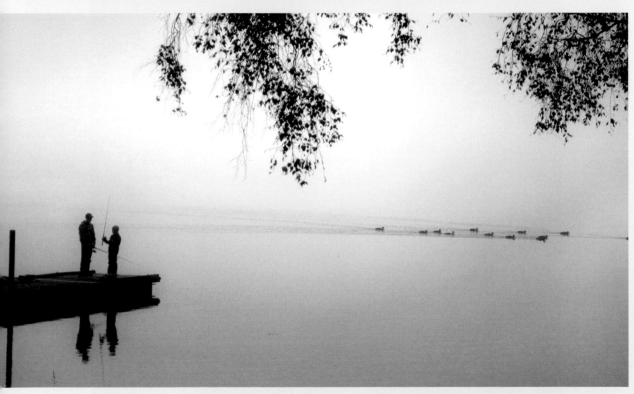

An alternative framing & moment

Passing ducks change the dynamics of the scene, taking attention away from the clearing fog above.

REFLECTED LIGHT The Glow from Bright Ground

This is one of the less-thought-about kinds of light, but very appealing and surprisingly varied. It's sunlight that bounces off different ground surfaces, often out of frame, and is almost an entire category by itself. As you can see here, it can go far beyond simply filling in the shadow cast by a main light. Here indeed, even though it is not intense in either image, it is still the main source of lighting. No direct light strikes either scene, and in both cases, it was a high, daytime tropical sun, giving a difference between sunlight and shade of easily 7 ƒ-stops. What I like about this kind of light, apart from it being a welcome relief from hard midday light (see pages 28–39), is that it comes from an unusually low direction, and is often much warmer in color than skylight. As well as providing a main light from the side, in both situations it gives a subtle range of mid-to-dark shadows, and renders them a warm brown.

One reason why this relatively delicate lighting often gets missed by photographers is that it all happens in the shade, and if you're outside that area and shooting in the sunlight, it's often difficult to adjust your eyes to the much lower light levels, even more so if you wear sunglasses. It takes a minute or two for the eyes to become adjusted, and it's important also to frame shots so that everything is within the shadow range. Glare from a sunlit corner of the frame will usually destroy the effect. Camera position becomes important. For the portrait of this man (right), who was sitting close to the edge of the shade, I had to find a position from which I could aim fractionally towards the interior—the sunlit areas begin just to the left of the image. The solution for the shaven nun was a little different; I used a 400mm lens, which tightened the area of dark background showing in the frame. ■

Akha man, Chiang Rai Province, northern Thailand, 1980

Bounced light from off-stage

This is the typical configuration, with the bounced light at its strongest and most effective when only just outside the image frame.

Thai nun, Wat Mahathat, Bangkok, 1979

REFLECTED LIGHT Opposite Walls

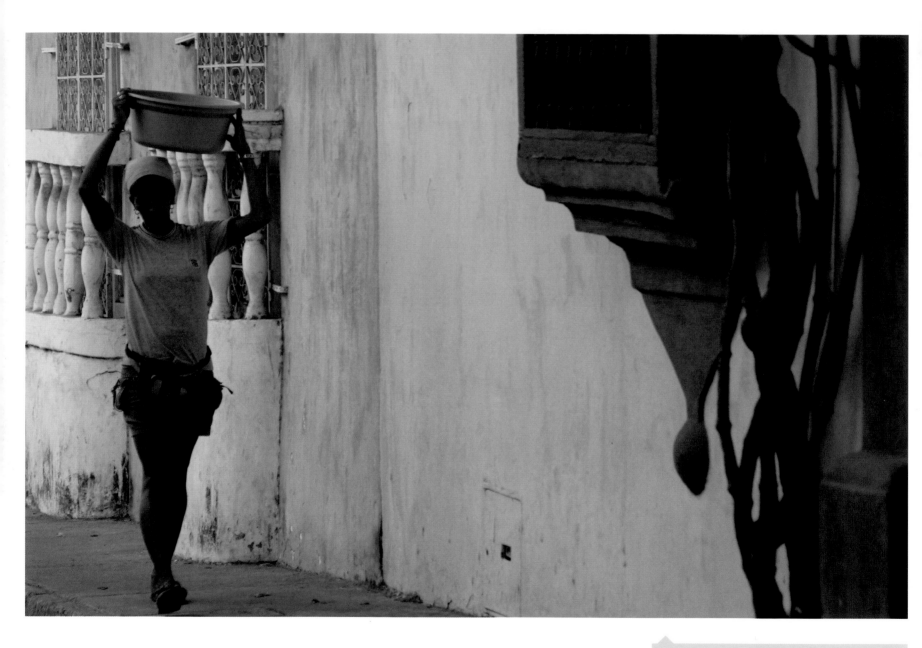

Fruit seller, Cartagena, Colombia, 2007

Here is a particular kind of reflected light with its own special characteristics, but also quite common at a certain time of day, and at times hugely attractive because of the broad glow it can bring to otherwise shadowed scenes. In fact, because light reflected from opposite walls tends to be broad and fills a large area, it tends to go unappreciated and even overlooked. If you ignore the bright sunlight elsewhere, which may seem counterintuitive, it's worth looking for this kind of light at a time when the sun is at medium height—higher than the limits of Golden Hour, but outside the midday hours. The timing is important because the sun needs to be striking a vertical surface and covering as much area as possible. As the illustration shows, it also depends on the setting, and a north-south running street is one of the commonest situations. If the sun were any lower than shown here, it would strike a smaller area of the walls, and also higher. This is the perfect angle for maximum side-lighting and broadest area.

The Angkorean temple scene, within a stone gallery, was lit in the morning by light reflecting off a stone wall on the opposite side of a small courtyard. In a way, this was almost a planned rather than a true chasing shot, because I had seen it a little too late in the morning, so returned for this wonderfully modeled effect. As with the bounced-light portraits on the previous pages, there's a sense of a glow coming from the image, which is partly to do with the extra warmth of color that the reflections add to the sunlight. Provided that you keep the shot framed so that none of the exterior pure sunlight shows, this kind of reflected light takes over as the principal light source. ■

The opposite-wall effect

Whatever the vertical surface opposite, it needs to be facing either west of the afternoon (as in this case) or east for the morning, in order to work effectively.

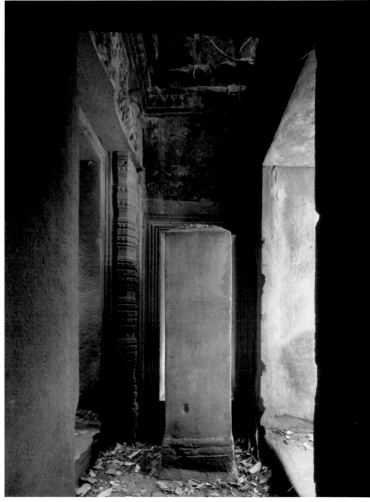

Khmer stele, Preah Khan temple, Angkor, Cambodia, 1989

REFLECTED LIGHT Surrounding Fill

Very occasionally, the ways the surfaces are arranged in an interior allow the light to bounce around more than once, and in different directions. This is a pinball effect with multiple ricochets of light, and as each one adds light to a different part of the scene, the result is that the entire scene lights up and shadows reduce. And, following the billiard analogy, the cue ball has to start fast—all of this depends on strong sunlight to start with, because each reflection lowers the intensity considerably, and it also calls for more than one fairly bright reflective interior surface. The interior of the Thai railway carriage is a classic example of this, with plenty of bright metal surfaces, including floor, ceiling, walls, and the backs of the seats, which are separated so that the light strikes each one. In the photograph of the drummer, the reflecting surfaces are out of frame, and not so complete, leaving shadows on camera right that give a strong modeling effect. In both of these cases, it's no coincidence that this is tropical daytime, which naturally gives the most intense of all kinds of reflected light. ■

Thai railway ticket collector, Bangkok to Hua Hin train, 2007

Key Points
Multiple Lighting
Multiple Direction
Strong Sourcelight

Multiple bounce

Interiors with a variety of bright surfaces, such as the seating and floor of the railway carriage, create a natural multiple-lighting effect when sunlight enters.

REFLECTED LIGHT Unexpected Spotlight

Shan woman drinking tea, Shweli Valley, Shan State, Myanmar, 1982

Spotlights, which we've seen before in various guises, from gaps in the roof of a bazaar on pages 138–139 through caverns and cathedrals on pages 142–143 to sudden breaks in a storm on pages 152–153, can also create bounced light, which has the advantage of being not only unexpected, but also concentrated. More concentrated, at least, than the general, broader fill flight that we've seen over the last few pages, though less so than a direct blast of sunlight itself.

In both these examples, both from Myanmar, van unexpected spotlight adds an unusual lighting quality, from offstage in the case of the novice nun, and from a hidden, but central source in the case of the teacup. In both situations, the shots themselves were inspired by this special light. I might possibly have taken pictures in both these situations if the light had been more ordinary, but it would have been more a case of just doing the job and shooting for the information value. ■

Reflecting cup
An unusually concentrated spotlight from the shape of the white tea cup, which bounces the sunlight up into the woman's face.

Spot Bounce
The lighting situation for the shot of the young Burmese nun, not immediately obvious from the photograph itself.

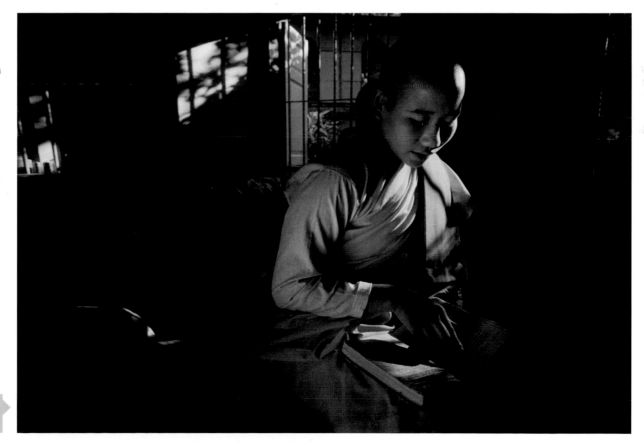

Novice nun studying Buddhist scripture, Zay Yar Theingi Gyaung convent, Sagaing, Myanmar, 1996

REFLECTED LIGHT Canyon Walls

The surface that is doing the reflecting can sometimes take center-stage in an image, particularly if it has some special qualities, such as color. As we've seen, strong reflected light entering a scene automatically brings an element of surprise, because it adds a new lighting direction, but when the surface changes the color of this light, it can dominate the picture. This is what's happening here, in one of the American Southwest's more spectacular slot canyons called Buckskin Gulch. It offers a fantastic sectioned view of the geology of the Colorado Plateau, beginning with the red rock of the Navajo sandstone, traveling downstream through each layer, it meanders between rock walls that pick up the colors of the sky and desert (see the picture to the right). The canyon is a narrow corridor of stone twisted by the wind and carved by irregular floods, allowing spectacular photography along its 13-mile length (about 20km). The colors look too good to be true, but are accurate. (As an aside, this was shot on transparency film, Fuji Velvia, and reversal film like this offers the kind of benchmark lacking in today's Raw formats, which are designed to be processed—and therefore interpreted.)

The reasons for the distribution of rich color are both simple and complex. Simple in that the blues are from the clear morning sky and the warmer tones from the red Navajo sandstones. Complex in the way that the light from two sources—sun and skylight— performs multiple bounces, as the illustration shows. We've seen the color opposition between sun and blue skylight elsewhere, as on pages 106–107 Magic Hour—*Subtle Oppositions*, but the difference in brightness between the two sources is so great—at least 3 *f*-stops—that the color from one of them

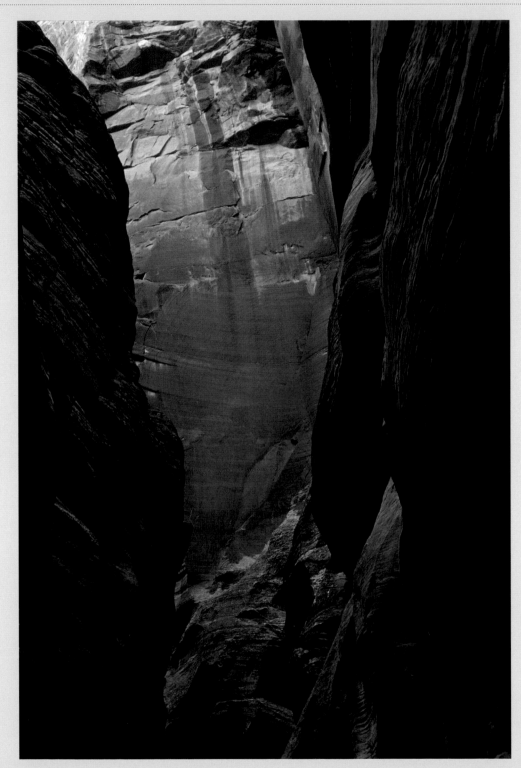

Buckskin Gulch, Utah, 1997

is often lost. Either the sunlit color is washed out, or the skylit shade submerged in darkness. This image is a special case because the sunlight bounces twice off the winding canyon walls. The result is that the light from the two sources is more evenly matched in this view.

The smaller image, in a part of the canyon at a different angle to the sun and sky and with different rock formations, stays more predictably within a common color range, though no less interesting. Actually, its most interesting feature has nothing to do with light, but a lot to do with the way the canyon was formed: the tree trunk jammed high up. It arrived there with a flash flood, obviously not the kind of event you would want to experience at first hand. ■

Light bounced & tinted

Blue skylight illuminates the deep foreground directly, but the sunlight bounces twice, each time off red sandstone, and this intensifies the hue and lowers the brightness.

A narrower range of color

In a different section of the canyon, the walls receive only reflected sunlight that bounces down, with little contrasting skylight.

SUFFUSED LIGHT The Color of Ice

There are just a few situations where light is absorbed selectively, in a way that suffuses the entire scene with color. One of these is photography through water, which most of the time involves the highly specialized underwater photography—too specialized for us here. A large aquarium gives a similar result, as does ice. The IceHotel in Jukkasjärvi, northern Sweden, first of several built in a craze for strange places to stay in, is built from ice blocks in the winter, and melts away in the summer, which at least prevents it from ever looking tired and in need of refurbishing. This is probably one of the practically least useful examples in this book, as most people won't be able to go around the corner to take similar shots, but it is nevertheless a spectacular case of suffused blue light. Even within the hotel, different thicknesses of the ice, different aspects facing toward or away from the sun, and the time of day, the exact blue varies considerably.

The hotel
Exterior of the hotel, with its owner, Yngve Bergqvist.

This is not the same as the surface of a lake or the sea appearing blue under a blue sky. From a sharp angle, this is almost all reflection from the sky. Water—and ice—has its own color, with blue shading toward turquoise, because it weakly absorbs the red wavelengths. As a result, it transmits blue, which is its complementary color. The greater the thickness of water, the more blue the light is at the end. On land, there are not many situations in which sunlight is on one side of the water or ice, and this is one of them. Not only that, but the building blocks for the IceHotel are carved from the exceptionally pure waters of the local river, the Torne. Thick blocks pass more daylight because pure equals deep blue. ■

Ice mammoth window, IceHotel, Jukkasjärvi, Sweden, 2001

COMPLEMENTARY COLORS, SELECTIVE FILTERING

When colors are removed from white light, what remains are their complementaries across the color circle.

IceHotel, Jukkasjärvi, Sweden, 2001

SUFFUSED LIGHT Yellow to Red

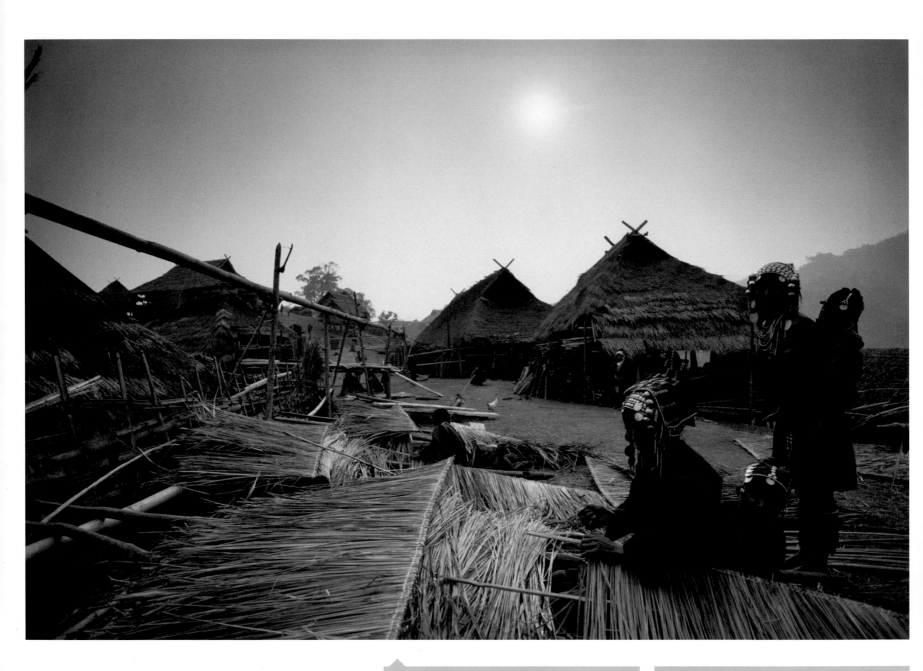

Mae Cha' Akha village, Thailand, 1981

An enveloping dust storm

The *haboob* built up and swept over the market
in just six minutes.

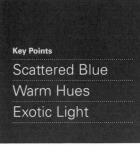

Haboob, Suq Libya, Sudan, 2004

Now we move from one side of the color circle to the other—blue to reddish, for reasons that may seem similar but are not. Water and ice absorb red wavelengths, but in the atmosphere, particles of different sizes scatter blue-ish wavelengths. It's very much a matter of size, because very small particles of dust—the kind that make the sky slightly hazy—scatter short wavelengths, which are at the blue end of the spectrum. By scattering them away, what remains is a light tinged with a warmer hue somewhere between yellow and red. In fact, we've seen this under Golden Hour, pages 94–101. I'm making the point here because different sizes of particles give subtle, but distinct variations in hue, as happened here in the Thai-Burmese hills, where the dry season burning of forest created a yellowish light much earlier in the afternoon than on a normal, slightly hazy day. This helped my shooting considerably, as it suffused the take with a similar, earthy color, bringing most of the pictures into a similar color range.

Colored light in this yellow-to-red range always means very small particles. When they are large enough to be similar to the wavelengths of light, they scatter all light equally, and there is no color cast, just a white haze. This is exactly what we saw in the Sudan picture under Dusty Light—*Particles & Pollution* on pages 176–177, and also in Foggy Light on pages 182–187. There, the particles were much larger than the ones in the images on these pages. This was my second surprise in the sequence of pictures here, taken near Khartoum, with the sudden arrival of the unusual desert storm called a haboob. The first surprise was how quickly it grew. There had been some rain from heavy and high clouds earlier, and we were driving south when I saw to one side in the distance a thin yellowish wisp hanging low in the sky. My driver looked, and said "Haboob." We turned and drove toward it, and over the course of minutes it visibly grew and thickened. What happened then was a wall of sand, several

hundred meters high that rushed forward. Fortunately, there was a livestock market, which gave me something to photograph as the wall engulfed us. The second surprise was that everything turned orange and then red. The sand was a normal sandy color, but that alone didn't explain the strong color, which came from even finer particles blown into the air. I later read that the standard advice for *haboobs* is "Moving to shelter is highly desirable during a strong event!" ■

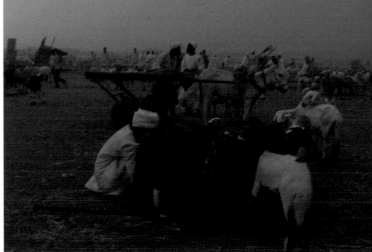

SUFFUSED LIGHT Colored Windows & Awnings

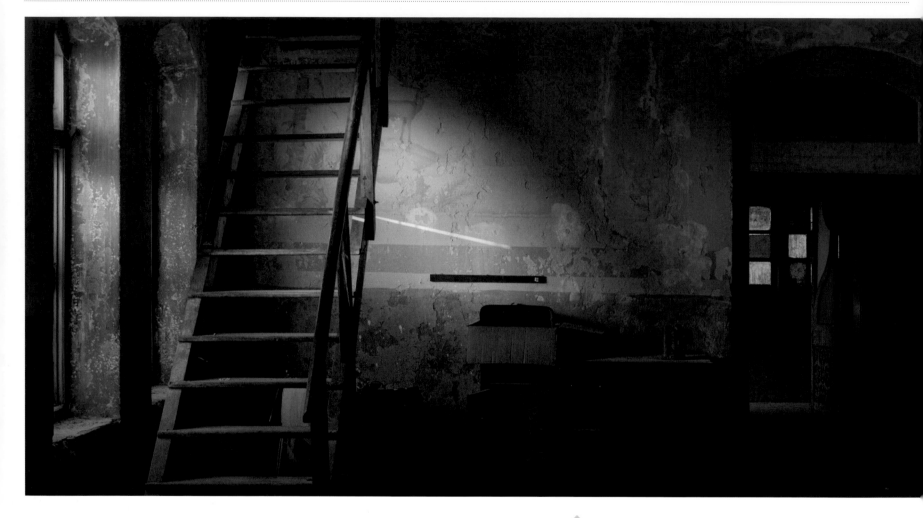

Coloring lights deliberately, as sometimes happens in a fashion shoot, is risky. The line between striking and cheesy is an uncertain one, and it needs considerable confidence to pull off. However, when the same thing happens naturally, which is not often, the result can be fascinating. To put it bluntly, situations like these shown here owe nothing to a photographer's decision, so there's no blame attached! Personally, I like the unusual effect of tinted light falling on at least part of a scene. Stained glass windows in a cathedral are the easiest example to imagine, at the time of day when the sun shines directly through them. Here, in the 1920s-built ballroom of an old Indian Maharajah's palace

(above), colored glass panes add a strange ambience to the already atmospheric feeling from a derelict hall that once hosted a Viceroy's ball. Even though I shot the entire, cavernous ballroom, for this image I needed to close in on details, so that the color washes were prominent. That depended on the timing as the sun moved round and moved lower, projecting the colors higher and higher onto the wall. If the windows themselves are included in shot, you may need some local processing over them, reducing exposure to strengthen color saturation. The difference in brightness is easily around 6 f-stops. For the main image, I chose to exclude the window panes.

Ballroom before restoration, Rajmahal Palace, Baria, Gujarat, 2012

A difference in brightness

The difference between these two exposures is six *f*-stops. The intensity of color on the wall of the lighter exposure is approximately the same as the intensity through the window panes in the darker.

Psar Thmei market, Phnom Penh, Cambodia, 2011

In the Cambodian market (above right), the plastic awnings, out of sight, were anything but deliberate in their effect. They were just available cheap plastic. But the mixture of green and purple, understated, again gave a slightly strange atmosphere. You could be forgiven for wanting to correct the slightly sickly color cast, but for me it was eye-catching because it was unusual. Ultimately, unexpected color casts work, if they work at all, exactly because they are uncommon. The eye adapts quite quickly to the color balance of such scenes to the point of not noticing after some minutes, but the camera sees it afresh each time. ■

Passage of the sun

Stills from a time-lapse video of the same ballroom show the movement of the light, and color, across the floor and walls, over a period of two hours (from top to bottom).

203

HELPING

The theme of this book is dealing with natural and found lighting, rather than the constructed lighting of studios, but there are still occasions for adding to or subtracting from that light. Some photographers prefer to stay entirely with what light is available, and make shooting decisions like viewpoint and composition accordingly. Others, particularly on planned commercial shoots, want to tweak the lighting to help their idea of what the image should be. The smaller the scene, the more possible it is to modify the light at the point of shooting, and the first part of this section looks at modifiers, from reflectors to diffusers. I'll even cover flash, briefly, though I'm not a great fan of on-camera units myself, and it steps over the line into created rather than captured light.

Moving from front-of-camera to simply front-of-lens, filters have a long history of modifying the light that reaches the film or sensor. Many of them certainly compete with digital processing, which can apply color-balance settings and can handle a range of different exposures, but filters also help with the argument that it's always better to get things right at the point of shooting rather than rely on processing and post-production. Often, it boils down to the time available, which is why landscape photographers, whose time-frames run to minutes or hours rather than seconds, still favor filter types such as grads, polarizers, and neutral-density filters (for slow-motion water effects).

Moving downstream in the workflow, processing is impossible to ignore. It occupies an odd position in modern digital photography. Some photographers think of it as a technical mystery, and by not getting to grips with it, fail to do full justice to their work. Others treat it as more important than shooting, so of course fail in a more complete way because at heart they just want to play on a computer. Getting the balance right is critical, but in any case it is important to invest time and energy in mastering what has become a rich and complex procedure. This is unavoidable. Even if many of your shots need minimal processing because your shooting technique was excellent, there will always be some that depend on using Photoshop (or another application) skills to get them to the state you want. This is not, really not, about software trickery, but simply using the tools developed by good software engineers to control your imagery. I'm not overly keen on phrases like "achieving your vision," which sound a bit pompous, but if you're shooting with full attention, you know how you want the image to look at the end of it, and intelligent processing is the solution to that. There is plenty of room for interpretation—unlike, say, Kodachrome, there is not a standard way of doing it—and this alone should convince anyone that it is worth integrating personal processing with shooting. Yes it can be highly technical, but that's no reason to shy away from it. You may be convinced of this already, but I'm still surprised at how many photographers I meet who don't use processing effectively.

FILLED LIGHT Tai Chi in a Tea Garden

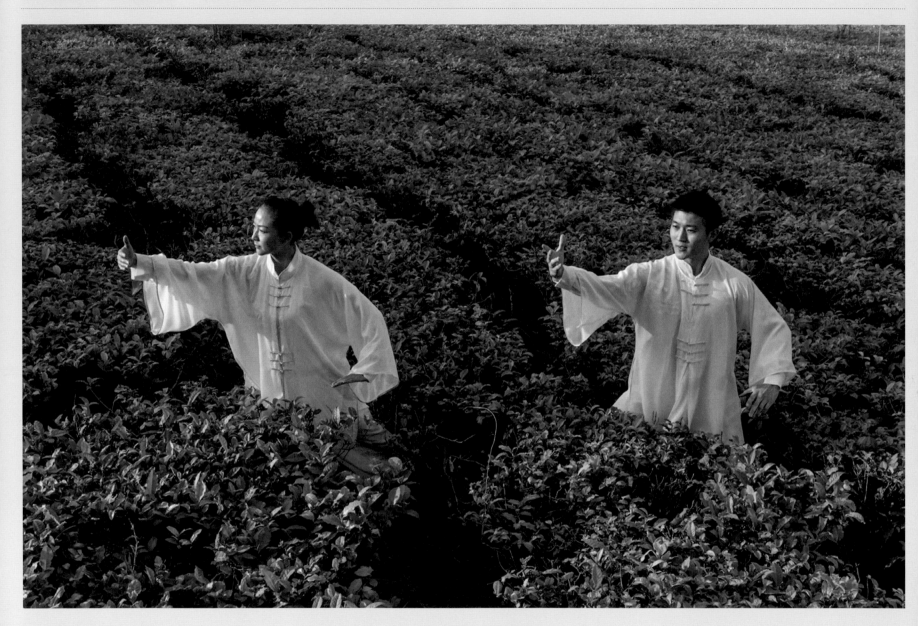

Tai Chi, Jingmaishan, Yunnan, 2012

Reflectors, despite clever new designs, are completely low-tech, which in photography means one less thing to worry about in case it goes wrong. So, a good thing. This is passive equipment that comes into play only because of the natural light that is already there. Their most basic use is to fill in the shadows on the side opposite the sunlight, but there are subtle differences even in this, from a simple balancing act between light and dark, all the way to a distinct "second light" effect. In this example, a commercial shoot in China, the intention was more toward a second light to add a sparkling glow to the two actors.

Opinion is divided on using reflectors, and the lines tend to be drawn between those who see photography as essentially documentary—telling

A RANGE OF SURFACES

Using stripes allows variations in reflectivity, and adding gold adds a measure of warmth to counter the blue tone that a clear sky brings to shade.

it as it is—and those who want to show it as they want it to look. This could be a cue for getting altogether too philosophical and navel-gazing, and I'll resist that, but ultimately it boils down to purpose. If you have to deliver an attractive picture of a subject that's already been decided—a definition of a commercial assignment, surely—then there are certain things you are honor-bound to do. Lighting being so important to the outcome of most photographs, helping it out where necessary is fundamental, and filled light is a basic tool for this. In fact, this has a lot to do with the way I organized this book, dividing it into sections on waiting (with some expectation that things will work out as you hoped), chasing (basically, coping pro-actively), and helping (doing whatever you're comfortable with to make it all look good). I make a reluctant nod to on-camera flash in a few pages' time, and using flash sparks an even more divided opinion.

This is probably the classic use of strong reflected fill, in which the camera angle is conventional, with the sun to one side and slightly back, and the reflector managed separately by an assistant from approximately opposite the sun. This was early in

The setup

Shooting within an hour of sunrise on a clear day meant that the fill from a medium-sized handheld reflector was powerful.

the morning with a clear sky, so I could expect a strong fill because the sun was low and available for a powerful bounce-back. Exact positioning of the reflector was important; it needed to be from an angle that took in both of the actors without casting a shadow from the nearer one onto the second. ■

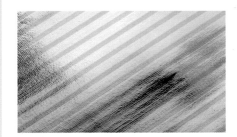

FILLED LIGHT In the Hall of Dancers

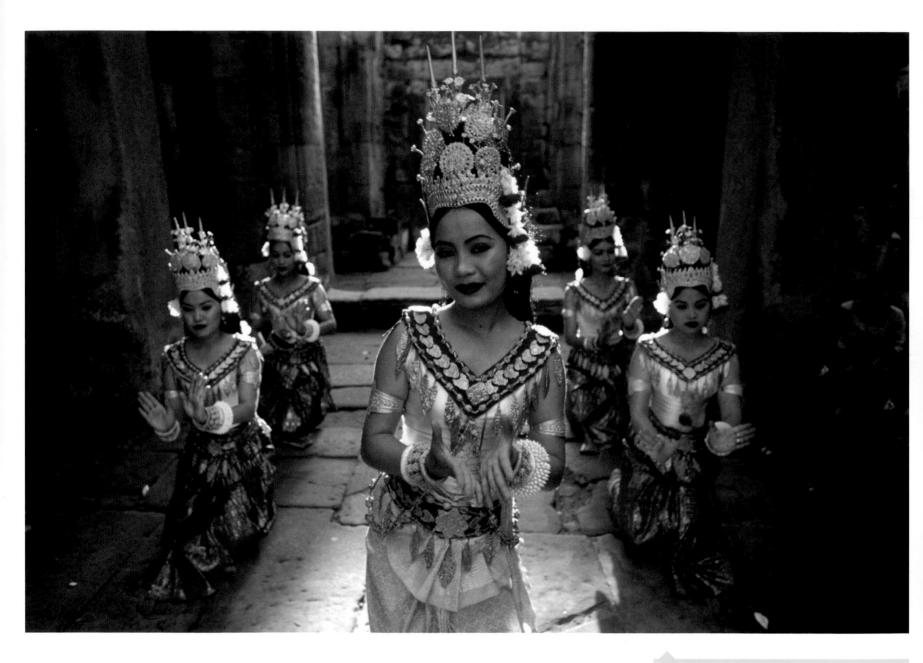

Khmer dancers, Preah Khan, Angkor, 2002

Range of Reflectors

Different sizes and surfaces with different reflectivity and color

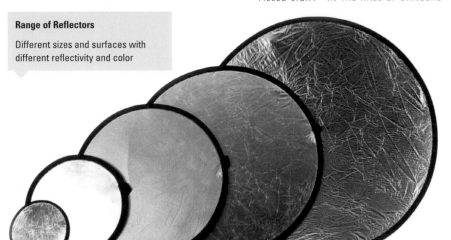

This was a situation, well planned, where the sunlight was directly in front of the camera, even though masked off by the building, so in one way it was a little similar to the situation on pages 140–141, Spot Backlight—*Light Against Dark*, but also the dancers were edge-lit as on pages 130–131, Edge Light—*Elusive & Special*. However, unlike an off-the-cuff edge-light shot, exposing down so as to hold the lit edges of the figures was not an option. This was an organized shoot in which the troupe of dancers had been hired, and it was important to show all the details of costume and faces. A reflector from the camera position was essential.

Managing the reflector fill needs attention, and always needs an assistant, even a co-opted companion. There are two absolutely key steps, very simple, but essential. First, you need to catch the light, which means looking at the reflector itself, standing in maximum sunlight (avoiding shadows cast by branches or buildings), and angling the reflector so that it holds the full sunlight. Next (and these two do need to happen in sequence), you direct the sunlight already caught toward the subject, which means shifting attention from the reflector to the subject. Simple and obvious though this is, it goes wrong surprisingly often, sometimes because the light shifts, or the subject moves, or the assistant holding the reflector needs to move back so as to widen the spread of light from the reflector. For such a simple piece of passive equipment, there is a certain skill and attention needed when using it. ∎

Unfolding the reflector

The circumference held with a band of flexible steel, circular reflectors are designed to fold in a figure-of-eight way for compact storage.

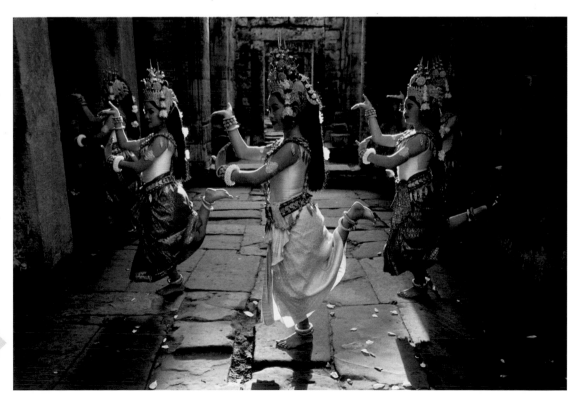

Khmer dancers, Preah Khan, Angkor, 2002

FILLED LIGHT On-camera Flash

I'm breaking one of my own habits here, but only by as much as I like to break it when shooting. The habit is to avoid on-camera flash. This may seem perverse, and probably is, because as you can easily tell from the many references throughout this book, I'm completely comfortable with planned lighting, and use it wherever necessary. When the occasion demands—and it's nearly always for a commercial shoot—working with a 9000K Maxi Brute or more demanding still, 5000-joule flash units, can even be fun. But that's another book, one about constructing lighting rather than, as here, capturing it.

My reason for not using flash is that it interferes with showing what things actually look like. This is an entirely personal view, and not one I'm necessarily recommending, although I'm in the company of a number of like-minded photographers. Basically, it's about the purpose of the job, which on the editorial shoots that I normally do, means documentary. The rapid rise of sensor sensitivity, combined with the superior Raw processing now available (and detailed a little later in this section), weakens the case for flash further. And it was Cartier-Bresson, after all, who wrote, "And no photographs taken with the aid of flash light, either, if only out of respect for the actual light—even when there isn't any of it."

Even so, it really would be perverse of me to ignore using flash on location to perform the same kind of fill as the reflectors we've been looking at. Try hard though I do not to use on-camera flash, there are situations when the only alternative answer would be to walk away from the shot entirely. If you shoot only for yourself, you can do that, but assignments are a different matter. These two pictures were both in that assignment category where I needed to shoot in a

Katakau, Kenana sugar plantation, Sudan, 2004

Squid fisherman, Gulf of Thailand, 2007

level of darkness with fast movement, and flash was unavoidable. Flash offers fill lighting with a difference—it lasts a very small fraction of a second. On a good, modern portable unit, speeds can be in the order of a ten-thousandth to twenty-thousandth of a second. Both of these situations had fast movement in near-darkness, one before dawn on a sugar plantation in Sudan (above), the other on squid boat at night in the Gulf of Thailand (opposite). Both needed to rely on ambient light to show the setting, so the flash fill was triggered as rear-curtain (or second-curtain). This

method means that the flash fires at the very end of the exposure, putting the stamp of a sharp closure to a partially streaked image. The technical settings vary from equipment to equipment, but all are relatively straightforward. Incidentally, on the squid boat, shortly before shooting, I received a text message from a photographer friend, Chien Chi Chang: "Remember, HCB says no flash!" His idea of a joke. ∎

REROUTED LIGHT Deep into an Angkor Temple

Reflectors can be used in a fundamentally different way to the usual fill. When necessary, and given a direct route from the light source to the subject, reflectors can provide the actual lighting. This usually means a bigger throw, because situations where there is almost no light tend to be very deep recesses, sheltered a long way from direct daylight. This was exactly the case here, in one of the more complex temples at Angkor in Cambodia. Preah Khan, built in the twelfth century, was one of the largest temples as well as a Buddhist university, and has many convoluted enclosures with narrow galleries. A very long exposure with the camera's noise reduction switched on would have coped with the very low light levels, but deep in shadow also meant lacking in any kind of contrast. The solution was to wait until the sun was in the right part of the sky (mid-afternoon), and reroute its light from outside the gallery to deep within, as the illustration shows. There was nothing more complicated to it than this, and the effect was perfect. Bas-reliefs—which is the form that most of Angkor's decoration takes—project themselves strongly and best in raking light, as we already saw on pages 42–43 in Raking Light—*Perfect for Bas-reliefs,* and this put a proxy sun in the right position.

The method follows the same principle as for normal fill in sunlight. First, you position the reflector in full sunlight to catch the maximum, and the effect is strongest when you face the sun. Then you direct the caught light from the reflector into position. When I mentioned that we waited for the right time of day, the strongest fill is when the sunlight is being directed at close to 180°, almost straight back. One variation on this is to use two reflectors to turn another angle, but the amount of light is heavily reduced. ■

Devata, gallery of Preah Khan, Angkor, Cambodia, 1991

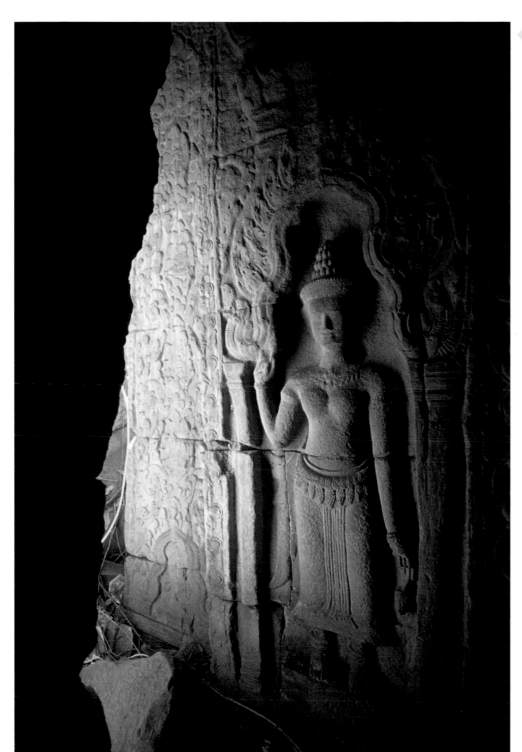

Devata, gallery of Preah Khan, Angkor, Cambodia, 1991

Reflected light as source

The construction of stone temples like these at Angkor creates galleries and chambers completely cut off from direct light, and for this a reflector can make a spectacular difference.

ENVELOPING LIGHT A Sense of Scale

The idea here was to produce an image of this heavily worn shell interior (above) that would look large in scale when printed large. Of course, printing large (to a yard/meter or more) is part of the effect, and not possible to show here, but the other two keys are the depth of field and the lighting. In other words, I'm trying to confuse the sense of scale, and there are lessons to be learned from a sub-genre of photography in which scale models are created and shot to look exactly like the real, full-size thing. I'm not attempting that here, as it is, after all, recognizably part of a shell.

Full depth of field is not what we expect from a close-up picture, and so it becomes a very convincing technique when applied as here. Optical physics make full front-to-back depth of field impossible in macro photography, but focus stacking solves this problem. Several-to-many images are shot at different focus points, and then specialized software blends them together, choosing the sharpest areas from each. That was done here, and is a fairly automatic process. The lighting, however, needed more thought. With miniature sets, photographic lighting often gives the game away for two reasons: one is the fall-off because of the inverse square law that we saw in Window Light—*Classic Fall-off* on pages 86–87, the other is the softening of shadow edges with distance. The combined result is that hard lighting lacks the naturalness of true sunlight. One solution is to shoot in natural daylight, which is what the American photographer Michael Paul Smith does for his scale model recreations of 1950s small-town street scenes.

The alternative lighting solution is to remove all shadows. The way to do this, as here, is to create enveloping light with first, a broad source, and next, invasive fill reflections. The reflections need careful management to keep them anonymous, and in this case (opposite) involved several dental mirrors, each lighting a particular part of the shell. The light source was simply a window, and cloudy daylight. ■

Eroded gastropod shell, 2011

Actual size

Only the spiral central structure of this relatively large sea gastropod remains.

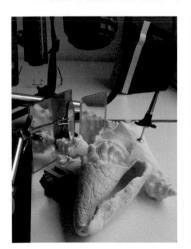

Praying mantis, Ise Grand Shrine sacred rice field, Japan, 1996

The setup

With daylight as the base source, the lighting was constructed with small mirrors to remove shadows and shadow edges.

ENHANCED LIGHT Boosting Highlights

Reflectors, as we've just seen, have more uses than many people realize, and straight shadow fill is just the start. In fact, as here, reflectors can be used opposite of their normal effect. Instead of filling shadows to lower the overall dynamic range of a scene, they can raise the dynamic range by adding to the highlights. Positioning the reflector is a little trickier, because I'm trying to put the light in on the same side as the sunlight, but is still useful. This was a situation in which the lighting inside the room was already quite soft, but because I'd chosen to do a mirror-reversed portrait, I wanted to increase the modeling on the face. The mirrored reflection was automatically taking down the contrast and softening the image slightly, which was part of the intention, but I certainly didn't want a flattened effect on the face. The light from the window behind came from sunlight reflected on the courtyard's walls, and so was quite broad and pleasant. What the face lacked was definition on the profile side— camera left, and that was where the reflector came in. I had a helper stand in the courtyard in full sunlight and aim the light to the edge of the face. Looking at it in reverse in the mirror this became an edge light, so I positioned the camera (this was a tripod shot) so that this edge-lit half-profile was set against the pale shadow on the wooden wall beyond. This heightened the local contrast and made it better defined.

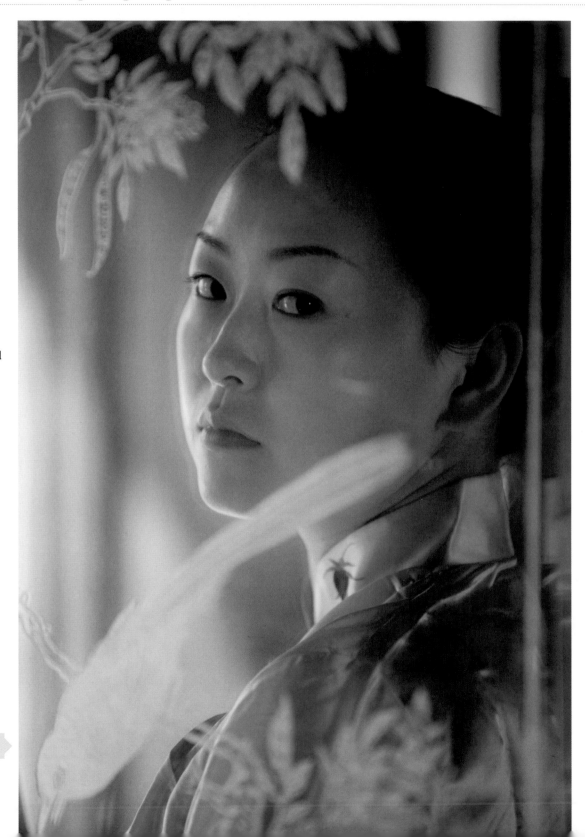

Young woman in *qipao*, Heshun, Yunnan, China, 2009

A family heirloom

Almost a century old, this green silk *qipao* belonged to the owner's mother.

A word about the setup. This was an impromptu portrait on a more general assignment—on the ancient trade route called the Tea Horse Road, in southwest China. Impromptu because the owner of the house we were shooting, whose family had been traders on the Road, showed me an old, exquisite silk *qipao* (also known as a *cheongsam*). That prompted the portrait session. The reason for shooting into the wall mirror, incidentally, was to take advantage of the lovely glass engraving, which when kept a little soft in focus would both add depth to the shot and provide some framing interest. ■

The setup

Rather than filling shadows, the reflector was used to add to and exaggerate existing highlights on the side of the face.

Silk *qipao*

The *qipao* as worn.

Engraved mirror

The engraving on an old wall mirror suggested a layered setting for the portrait.

SOFTENED LIGHT Making a Window a Light Source

Herbs, garden shed, London, 1974

Key Points
Window as Source
Diffusion Panel
Sidelit Modeling

I mentioned earlier, in Window Light—*Directional with Soft Shadows* on pages 84–85, that as long as there is no direct sunlight coming through, a window effectively becomes the light source, rather than the sky beyond being the source. Even so, it can still be improved on, by the simple method of adding a diffuser and turning the window into an oversized softbox. This is particularly useful if you want to show the window in-frame and to guarantee that it appears as a blank, white rectangle. One advantage of doing this is that it removes any distractions that might be seen through the window, such as buildings, trees, or changes in color or tone in the sky. More than this, however, it blocks any direct sunlight. This is important because, while direct rays from the sun can be very attractive, as we saw on pages 88–89 in Window Light—*Streaming Sunlight*, and also on pages 148–149 in Patterned Light—*Windows & Blinds*, they do not lend themselves to the kind of planned shot that can take an hour or two to set up. Sunlight falling through a window moves visibly in several minutes. Worse still, you might set up facing a skylight only to find that the arrangement takes longer than you thought and the sun starts to stream through.

That was the case here, where the brief called for a delicately lit still life of herbs and other plants. There were two ways of doing this, one of them involving gathering the plants and bringing them to a studio; the other, shooting on location. Once some scouting had found this old allotment garden shed, full of the weathered and natural detail that is almost impossible to reproduce authentically as a studio set, that tipped the balance to shooting on location. The lighting plan was decided as a Vermeer-ish single window from the side, with the north European muted colors and rich shadows that the Dutch painters captured so well (see pages 84–85). Shooting at a slight angle into the window, and including part of it in-frame, just as in Vermeer's *The Milkmaid*, increased atmosphere and mood, so no other light was wanted. A barely noticeable, and sufficient, fill came from the shed's open door. All of this made it important for the window to function perfectly as a large light bank, hence the use of a lighting silk slightly larger than the window and fixed in place outside. ■

Range of location lighting panels

For location shooting, rigid-framed panels on adjustable stands are standard.

The setup

A silk slightly larger than the window was fixed just outside, while the open door allowed minimal front fill.

BROADENED LIGHT Wide Diffusion from a Large Window

Chinese desserts, 2012

A variation on the use of a silk to turn a window into a light bank, shown on the previous pages, is to stretch the diffuser *inside* so that it becomes a large and even light source. One very good reason why you might want to do this is to give solid backlighting. This kind of effect is standard practice in studio still-life shooting for the kind of image you see here—an even flood of light from behind the subject. This in turn is what you need for two kinds of arrangement, both shown here, and both useful in different ways for shooting food. One is a horizontally aimed shot that effectively puts the subject against a clean, white backdrop (opposite). If there is no other light, the result is a silhouette, but for normal still-life shooting it's usual to either add a light or a strong reflector from front or side. The other is a more normally framed food shot, looking slightly down (the eater's viewpoint) so that the backlight is just out of frame but bathes the top of the subject (right). There are many styles and fashions of food photography, but clean and broad lighting from this angle, so that it heightens any glistening textures, is a perennial. Doubly necessary in this case, because of the glossy ceramic surface, which is going to reflect something whether I like it or not, so it might as well be a large and smooth light. This will convey the sense of the plate's high glaze without showing distracting objects.

The location, however, was remote and we needed to improvise a food still-life studio. You might think that the lights themselves with their stands are the bulkiest part of a studio kit, but the real difficulty for location work is carrying a large enough pristine background (unscratched, smooth, unmarked). Often this is impractical, as it was here in the far southwest of China. Absolute evenness of illumination is the ideal in this kind of set-up, and when the entire backlight—or its reflection—is in shot this becomes critical. In the studio, where the light sources are always close—much closer than the sun, that is—the thickness of the diffuser is important. The thicker it is, the more evenly it spreads the light, and we saw this in the illustration on pages 68–69 of translucent sheets. Using daylight instead solves this particular problem, because even if there is direct sunlight falling on the diffusing sheet, the distance of the sun ensures that there is no side-to-side fall-off. However, the material itself can create shadows, and if I'm improvising with a bedsheet or tablecloth, as here, smoothing out the natural folds takes time. One partial solution is to be careful with the aperture setting. It needs to be small enough to have the whole subject in sharp focus, but no more than that, so that the background will be out of focus, as this will smooth out folds, shadows, and marks. ■

Scallops, 2012

Improvised diffusers

Two large bedsheets were hung inside the large glass window on both sides of the corner of the dining room to create an enveloping, soft, and shadowless light.

FILTERING LIGHT Grads, Stoppers, Band-stops, & More

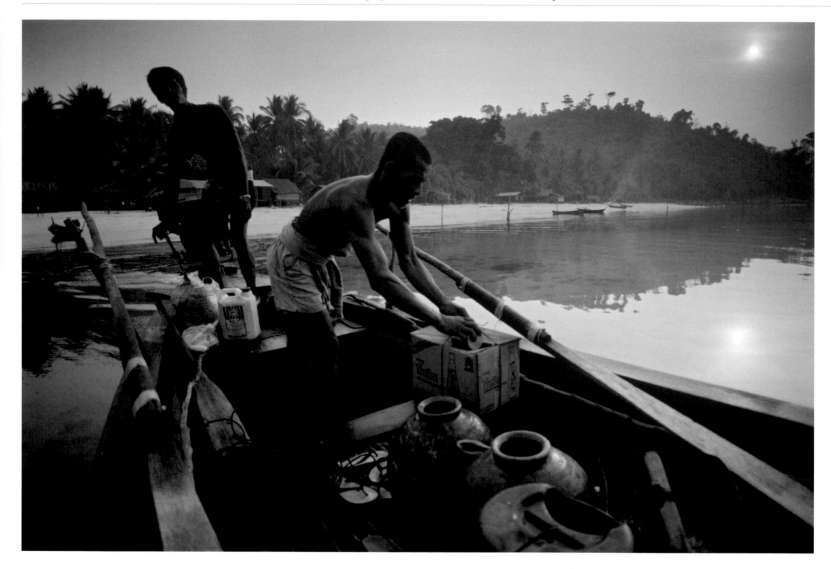

Birds' Nest collectors, Ko Phi Phi, Thailand, 1983

Much of what filters did for film can be replicated in processing and post-production, so why bother with the extra equipment and the extra time it takes in shooting? The reasons are specific to each type of filter, and we can start by dismissing color correction and color balancing filters, which really are unnecessary if you shoot Raw. Those are settings that can be applied and tweaked as you process. The others here, however, do have uses. Some, like a circular polarizer, do something selective to the light entering the camera that no amount of post-production can recover. Others, notably grads, have digital alternatives, but are liked by the school of get-it-right-when-you-shoot.

First, grads, which are slidable, rotating filters that we already saw in action in Top Light—*Deep Forest* on pages 82–83 and Window Light—*Classic Fall-off* on pages 86–87. Half is clear, half is darker by a certain amount, and the transition line is blurred to some degree. The main use of these is to darken the sky by aligning the transition line with the horizon, and grads that darken by 1 or 2 *f*-stops are the most

popular. The exact blurring of the transition is important for a natural result, and there are two ways of controlling this. One is to buy either a sharp-cut grad or a soft-cut (hard-edge, soft-edge)—whichever is appropriate. The second is to alter the combination of aperture and focal length—the sharpest transition is with a wide-angle lens stopped right down, while opening the aperture and/or zooming in for a longer focal length will spread the transition out. In the main shot here, a 2-stop grad was placed to darken just the sky—and the reddish color around the sun, by the way, is not because the filter was tinted, but because at this lower exposure the early morning sky was warm.

ND STOPPERS

While ISO sensitivity in new sensors races in one direction, there are also reasons for wanting to reduce the amount of light passing through the lens. One is so that you can use the maximum aperture of a fast lens for highly selective focus (this can be difficult in bright daylight). Another is the kind of water shot that turns waves and flowing water into a mist because of very long exposures, and a third is video-plus-selective focus, where you want to keep the shutter speed down to 1/30 second. For all of these, neutral-density filters have their use in varying strengths (misty sea shots in daylight call for something like a 10-stop filter).

POLARIZERS

Polarizing filters suppress reflections from non-metallic surfaces (includes water and glass, and therefore reflections from minute water droplets in the atmosphere). One obvious effect is to darken blue skies—this effect is strongest at 90° to the sun—but more generally useful is the increased saturation from surfaces, including rock, which would normally appear lighter. Circular polarizers generally allow more accurate metering than linear polarizers (both are

round; the term circular applies to the polarization, not the shape of the filter). For suppressing reflections from flat or flattish surfaces like water or glass, the effect is strongest at about 35° to the surface. With blue skies, because the effect varies with the angle to the sun, using a polarizer on a wide-angle lens (wider than about 28mm) gives unnatural-looking deeper shading to just part of the sky.

HOT MIRRORS

These are optically clear filters that cut infrared, generally above 700nm, with a sharp-cut effect. The technology involves reflecting infrared wavelengths back to source while passing the visible spectrum, and has become more important than it was because inherently, digital sensors are sensitive to infrared. The sensor's high-pass filter is intended to take care of this, but for an absolute solution to infrared pollution (as it's now called), hot-mirror filters are the answer.

RED-ENHANCING FILTERS

These are one of the rarer members of the filter collection, and use Didymium glass, which was developed for safety glasses used in glassblowing and forges, to selectively enhance reds. Dydymium does this because it acts as an optical band-stop filter, by blocking a narrow band around orange. This in turn makes reds appear more vibrant because orange and yellow-orange components in red tend to give it a muddy appearance. These are expensive filters, but popular in particular for shooting fall colors. ■

Circular polarizer

The more subtle effect of a polarizer in landscape shooting is to increase saturation and therefore contrast, which translates into black and white also.

Oversized grad

DSLR video adds another reason for using a grad to reduce the dynamic range, as applying a grad effect digitally to a moving image is much more time-consuming than for a still. New fittings are available for ultra-wide lenses, such as this 14–24mm.

BROKEN-SPECTRUM LIGHT Making the Best of CFLs

The wholly admirable drive toward energy efficiency has created a minor visual disaster for photography. The warm and lovable tungsten lamps that continued the ancient tradition of lighting by burning are being ousted by CFLs (Compact Fluorescent Lamps), and the light in home interiors has plummeted in quality. In this sense, by quality, I mean light that looks pleasant and as it should be, which is surely not an unreasonable thing to ask. CFLs, however, produce a light that can be described only as white(ish), with something hard to pin down but wrong about the way they render human skin to the eye (unless you like that zombie/ living dead appearance). And this is just the appearance to the human eye, which is very tolerant and adaptable. Photography much less so, whether on film or via a sensor.

The bottom line is that CFLs completely fail to emit some colors of light, so little wonder that processing images shot under their light is so unsatisfactory. The reason is that while both daylight and tungsten emit a smooth and continuous range of wavelengths (that is, colors), CFLs emit spikes of narrow wavelengths. Phosphor coats the inside of the glass tube, and it glows when backlit by ultraviolet light from mercury vapor. As a continuous range is impossible, CFLs have a combination of phosphors, each glowing a different color, the idea being that when the eye adds them together, it approximates white. Needless to say, this approximation varies between brands, but it seems that only photographers care, so we are not catered to.

This is definitely a light-capturing problem, which I'll now tackle, but be warned that there is no completely happy ending. The missing bits of the spectrum are simply absent colors, and there is no way of replacing them. The best result possible is a slightly monochrome effect that you can place according to taste between neutral white and creamy. Even achieving this meager goal takes some effort in

Zhong Song apartment, Beijing, 2007

The original exposures

Spaced 2 *f*-stops apart, these four frames cover the dynamic range, but also show that the color changes with brightness.

A JAGGED SPECTRUM

This is the spectral emission from a typical CFL, and while it's evident that the manufacturer tries to mimic "white" and the eye's response by peaking in important colors, there are large and irreplaceable gaps. The pale bell-shaped curve is the response of the human eye.

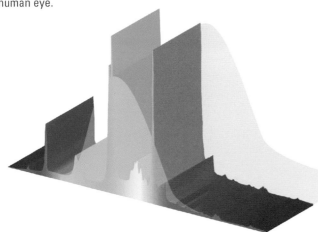

processing, and what follows is my workflow when I have to shoot by CFL light. First, though, a reasonable suggestion is to replace the lamps or shoot in daylight. These are possible sometimes, but it's more likely that a room will have a number of different light fittings, making replacement impractical.

The small mezzanine bedroom here is a case study, a minimalist space that if lit with tungsten would be pleasant, light, and graphic. As with all forms of this kind of concealed lighting, which first became popular in the 1920s with Art Deco, the dynamic range is very high, because the total effect depends on a bright glow from parts of the room. The eye manages this perfectly well, but photographically it calls for a range of exposures and HDR, which we'll see in a short while, on pages 242–247. This would be the case with tungsten or any kind of lamp, and is not complicated, but as you see from the four original frames, shot at Auto color balance, with CFLs there is an additional problem. Not only is the base color an unpleasant yellow with green tendencies, but also it varies according to brightness. However we handle it, this will translate into an exasperating color banding in the top highlights. ■

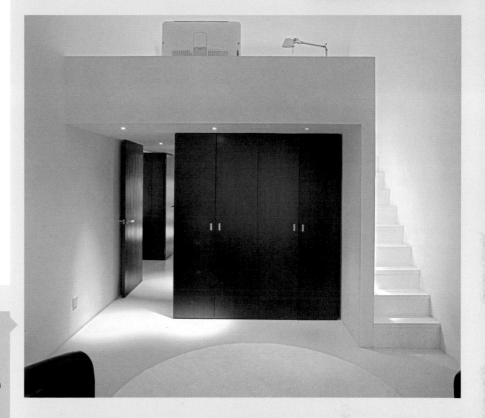

Zhong Song apartment

The apartment in which the main shot was taken. The bedroom was in fact at the top of the flight of steps in this picture. In combination with the bluish hue from daylight and the orange-yellow from the tungsten ceiling downlighter, the CFL lighting does not dominate and is more acceptable.

Nissan Showroom control center, Ginza, Tokyo, 2002

Also lit by fluorescents, the hi-tech room in the car manufacturer's principal showroom had similar light problems, and was filtered for a warm, creamy effect.

BROKEN-SPECTRUM LIGHT Making the Best of CFLs (continued)

The first step is to combine the different exposures into a single HDR 32bpc (bits-per-channel) file. I'm jumping ahead, as this technique is dealt with on pages 244–245, and I will not repeat the technical steps here. The point, however, is that with this degree of high dynamic range, there's no real need to use the tone-mapping techniques that introduce artificiality. If we simply save the Photoshop-merged image as a 32bpc TIFF, we can reopen it in the ACR Raw-processing window and recover all that we need to from highlights and shadows. Again, see pages 244–245 for how this works in detail. You can see the result before I've made any attempt at color correction, and it's fairly unpleasant. Worse still, the color shifts that we saw in the original exposures have been combined, and in the higher register of brightness, there's a cross-color shift between greenish and pinkish.

Raw processing complete

With the color corrected by eye during Raw processing, the now-16bpc image shows patchy color shifts as arrowed. The ends of each arrow show the shift, slightly enhanced for clarity.

R	210
G	205
B	197

The target color

Using the small square area outlined in the picture on the right, the image is color-adjusted to this warmer target color.

Intermediate step

The 32bpc file generated from the four originals has been re-opened in Photoshop ACR and at this stage simply optimized: Highlights and Whites fully down, Shadows fully up, Contrast higher and Blacks down to the point just above clipping. The color remains untouched.

As I mentioned, we would have to do this anyway for any light source in a situation like this, just so that the highlights can be smoothed, to avoid clipping. At the same time, however, we can use the Raw processor to alter the color, and what I've done here is to judge it by eye and make the overall appearance very slightly warmer than neutral, taking it very far from the greenish-yellow. The result, nevertheless, is far from good, with patchy discoloration—and this discoloration has shifted because of the color adjustment just made to the overall image. In the higher register of brightness, there are now green notes adjacent to pale magenta notes.

At this stage, the only way to deal with the discoloration is selective color shifts of some kind. The method I used here was to choose an acceptable target color with reduced blue—a creamy hue—and then use a soft brush set to Color and a 60% opacity to work over the offending areas. What's wrong with this technique, of course, is that it goes partway toward making a monochrome image. But it can't be helped. As I said, no perfectly happy ending. ■

Zhong Song apartment, Beijing, 2007
The kitchen of the same apartment. Here the problem is balancing the CFL-lit kitchen with the more attractive combination of daylight and tungsten in the living room beyond. This called for selective area adjustment, but the fact that there is a variety of cultured lighting compensates a bit.

Detail processing sequence
This part of the scene is lit by CFLs. (1) as opened in the Raw processor; (2) Exposure, Highlights, Shadows, and Whites adjusted; (3) color adjusted by setting the handle of the kettle at neutral; (4) lowering the color temperature and increasing Vibrance.

FLARE UP Distressing an Image

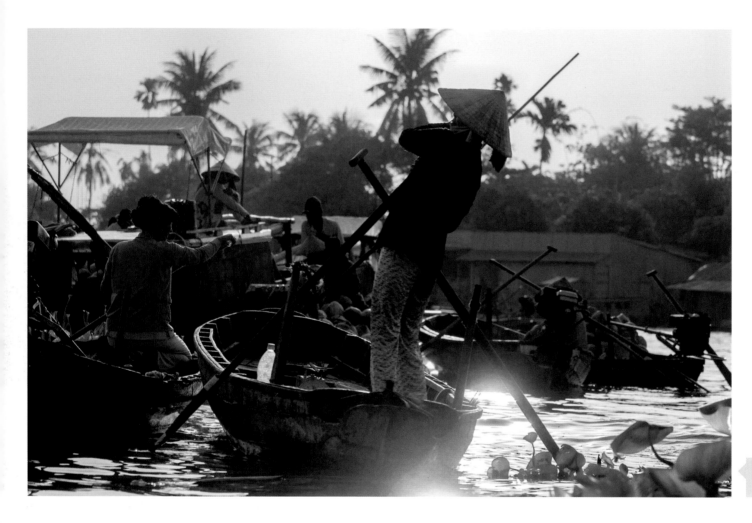

Floating market near Can Tho, Vietnam, 2011

| Default process | Optimized process | Converted to black & white | Black & white points closed up | Contrast curve applied to shadows & darks |

 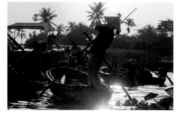 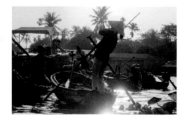

As we saw in Flared Light on pages 170–171, this optical fault—well, imperfection, anyway—can be useful for atmosphere and for getting across a more intense feeling of brightness. Depending on personal taste, it can enhance rather than detract from an image. And with so much possible in processing, it's also natural to consider increasing or controlling flare at the final stage. Here are two examples, one using purely processing tools to make the flare more prominent, and the other going much further.

In the shot of the Vietnamese boat woman in the Delta (opposite), the glint of early morning sun off of the water is a key part of the shot, but there are two problems. One, the flare, attractive around the water ripples, has leaked across most of the image, weakening the contrast. Second, this flare has also contributed to an unpleasant greenish yellow in the light mid-tones. The processing sequence shows the solution, which is first to optimize in the Raw processing, recovering highlights while increasing contrast, then to convert to black and white, raising the lightness of reds and yellows, which are concentrated around the water. Next, use levels to close in the black and white points, and finally, apply a contrast curve to the darker 50% of tones. In Photoshop, there is a button under Channels that automatically selects the lighter 50% of pixels. This selection is concentrated by increasing the contrast to a Quick Mask of this, and then inverting the selection. The result is to darken and enrich the shadow areas, while leaving the flare alone.

The next procedure is contentious. There are post-production techniques for introducing flare, and though I won't even try to justify this to a purist, it really is worth considering why this software exists in the first place. All the effort that goes into making superior optics, with coatings that protect the clarity of the image from flare, and some people actually add it back in! Well, where it routinely gets added back in, though you might not always be aware of it,

An infinite combination of flare elements from Light Factory

Because flare can contain multiple elements, and each of these varies in intensity, size, and color, the possible combinations are endless.

is in the movies, and the motive is simple—to add reality. Most movies are fiction, and increasingly use CGI (computer generated imagery) to achieve effects that would be impossibly expensive, or just impossible, in front of the camera. Now there happens to be a repertoire of camerawork techniques—movie and still—that help to give the impression of being in the real world, with all its little imperfections. These include cinema vérité, handheld cinematography mimicking amateur practice (*The Blair Witch Project*, *Cloverfield*), framing that cuts into foreground subjects, and lens flare.

Real lens flare doesn't always behave in the way you might like it to, and the alternative is to generate it as CGI, overlaying it on a video sequence or still image. The software used here is professional level and very convincing, called Knoll Light Factory from Red Giant software. This is deep stuff, with a huge number of flare elements that can be combined and adjusted infinitely, created by people who have a very good understanding of lenses (as you would expect in Hollywood). In fact, it's the invention of John Knoll, visual effects supervisor at Industrial Light and Magic and co-creator with his brother Thomas of Photoshop. I once did a story for *Smithsonian* on ILM, at the start of digital effects, and remember Knoll explaining to me how a spline algorithm worked. Here in this flare generator there are glowballs, ramps, rings, caustics, and polygon spreads, and just operating the controls is itself a lesson in how light works. ∎

Pathan boy learning to shoot, Northwest Frontier Province, Pakistan, 1979

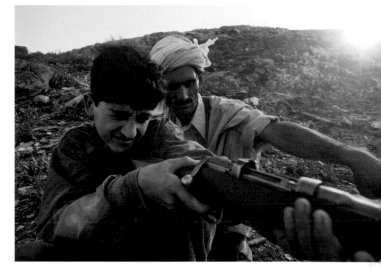

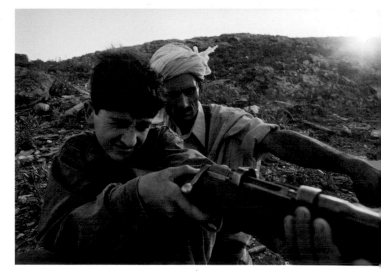

Original without digital flare applied

FLARE DOWN Flagging the Source

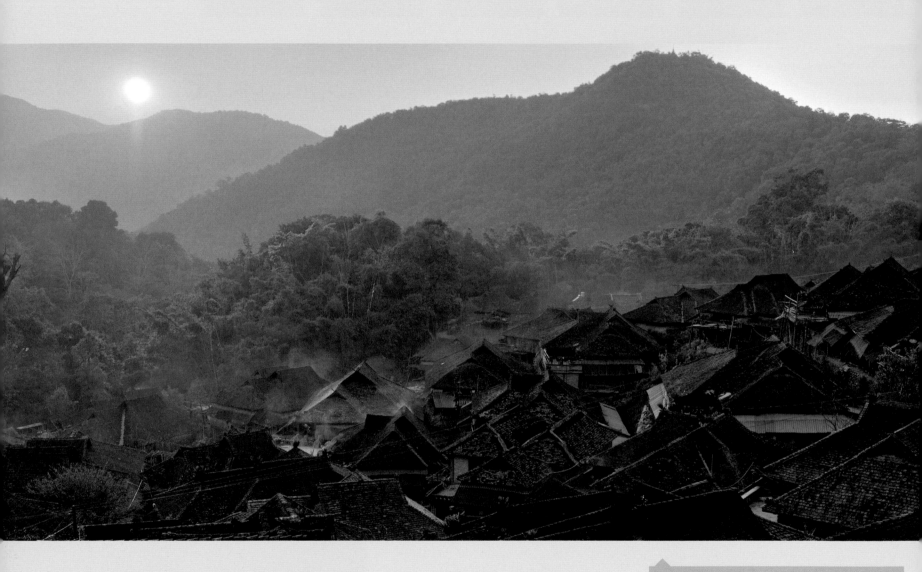

Zhanglang village, Xishuangbanna, China, 2009

Having just more or less promoted the case for injecting atmospheric, image-destroying flare into the picture, I'll now take the more conservative, cautious, and basically professional view for eliminating it. This is the technical, lens manufacturer's view, which is concerned with well-designed and well-made optics. Indeed, good optics are the first port of call, as decades of research have gone into contemporary lenses, and the arrival of multi-coating in the 1970s made a huge practical difference to lens flare.

Nevertheless, even with coated lenses and a lens hood, shooting toward the sun always creates some degree of flare. One of the standard techniques for reducing the diffuse flare that comes from bright surroundings outside the frame is flagging off. A flag is a sheet of something, such as black card or metal, designed to be held or fixed in front of any light forward of the camera. With a set-up shot where there are the facilities and the time to perfect things, and the camera is locked on a tripod, it's usual to put a flag on a stand so that its shadow just falls across the lens without appearing in shot—one thing less to worry about—but you can improvise with your hand. In fact, it's much easier to use someone else's hand: They stand in front and to one side, at a distance of a few feet, and simply watch where the shadow falls— no more than a fraction beyond the lens surface. But for the image I'm showing here, the only solution was an extreme one. The view I wanted, of a Bulang minority village in the border hills between China and Myanmar, was exactly this, and there were no other real choices. I needed the sun to illuminate the roofs, and this was the one effective viewpoint. If I waited any longer, the sun would go off the village. The only answer was to lock the camera off on a tripod and take two rapid shots, one with my hand blocking the sun, the other without. Combining the two as layers digitally was straightforward; it meant simply erasing part of the upper layer. ■

Flagging precision

The key to effective flagging is to shade the lens exactly up to the edge of the front element—always best performed from a position in front looking back at the lens.

A two-step shot

The sun's position and the viewpoint made this inevitable: a rapid sequence with and without the sun obscured by the photographer's hand.

FLARE DOWN High-Radius Sharpening

Household Cavalry at the Lord Mayor's Show, 1977

The most effective way of controlling flare is at the time of shooting, by blocking a direct view of the sun, as we saw on pages 56–57 Into the Light—*Blocking the Sun* and pages 60–61 Reflection Light—*Mirror Smooth*. Even so, post-production can also definitely help with generalized flare, and there is one easy and very effective procedure in Photoshop, developed in the printing industry by reprographic houses to deal with flare on scanned photographs. Flare, as we saw, is caused by light reflecting from lens surfaces instead of passing through and refracting to make the image. Scanning an image can also do this when there is an optical system involved. The answer is to treat the flare

STEP ONE

Make a duplicate layer and set it to Darken. This means that only the darkening effects of whatever procedure happens next will be visible.

STEP TWO

Apply USM sharpening at a low level (approximately 15–30%), a large Radius (here 300 pixels as already measured above), and without any Threshold protection (not necessary for this procedure).

as lowered contrast spreading out from bright light within the frame. High-radius, low-amount sharpening is a way of increasing contrast, and this variation applies it to just the brighter areas caused by flare.

This use of USM (Unsharp Masking) inverts the normal settings, which are a tiny radius to enhance the contrast from one pixel to its neighbor (typically slightly less to rather more than one pixel) combined with an amount in the region of 100%. A larger radius, of several pixels, creates an unpleasant halo effect around edges, but when the radius is increased greatly, up to a few hundred pixels, the sharpening effect is diffused, and if the amount is kept down to something like 15% to 25%, the result is not at all artificial looking. What makes this technique so good for flare is that it is applied to a duplicate layer set to Darken. Only the brighter flare is affected.

This image has all the makings of flare that is difficult to control. The polished armor of the Horse Guards is reflecting weak sunlight against a dark street background, and the surrounding flare is noticeable, as if through spectacles that need cleaning. The ideal radius depends on the resolution of the image, as it's measured in pixels, and on how far you want to darken from the bright areas that cause this kind of flare. The amount chosen in this case is shown graphically. The amount is best judged by eye; although in this case I've measured the amount needed on the image beforehand—about 300 pixels. ■

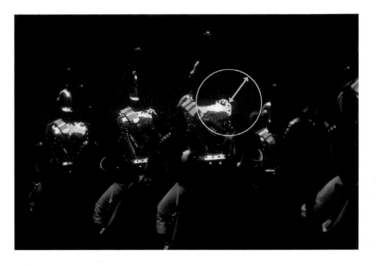

Flare as shot

The original, with flare leaking into the dark areas surrounding the body armor. The circle shows the amount of spread, which in this image has a radius (the arrow) of about 300 pixels.

Conventional contrast

Some seconds before, I shot this more conventionally lit version of the cavalry.

233

PROCESSED LIGHT Making the Most of Raw

Farm, Dentdale, Cumbria, 2011

Think of digital capture as being something like an iceberg. A good digital camera, working in 12-bit or 14-bit, captures more visual information than a computer or tablet screen, or a printed page, can display. Modern DSLRs have a very good dynamic range, in the order of 13 to 14 *f*-stops, of which about 10 to 11 stops is clean and usable, but in the end this will be reduced to a displayable 8-bit image. Processing allows the "hidden" parts of this range to be recovered and used, such as by lifting shadow detail. The camera's own processor can do this to deliver a JPEG or TIFF, or you can do it with much more computing power and a wide range of tools on a computer, using one of a number of what are called Raw-processing engines. Adobe Camera Raw (ACR), the engine used in Photoshop and Lightroom, is probably the best known of these.

This is the reason for shooting in Raw format rather than JPEG or TIFF. It captures more information and you can put this to use when you process. What you see, on the camera back or on a database screen, is simply a JPEG generated on the fly from the Raw file, so is at best just an indication of the tonal detail actually contained in the file. If you invest in a 14-bit monitor, such as an Eizo, you can see a little more into the shadows, but practically, the only way to tell what you can pull out of a 14-bit Raw file is to work the processing sliders, and pay close attention at 100% magnification to noise in the shadows.

There is enough material for an entire book on best practices in processing Raw files, though I suspect it might end up being rather dull. Here I want simply to introduce the potential and what it means for the play of light and light quality that was originally shot. Raw processing really comes into its own when the dynamic range is high. For the main image here, shot into the sun which was lightly masked by the tree, I exposed down to the point of being able to hold the top highlights, knowing approximately what I could—or could not—recover in the processing. There are many permutations of the six main sliders that control tonal value, each with subtle differences. I relied here mainly on recovering highlights and shadows with their respective sliders, but as they tend to flatten the image, I raised the overall contrast to compensate. The upper limit to highlight recovery was an edge effect around the outer leaves of the tree. Even when the original is within range and has no obvious problems, Raw processors offer many—almost infinite—subtle variations in such personalized qualities as contrast, color balance, vibrance, and clarity. This alone argues very strongly for shooting in Raw, so that with important images you can take your time, well away from the shooting, to make them look their best. ■

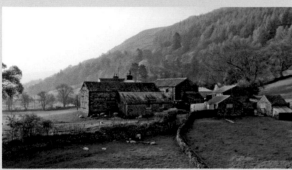

The width of the Raw exposure adjustment

The Raw-processing exposure range, from minus 4 stops to plus 4 stops (though the image file itself does not contain that entire range). The second image is the default as exposed.

R: 131	f/8	1/100 s
G: 136		
B: 130	ISO 80	8.8 mm

Basic

White Balance: As Shot

Temperature — 4700

Tint — -8

Auto Default

Exposure — +0.15

Recovery — 64

Fill Light — 68

Blacks — 48

Brightness — +50

Contrast — +71

Clarity — 0

Vibrance — +13

Saturation — 0

TWO DIFFERENT RAW PROCESSORS

There are several Raw processing packages on the market including Photoshop (above right) and DxO Optics Pro (below right). All can perform the same basic functions, so there is nothing to be judged from results, only from ease-of-use and operating features. Photoshop offers a slightly fuller set of controls, while DxO Optics Pro concentrates on delivering good Auto settings by default.

The Raw settings applied

The main work done here is by the Highlights and Shadows sliders to recover their respective tones, with Contrast raised to counter the flattening tendency that both of these have.

PROCESSED LIGHT Local Control in Raw

One of the biggest improvements made in Raw processors was to enable local control, which is hands-on and specific—the digital equivalent of the old wet-darkroom techniques of dodging and burning. The advantage of doing this digitally rather than on a projection print is that the clock is not ticking, and local selections can be fine-tuned down to the nth degree. And you can revisit and rework. On the previous pages, the controls used for recovering, brightening and generally bringing into range the hidden potential of a Raw file were all sliders that work in some way globally across the image. Local control is an entirely different operation, both in concept and in action, because it allows you to specify distinct areas for your changes.

Indeed, it depends very much on your judgment and manual skill to bring it off. If we assume that a Raw file has up to two stops of recoverable shadow and another two stops of recoverable highlight (not all images do, but it's certainly possible), this means that you could have two adjacent areas on the image with four stops of processed contrast between them. This can easily look extreme, which is where judgment comes in, while the making of the selection involves fine control over the edges, which can be from sharp to very soft. In the example here, I'm using Photoshop's ACR, and by checking the box that displays the mask used for local selection I can show these edge transitions.

With any picture that you think is worth making an effort for, it helps to have a plan before processing. I had taken this shot because I liked the abstraction of what was actually a shopping mall, so the processing plan was to enhance the abstract design. This in turn meant heightening the contrast, and exaggerating the color pattern (which came from distorted reflections in a polished metal ceiling) and the lines of orange lights. This was a clear case for local control. There were three steps, meaning three

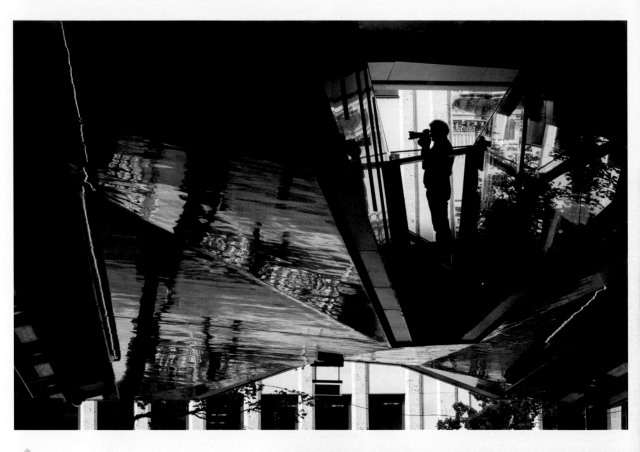

One New Change, London, 2012

The unprocessed original image

Considerably flatter than the final version, this would have a global increase in contrast applied, in addition to the local controls.

masks: one to darken and increase the contrast of the upper left area; a second to darken the distracting gray patch top and slightly right; and a third to lighten and increase the contrast of the colored patterns and lines. This last alone emphasized the colors; there was no need to alter Saturation. ∎

THE PROCESSING PLAN

The goal was to have a clean, abstract, and essentially monochrome design, over which would be laid the strengthened block of distorted colors and the distinct arrangement of orange lines fanning out.

Key Points
Planning
Adjustment Brush
Global vs. Local

LOCAL MASK #1

Exposure down and contrast up to knock back the upper left.

LOCAL MASK #2

Exposure right down to take the small lighter area at top back into the background.

LOCAL MASK #3

Exposure up and contrast strongly up on the colors.

Adjustment Brush

New ● Add Erase

Temperature	0	
Tint	-7	
Exposure	+0.50	
Contrast	+69	
Highlights	0	
Shadows	0	
Clarity	0	
Saturation	0	
Sharpness	0	
Noise Reduction	0	
Moire Reduction	0	
Defringe	0	
Color		
Size	8	
Feather	36	
Flow	40	
Density	100	

Auto Mask ☑ Show Mask

Adjustment Brush

New ● Add Erase

Temperature	0	
Tint	-7	
Exposure	+1.05	
Contrast	0	
Highlights	0	
Shadows	0	
Clarity	0	
Saturation	0	
Sharpness	0	
Noise Reduction	0	
Moire Reduction	0	
Defringe	0	
Color		
Size	8	
Feather	36	
Flow	40	
Density	100	

Auto Mask ☑ Show Mask

Adjustment Brush

New ● Add Erase

Temperature	0	
Tint	-7	
Exposure	+0.50	
Contrast	+69	
Highlights	0	
Shadows	0	
Clarity	0	
Saturation	0	
Sharpness	0	
Noise Reduction	0	
Moire Reduction	0	
Defringe	0	
Color		
Size	8	
Feather	36	
Flow	40	
Density	100	

Auto Mask ☑ Show Mask

PROCESSED LIGHT Smoothing Banding

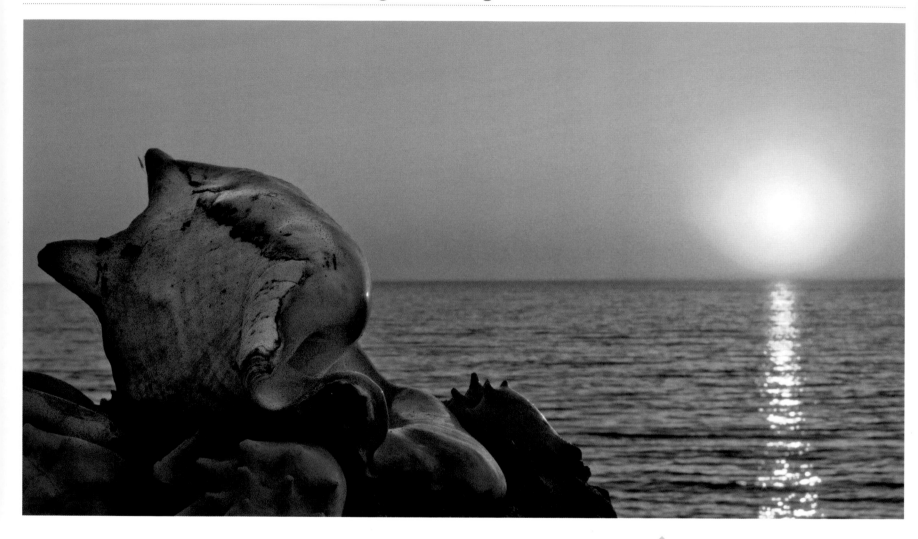

One of the stickiest problems in processing is handling images that have a sun and clear sky in view. The reason is that, because the rest of the landscape has to be taken into account, a typical exposure leaves the sun well overexposed. This in itself is no disaster, as we've already seen—there's nothing wrong with overexposure if you want a bright, glowing effect—but it usually creates visible circular banding. This happens because of the way the photosites in a sensor work. Each one, which produces one pixel, is a light well that catches photons. The more it fills, the brighter the pixel. But when it fills to the top, it simply delivers nothing—

total white. It is the abruptness of this filling-up that causes the banding, because the visual difference between pixels that are almost white and those that are totally white is a sharp edge. And because each of the three channels may clip at a different point, there may be two or more concentric bands. Other things contribute, including the color space, color profile, the bit depth, and the specific Raw processor (some handle this issue better than others).

So, what we typically have is a gradient converging on the sun's disc going from pale to white, and at some point it breaks into an edge—or two or three edges. Worse still, this is surprisingly resistant to

With banding reduced

With the procedures shown on the cropped version applied: first the colors of bands adjusted as much as possible using Replace Color, then 20% noise applied to a soft selection around the sun, then 15-pixel Gaussian blur.

Key Points

Recording All

Bracketing

Tonal Fall-off

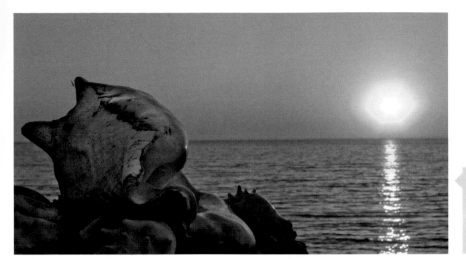

Optimally processed

Here, nothing has been done to banding around the sun, and there has been no highlight recovery, but otherwise exposure has been raised, shadows filled, and local contrast and brightness increased on the shell.

the normal Raw recovery processes. Highlight recovery algorithms can actually worsen the banding problem be making banding edges more definite. As we saw in Glowing Light—*Things Burning* on pages 124–125, Highlight and White recovery is not the answer.

This is a purely digital problem, and we've seen it rear its head earlier, both on pages 124–125 and in Golden Hour—*Facing into Soft Golden Light* on pages 98–99. Film, which loses to digital sensors in so many ways, here delivers smoothness automatically. While just saying that hardly helps matters, understanding the difference between the response of film and sensor to bright graded light makes it a little easier to process this tricky condition. The response of film to increasing light tails off gradually, so it has a natural smoothing action. And what we need is just this, a smooth gradient from the bright highlights to the truly overexposed center.

All solutions involve local selections in the area around the sun, and there are two ways of doing this. One is to make a soft-edged circular selection around the sun (in Photoshop, a large soft brush in Quick Mask or in ACR). The other is to layer two versions of the entire image, normal on top, filtered below, and erase around the sun in the upper layer. Sharpness/blur controls work to an extent, but highlight recovery, exposure, and clarity sliders usually exaggerate the band edge. The ultimate solution is not particularly elegant, but works, and takes advantage of the way in which noise can break up an image. As shown here, apply noise, then Gaussian blur. The amounts need experiment, and depend on the specific image. ∎

Default

Cropped, this is the file as opened with no adjustments. Noticeable banding in both color and tone.

Selective brightening

A soft-edged selection has been made around the sun, then brightness increased and contrast reduced. This is an independent solution from the more effective noise/blur procedure.

Noise added

A soft-edged selection has been made around the sun, and 20% uniform noise added.

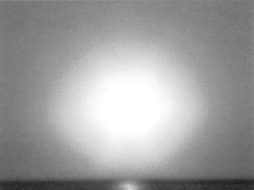

Noise & banding blurred together

Immediately after the noise filter, Gaussian blur is added at a radius of 15 pixels.

PROCESSED LIGHT Pro-level Dodge & Burn

In wet-darkroom photography, the duo of dodging and burning is the height of craftsmanship, and in pre-digital days it was an important skill. Digital processing methods have pushed it into the background, as there are several other ways of exercising local control over tones, but in professional retouching it is still used, and for good reason.

In a wet darkroom, dodging means holding back exposure from an area of the print by holding something in the light path below the enlarger lens: a piece of shaped card, your hand, or one of a number of tools on the ends of rods. The effect is to lighten part of the image by hand, and this of course had to be done in real time—the length of the exposure. Burning is the opposite, using a hole in a larger card to increase the exposure for part of the image so that it darkens.

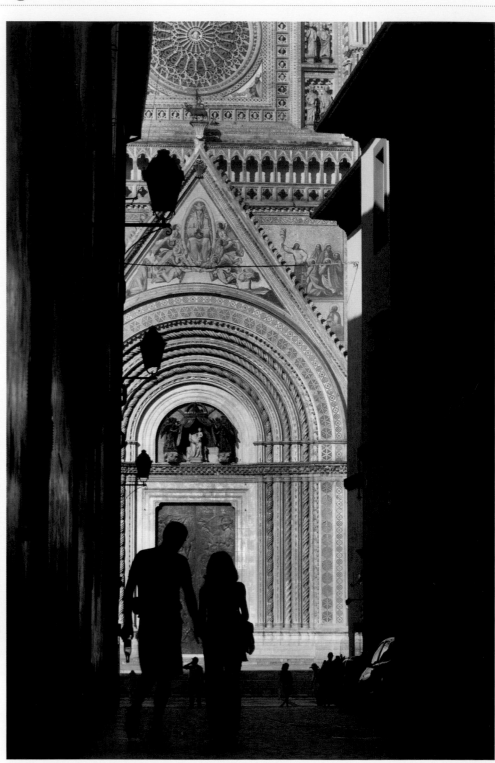

The separate elements

The three key elements of the image are tonally separated: the brightly lit façade of the Duomo, the shadowed street, and the dense silhouette of the couple.

The Duomo, Orvieto, Italy, 2011

In Photoshop there are Dodge and Burn tools, with much more control than in a darkroom, but still not quite enough for high-level retouching. Instead, we can use layers, and the principle is that different blending modes allow you to paint on the image in such a way that you lighten or darken—and very usefully split this between Highlights, Shadows, and Mid-tones. Retouchers have their own idiosyncrasies when it comes to the type of blending mode and the settings, but here is one that I use:

Three layers, all filled with 50% gray, and all set to a very low opacity: 10%

LAYER 1
Set to Hard Light. Paint with black to burn (darken) Highlights. Paint with white to dodge (lighten) Shadows.

LAYER 2
Set to Vivid Light. Paint with black to burn Shadows. Paint with white to dodge Highlights.

LAYER 3
Set to Soft Light. Paint with black to burn Mid-tones. Paint with white to dodge Mid-tones.

Vary the opacity of the brush as necessary. To restore parts of a layer to their original state, paint in 50% gray.

Some of this dodging and burning, incidentally, can be done on a 32bpc floating-point TIFF, although there are fewer blending modes for the layers because we're dealing with a floating-point image. For instance, make a layer filled with 50% gray and set it to Multiply mode. Painting on this with black does not simply darken the image, but actually reveals parts of the dynamic range that were out of the monitor's range. Very powerful, but also very difficult to control. ■

Raw process

At this stage, the processing has been taken to its full extent using Photoshop ACR, but there is still room for increasing contrast in the shadow areas of the walls and cobblestones.

Make three 50% gray layers

Three dodge-and-burn layers are made above the image, each with a different function.

The retouching record

The three layers shown at 100% opacity to give an idea of the retouching in black and in white (normally never seen this way). Most of the work has been to give more punch to the shadow areas, revealing more of the rich reflections of the Duomo on the shaded walls of the narrow street facing it, while separating better the silhouetted couple from the paving and the green bronze door beyond.

ARCHIVED LIGHT What HDR Really Means

Basilica of Saint Lawrence, Asheville, North Carolina, 2007

HDR, meaning High Dynamic Range, may well be shorthand for breathless, steroidal processing, but what it really means is just a way of capturing the full dynamic range in a scene, however contrasty it is. I know I need to restrain myself from being hypercritical of the HDR offerings swimming out there in the online image-sharing oceans, but the problem is that almost all of them look exactly the same. It's a classic case of the process swamping the personality of the photographer. More on how to overcome this in a few pages' time, but for now I want to concentrate on what's much more interesting about this technique—the idea of archiving light.

It's a strange concept, the archiving of light. What it means is collecting all the visual data possible from a scene, and storing it somewhere for future use. That's what archives really are—an historical record—in this case of all the light falling on the scene. What is interesting about this is that as long as you have all that data, it's not so important whether or not you have software to make it all visible on a screen or in a print in exactly the way you want. You will be able to at some point, as

A range of exposures

With exposures at 1/2 second, 2.5 seconds, 5 seconds, and 10 seconds, these four exposures cover a range of almost 12 stops (6 stops of exposure spacing plus the range contained in the brightest and darkest frames).

 EV -4 EV -1 middle EV +2

software improves and evolves. As it happens, there are some real perceptual difficulties in showing all of an HDR scene, but I'll save that for the following pages. For now, the point is the camera's limitations.

Sensors get better all the time, but even the best are nowhere near able to capture all of a really contrasty scene, such as shooting straight into a bright sun in clear weather with foreground shadow detail. At least, not in a single shot, which is what the inventors of HDR realized. Neither, frankly, was film able to capture everything, but at least it has a built-in smoothing-out response. That means at the bright and dark ends of the range the image recorded on film does not simply and sharply go pure white and pure black. It tails off in a natural-looking way. For those familiar with film, these are the toe and heel of the characteristic curve.

Down to the nitty-gritty. If you shoot the same scene, identically framed, at different exposures, then you can capture all the detail. It may take several, even many shots, but the result is that you will have captured it all. The perfect procedure is to lock the camera down on a tripod, then shoot a sequence of frames from a very dark exposure to a very light one. Vary the shutter speed, not the aperture, as the latter changes the depth of field. Start by finding the darkest exposure at which there is no clipping (overexposure) of the highlights, then continue shooting at slower shutter speeds until you reach the lightest exposure at which the deepest shadow detail looks like middle tones. If you shoot Raw, for the reasons we just looked at, then you can space out the exposures by 2 *f*-stops. For safety overkill, space them by 1 *f*-stop. And there you have it, all the light information from the scene archived safely.

What you do with all this extra data later is another matter, for which see below. ■

Highlight clipping

Making no adjustments in the Raw-processing stage, the longest exposure shows clipping in the highlights.

FILM'S GENTLER FALL-OFF

A black-and-white film negative as it typically looks on a lightbox, covering a range of grays with no pure black or white. The characteristic curve of film shows how its response to light fades smoothly at both ends, unlike the abrupt clipping of a digital file.

A 32-bits-per-channel HDR image file

The Photoshop window at the stage of combining the four different exposures into a single image file that contains all the values. This is an archived-light file, although unviewable on a normal monitor. The slider allows you to view just parts of the entire range that it contains.

ARCHIVED LIGHT Realistic HDR from 32pbc Editing

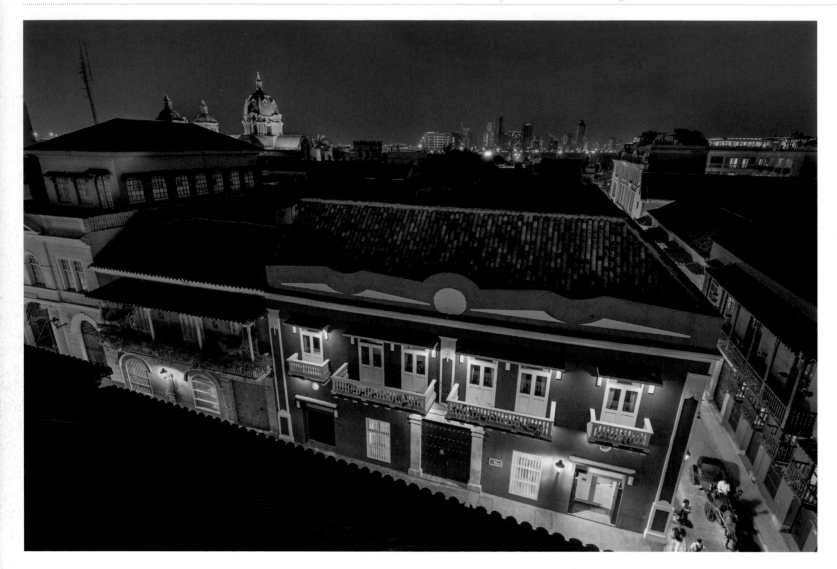

Cartagena, Colombia, 2008

As we just saw, HDR is really about capturing all the light information in a scene. What you then do with it is a different matter, and what concerns many professionals is delivering an image that looks like a normal photo rather than an illustration. There are many options, but the problem is that all the ways of showing photographs, from screen to print, cover a much more limited range than we can experience with our eyes. The popularity of extreme HDR tone mapping is a by-product of software that tries in various ways to cram the information into that short range of tones. At the risk of disappointing people who like that kind of effect, I'll move beyond that solution to ones that promise a more photographic look. On the following pages is the way to use exposure blending to combine exposures, but here is the 32 bits-per-channel solution, and of all the ways I show, this is my preferred one.

Without any great fanfare, Photoshop can now handle HDR images in a normal and photorealistic way that for most images completely does away with the usual problems of HDR processing. The key to this is that you can now open an HDR file as if it were a regular Raw file, in Photoshop's ACR (Adobe Camera Raw). This may sound like a small thing, but it makes a huge difference for professionals who simply want to recover more highlight and shadow detail from a shot.

First, shoot the exposure range of several frames, with as little movement between them as possible (see the previous pages). Then combine them into an HDR file as follows:

1. Go to Preferences > Camera Raw and at the bottom choose the last option: Automatically open all supported TIFFs. This now means that each time you open a TIFF, it will open in ACR, so you may need to go back to these preferences after processing the HDR image and revert to the default Automatically open TIFFs with settings.

2. Open the Raw files, adjust the lens and chromatic aberration, but nothing else. Save as DNG or TIFF.

3. File > Automate > Merge to HDR Pro, and follow the instructions.

4. In the top-right corner of the resulting window, choose 32 Bit for Mode, and click OK.

5. Save as a TIFF (under Format) and as 32 bit (Float).

6. Open the saved 32bpc TIFF, with Format set to Camera Raw.

7. You now have all the ACR tools available for processing this file. As you slide the Exposure control, you'll see that you now have a huge range to play with.

Simply using the adjustment sliders—but taking them further than you would normally—can be sufficient for a surprising number of high-range situations. If you then add in the local brush and grad controls, the processing becomes very powerful indeed. In a way, it's like turbo-charged Raw processing, and yet still retains a natural feel that tone mapping does not. An interesting starting exercise is to take Highlights to the minimum and Shadows to the maximum, and then adjust Contrast. ■

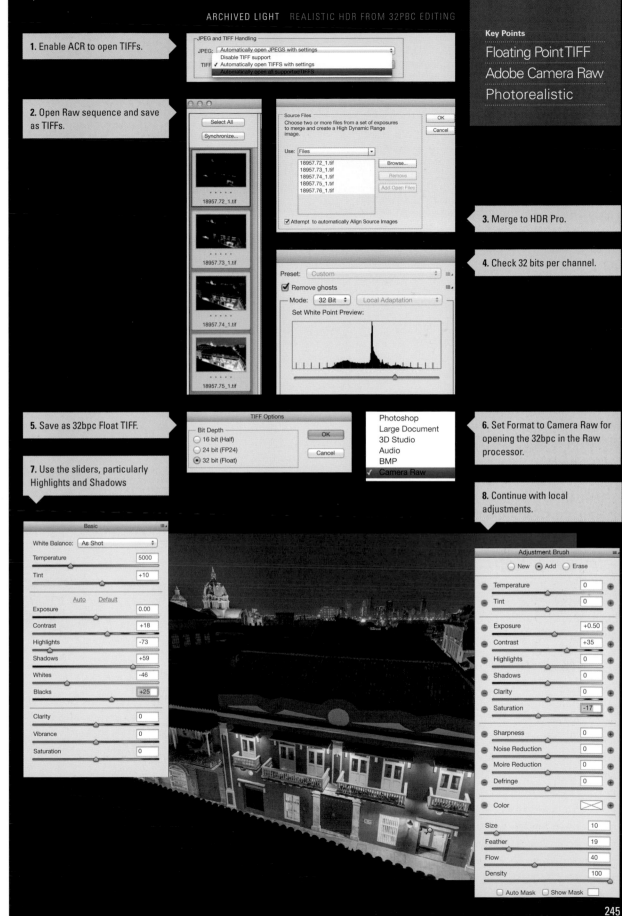

1. Enable ACR to open TIFFs.

2. Open Raw sequence and save as TIFFs.

3. Merge to HDR Pro.

4. Check 32 bits per channel.

5. Save as 32bpc Float TIFF.

6. Set Format to Camera Raw for opening the 32bpc in the Raw processor.

7. Use the sliders, particularly Highlights and Shadows

8. Continue with local adjustments.

Key Points

Floating Point TIFF
Adobe Camera Raw
Photorealistic

245

ARCHIVED LIGHT Natural Exposure Blending

More familiar as a way of rendering an HDR file is dedicated software, of which Photomatix is the most well known. Tone mapping is the most powerful method for showing every tone, but it carries a penalty of looking less than realistic. You could perfectly well argue that it depends on your definition of realism, but for me in photography it means "photorealistic," i.e., looking like a photograph. The term tone mapping explains all: Each tone in the huge HDR image file with its unviewably large dynamic range is mapped to a predetermined viewable tone. The formula for working out what gets mapped to where, called the algorithm, holds the secret, and there are many of them, devised by different software engineers, all striving to offer users the most effective tools.

So, between the different software packages available and the many slider controls that each one has, there are infinite ways of processing an HDR image, and I could fill this entire book with variations on just a single image. However, if the goal is to keep the image looking photorealistic while pulling back in all the highlights and shadows, there are much fewer possibilities. Here I'm using just Photomatix, which intelligently divides its processing into three groups. One is global tone mapping, called by Photomatix Tone Compressor, in which the tones across the board are allocated together. The second is local-contrast tone mapping, called Details Enhancer, which searches local neighborhoods of pixels and takes these neighbors into account as it processes. This is the most powerful method, but also the one that most easily looks unrealistic. The third is not tone mapping at all, but Exposure Fusion, in which the "best" exposed areas from each of the original sequence of exposures are chosen. This is how the main image here was processed, and while it is by no means as powerful as the two tone-mapping methods, it stays looking fairly realistic. However, that said, for me the 32bpc

Interior, Primrose Hill, 2007

process on the previous pages gives the most powerful, yet most photorealistic result, with the least complications and effort. For comparison, I include a version of this image done in this way. ■

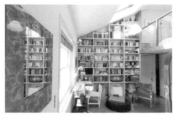
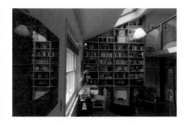

Bracketed sequence

The sequence of exposures, each separated by 2 *f*-stops. Roughly calculated, the entire dynamic range covers about 11–12 stops, made up of the 6-stop difference between the four exposures plus the latitude within the lightest and darkest Raw files.

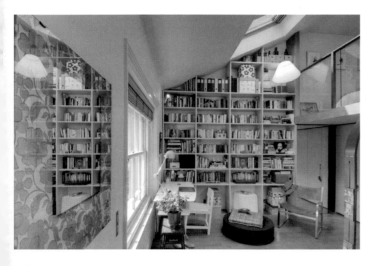

Exposure Fusion

This is Photomatix' name for exposure blending, designed to look more photographic while sacrificing recovery at either end.

Tone Compressor

Of the two tone-mapping methods offered by Photomatix, this one is designed for more photo-realism (though not as much as Exposure Fusion), by sacrificing some recovery power.

Details Enhancer

The most powerful tone mapper from Photomatix, and the one commonly used for extreme (i.e. non-realistic) results.

32bpc opened in Raw

For comparison, the same HDR file treated in the 32bpc process from the previous pages, and ultimately the most realistic method of all.

TIME-LAPSE LIGHT Accumulating Light & Shade

What used to be a separate piece of equipment, an intervalometer, is now built into many cameras, as is video capability, and due to of this, time-lapse video has become very popular. Less common, but a by-product of this, is time-lapse light, in which a scene shot at different times of day with the camera locked off is combined into a single image. The combination is automatic and makes use of Photoshop's Stack Modes, and although the work is intensive for the computer, it needs little attention for the photographer. I say "by-product" because the shooting procedure is the same, and you can choose later to do one or the other, or both.

The result is that you capture the movement of light over hours, so in theory you're adding the dimension of time to the image. In practice, whether it is successful or not depends on anticipating how the light will move, how you combine all the frames, and on taste. In principle, time-lapse lit images have less form, and less chiaroscuro than most, simply because they tend to average out different lighting directions. This can often be quite dull, and less interesting than a normal image, so this is where preference comes in. To be worth doing, the effect has to have some point of difference from a cloudy-day image, which it can often resemble. Shooting in bright sunlight has some advantage, because the expected shadows (from the other clues, such as blue sky) are absent. Nevertheless, results can be disappointing, and by no means always predictable.

I'll go through the technical side of the blending process in a couple of pages, but for now I want to look at the possible results, because there is always a choice, depending on the kind of blend. The example here, which we'll follow through in detail on the following pages, was shot over five hours from the middle of the day to dusk, on a Caribbean beach. It works very well as a time-lapse video, for which the shoot was intended, because it has long-term

Punta Iguana, Baru Island, Colombia, 2012

speeded up movement in the form of the shadows of the mangrove tree on the white sand, and the sun itself at the end setting. This is usually the key—showing movement that the eye doesn't normally register. You can view the video on this site: www.ilex-press.com/resources/capturinglight

It also gives possibilities for time-lapse light in a single image, for the same reasons. Because it was shot with a ultra wide-angle lens (14mm) close to the ground in stark sunlight, the shadows are definite and move a lot. As we'll see, they can be combined to cancel each other out, or to add to each other, or as an average. The only justification for going to this trouble is to end up with an image that looks slightly strange or otherworldy, that couldn't be achieved any other way. In this case, I liked the combination of stark and flat light with an absence of shadows, apparently at the same time under a cloudless sky. The final descent of the sun, with a string of sunstars, also appealed. ■

The actual scene

One frame from the sequence shows the typical appearance, with a constant flow of activity. At no point were the streets empty.

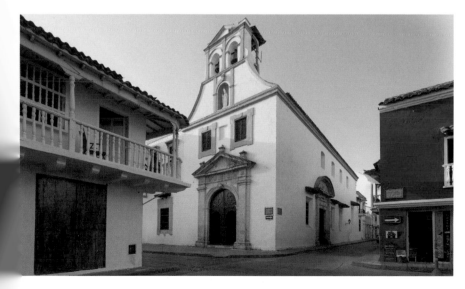

Constantly moving shadows & sun

Over the course of almost six hours, the shadows, the position of the sun, and the colors all shifted. These five moments from a sequence of 364 show the range available to combine.

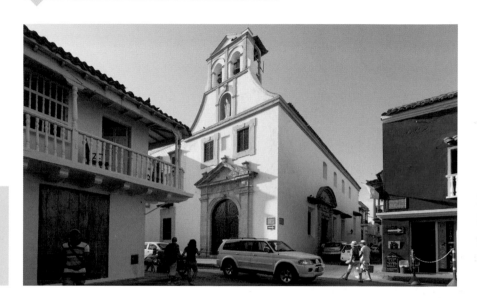

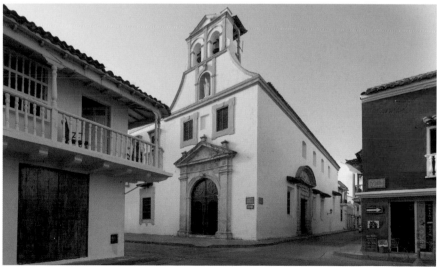

Emptying a busy street #1

Visually less successful was this combination from a similar sequence shot in the center of Cartagena, Colombia. Using Median mode achieves the effect of emptying the scene of people and traffic, but the image itself is bland.

Emptying a busy street #2

Using both Mean and Median modes allows for some variation in how the sunlight appears on the façade of the old church.

TIME-LAPSE LIGHT Shooting Procedures

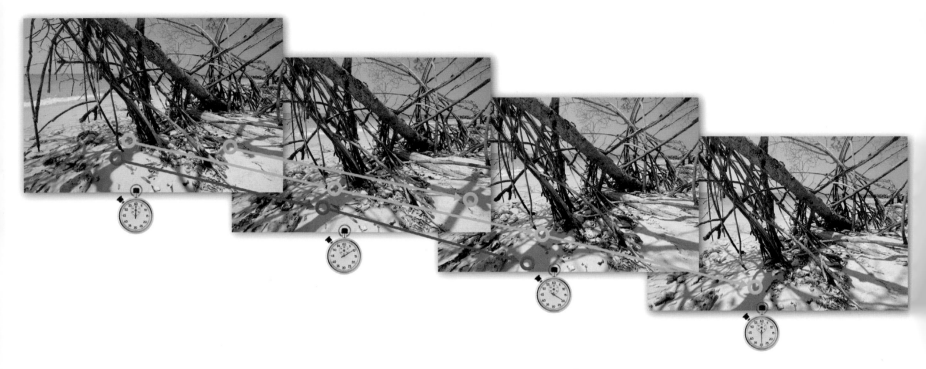

Whether you choose to shoot time-lapse for a video sequence or a single composited image, it demands a careful setup with no mistakes and no camera movement over a long period, typically a few to several hours. You need the camera locked off securely (MoCo, or motion control, is another world), as any camera movement at all will ruin the sequence, and you need a fully charged battery. In the example here, shot for almost six hours on a beach, one potential problem was movement from wet sand as the tide moved, so the tripod was supported on stones. Another was exposure to salt air and to heat from a Caribbean sun, so the camera was covered. A third was the slight possibility of someone coming close to investigate, hence the notice taped to the equipment. Time-lapse is very much about planning and anticipation.

How long you shoot for depends first on the movement you expect in the scene, for example, the movement of shadows. It also depends on how long you will want the clip to play for if it is to be a video,

and what variation of light and shade you need if the main purpose is a composited image. The calculation for video is as follows. Assume a playback rate of 24 or 30 frames per second, at which rates the movie will look smooth and realistic (any less and it may flicker), and a ten-second clip (not long, just count it in your head) will need 240 to 300 frames. If you shoot late afternoon shadows, you'll probably need about three hours to get a good effect, so that would mean around one shot every 40 seconds.

Also decide whether to use a fixed exposure or automatic; for this there are two options. If the light will remain fairly constant, fixed will give less flicker, but if you're shooting from, say, late afternoon through to night, you'll need to vary the exposure, and autoexposure is the easiest way of doing this, and also avoids the risk of camera movement. Shooting Raw or TIFF is overkill for most projects. If you take care of the exposure settings, shooting JPEG is fine.

Time-lapse video generally works best when there is a smooth movement during the period. Jerky can

Fast-moving shadows from a 14mm lens

Four frames from the beginning of the sequence of 364 give an idea of the speed of the moving shadows and the direction. Using a very wide angle from very close exaggerated this movement toward the lower right of the frame.

be successful too, but is less mainstream. One of the guaranteed-to-please movements is of shadows, and one of the reasons why this image works as a video clip is that the close view of mangroves with a wide-angle lens, and the angle chosen toward the sun, allow the sharp shadows to race across the almost-white sand. Rendered as a composited still image, it works because of the changing angle of the sun, which ends up facing into the camera. ■

The complete sequence of 364 frames, from 12:24pm to 6:30pm.

The setup

Setting up the camera for an uninterrupted sequence involved securing the tripod on stones to minimize the risk of shifting sand as the tide moved, protecting the camera from salt air and heat, and warning off potentially curious passersby.

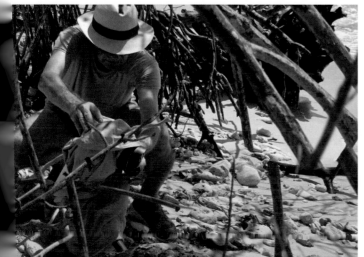

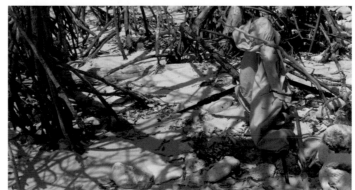

TIME-LAPSE LIGHT Blending Procedures

Staying with the Punta Iguana shot, here are the four potentially useful ways of combining the 364 images. The advantage of shooting a large number of images in a time-lapse sequence—a few hundred—is that the tiny differences between each frame smooth out all the light changes. Also, the sequence becomes available for a time-lapse video if you want. The technical procedures for time-lapse, which are quite strict, are on the preceding pages. One caution, though: Shooting even just JPEGs at full size can result in a huge file when a few hundred of them are stacked, and this severely taxes Photoshop. It may even be impossible to save the file after you've finished working with it—the beach image here grew to more than 2GB. Check that your computer can handle it.

In post-production, first load the frames into one image file as a stack of layers. There are two easy procedures for this in Photoshop. One is File > Scripts > Load Files into Stack. The other, in case you are working from a video, is File > Import > Video Frames to Layers. In either case, the next step is to combine all the layers into a Smart Object. With the Load Files into Stack script, simply check the box Create Smart Object after Loading Layers. Otherwise, go to Layer > Smart Objects > Convert to Smart Object. Then choose a Stack Mode by going to Layer > Smart Objects > Stack Mode and on to the choice offered in the list of modes. (These were originally designed for statistical analysis, and most are irrelevant for normal photographic imagery.) There are generally four useful Stack Modes for this kind of image. One is the well-known Median, often used to remove passing people from a shot of a fixed subject such as a monument. Median means the middle value, and the effect in an image stack is to remove elements that appear just occasionally, like something moving across the scene.

Also possible is Mean, which is what most people think of as averaging—the sum of every image

The layered composite

The final image shown on page 248 was combined from three different stack modes: Median, Mean, and five differently treated versions of Maximum. It involved considerable manual erasing, together with varying percentages of opacity.

averaged out, so changing elements in a scene tend to appear ghosted, as opposed to being filtered out, as happens with Median. Maximum Stack Mode gives the brightest combination possible, while Minimum gives the darkest. In practice, it's difficult to predict which will be the most useful, so the best procedure is to make versions of all four, and then consider which of these to combine. In the case of the beach scene with mangroves and a sun that finally sets, the Maximum version was the most dynamic because of the several sunstars. For the final image, this was combined with Mean and Median as layers, using copies in different blending modes and at different opacities, and then using an eraser brush to remove different parts. There are no set procedures for doing this, and experimentation by eye works best. ■

STEP 1

Photoshop has a stack-loading script already prepared.

Load Layers

Source Files
Choose two or more files to load into an image stack.

Use: Files

20024_001.jpg
20024_002.jpg
20024_003.jpg
20024_004.jpg
20024_005.jpg
20024_006.jpg
20024_007.jpg
20024_008.jpg

Browse...
Remove
Add Open Files

☑ Attempt to Automatically Align Source Images
☑ Create Smart Object after Loading Layers

OK
Cancel

STEP 2

Choose the image files to load. Check the box that will automatically convert them into a smart object.

Layer　Type　Select　Filter

New
Duplicate Layer...
Delete

Rename Layer...
Layer Style
Smart Filter

New Fill Layer
New Adjustment Layer
Layer Content Options...

Layer Mask
Vector Mask
Create Clipping Mask　⌥⌘G

Smart Objects
Video Layers
Rasterize

New Layer Based Slice

Group Layers　⌘G
Ungroup Layers　⇧⌘G
Hide Layers

Arrange
Combine Shapes

Align
Distribute

Convert to Smart Object
New Smart Object via Copy

Edit Contents

Export Contents...
Replace Contents...

Stack Mode
Rasterize

None

Entropy
Kurtosis
Maximum
Mean
Median
Minimum
Range

STEP 3

Choose which stack mode you want.

Key Points

Stacking
Experimentation
Workflow

Image Processor...

Delete All Empty Layers

Flatten All Layer Effects
Flatten All Masks

Layer Comps to Files...
Layer Comps to PDF...
Layer Comps to WPG...

Export Layers to Files...

Script Events Manager...

Load Files into Stack...
Load Multiple DICOM Files...
Statistics...

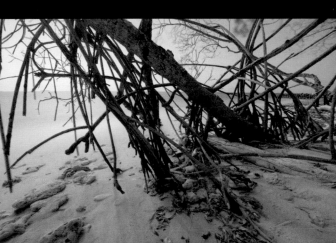

Mean Mode

This mode gave a flat, shadowless result.

Median Mode

This version is the most realistic, preserving some sense of the shadows.

Minimum Mode

Striking in its own dark way, there was eventually no place for this in the final composite, as I chose to go for the Maximum version— effectively the opposite of this.

Maximum Mode

Probably the most striking of the four modes because of its harsh light and the multiple images of the sun, this was very useful for giving a slightly surreal air to the final image, although the overexposure had to be moderated by lower opacity and selective erasing.

INDEX

INDEX